YOU ARE AN ARTIST

Sarah Urist Green is a curator, art educator, and creator of *The Art Assignment*, a PBS video series exploring art history through the lens of the present. A former curator of contemporary art at the Indiana polis Museum of Art, Green holds an MA in modern art history from Columbia University. She lives in Indianapolis with her husband and two children.

YOU ARE AN ARTIST

ASSIGNMENTS TO SPARK CREATION

SARAH URIST GREEN

PARTICULAR BOOKS
an imprint of
PENGUIN BOOKS

PARTICULAR BOOKS

UK | USA | Canada | Ireland | Australia
India | New Zealand | South Africa

Particular Books is part of the Penguin Random House group of companies whose addresses
can be found at global.penguinrandomhouse.com.

First published in the United States of America by Penguin Books, an imprint of Penguin
Random House LLC 2020
First published in Great Britain by Particular Books 2020

001

Conversion of the UK edition by Rhapsody Media

Printed and bound in Great Britain by Livonia Print, Latvia

A CIP catalogue record for this book is available from the British Library

ISBN: 978-0-241-44289-0

Penguin Random House is committed to a
sustainable future for our business, our readers
and our planet. This book is made from Forest
Stewardship Council® certified paper.

FOR MY MOM, WHO GAVE ME MY FIRST ART ASSIGNMENTS

CONTENTS

INTRODUCTION — ix

SURFACE TEST Kim Beck — 1

BECOME SOMEONE ELSE T. J. Dedeaux-Norris — 5

IMPRINT Sopheap Pich — 10

DRAWING WHAT YOU KNOW RATHER THAN WHAT YOU SEE Kim Dingle — 14

NEVER SEEN, NEVER WILL David Brooks — 18

QUIETEST PLACE Jace Clayton — 22

CAPTION CONTEST David Rathman — 26

MAKE A RUG Fritz Haeg — 31

CUSTOMIZE IT Brian McCutcheon — 36

EXQUISITE CORPSE Hugo Crosthwaite — 41

SYMPATHETIC OBJECT IN CONTEXT Genesis Belanger — 46

SELF SHAPE Tschabalala Self — 50

THE MUSTER Allison Smith — 54

BLOW UP Assaf Evron — 58

WHITESCAPES Odili Donald Odita — 63

PAPER WEAVING Michelle Grabner — 67

VEHICULAR PALETTE Jesse Sugarmann — 72

VIRTUAL SEESCAPE Gina Beavers — 76

COPY A COPY A COPY Molly Springfield — 80

COMBINATORY PLAY Pablo Helguera — 84

NEWS PHOTOGRAPHER Alec Soth — 88

THE ART OF COMPLAINING The Guerrilla Girls — 92

WALK ON IT Kate Gilmore — 96

PROPOSALS Peter Liversidge — 101

SORTED BOOKS	Nina Katchadourian	**107**
MEET IN THE MIDDLE	Douglas Paulson and Christopher Robbins	**111**
FIND YOUR BAND	Bang on a Can	**116**
CONSTRUCTED LANDSCAPE	Paula McCartney	**120**
NATIVE LAND	Wendy Red Star	**125**
BODY IN PLACE	Maria Gaspar	**130**
STATEMENT	Dread Scott	**135**
MEASURING HISTORIES	Sonya Clark	**139**
PSYCHOLOGICAL LANDSCAPE	Robyn O'Neil	**144**
QUESTION THE MUSEUM	Güler Ates	**148**
EMOTIONAL FURNITURE	Christoph Niemann	**152**
LOST CHILDHOOD OBJECT	Lenka Clayton	**156**
SIMULTANEITY	Beatriz Cortez	**161**
INTIMATE, INDISPENSABLE GIF	Toyin Ojih Odutola	**165**
EXPANDED MOMENT	Jan Tichy	**169**
WRITING AS DRAWING AS WRITING	Kenturah Davis	**174**
BOUNDARIES	Zarouhie Abdalian	**178**
OFF	Lauren Zoll	**182**
THOUGHTS, OPINIONS, HOPES, FEARS, ETC.	Gillian Wearing	**186**
EMBARRASSING OBJECT	Geof Oppenheimer	**190**
STAKEOUT!	Deb Sokolow	**194**
IMAGINARY FRIEND	JooYoung Choi	**200**
FAKE FLYER	Nathaniel Russell	**205**
BECOME A SCI-FI CHARACTER	Desirée Holman	**208**
GRAPHIC SCORE	Stuart Hyatt	**214**
SCRAMBLE SCRABBLE DINNER	J. Morgan Puett	**219**
PAPER PLATE	Julie Green	**225**
CONJURE A STUDIO	Hope Ginsburg	**229**
SHADOW PORTRAIT	Lonnie Holley	**233**
PARTING NOTE		**237**
ACKNOWLEDGMENTS		**238**
CATEGORIES		**240**
IMAGE CREDITS		**242**

INTRODUCTION

When I was a kid growing up in Birmingham, Alabama, I took an art class taught by Lonnie Holley. At the time, he went by the name "the Sandman," after the sandstonelike material that inspired his first artworks and into which he carved faces, figures, and forms. Holley was like no one I'd ever met: warm, wise, wildly imaginative, rings on nearly all of his fingers, and driven to make in a way I'd never witnessed before. Best of all, he took us young people seriously.

Holley presented us each with a block of sandstone and challenged us to carve something from it. We knew what his work looked like and not much else, but we set about our task with gusto, filing away our blocks until we were happy enough with what we'd made. The idea was not for us all to become artists like Holley or to make sculptures that looked just like his. It was to try on a way of working for a while, to gain a momentary glimpse into the materials and ideas that inspired him to make art.

I haven't carved sandstone since, but the experience stayed with me. Holley expanded my world by showing me his singular way of looking at our shared surroundings. This was the first of what would be many interactions with artists in my life, each of whom showed me there were vastly different ways of perceiving the world and manipulating the physical stuff around us. As I went on to make my own art and hack a path toward a career in art history and curating, I treasured each moment when an artist shared their time and perspective.

It didn't take long to see that not everyone felt this way. "Artsy," I learned, was a dismissive term. Found-object sculptures like the ones Holley made were "junk." People who tried to sell these things were "scam artists." If the art was minimal or abstract, at least one person in the room would say, "I could do that." This world of people and things that felt so precious to me was "pretentious" to many others. But I understood why they felt that way. By the time I became a curator in an art museum, I'd seen plenty of the money-fueled art world that gives

all art a bad rap. I wanted to do what I could to bridge what seemed like an enormous divide between the art world I knew and the one most people encounter when they visit a museum or gallery. Writing wall labels and organizing exhibitions from within those museums and galleries wasn't cutting it.

I want everyone else to feel the way I do when standing in a gallery surrounded by works I've seen in process in a studio, made by an artist I've eaten pierogies with. It's not that the art can't stand on its own; it's that after trying to make things myself and meeting a lot of artists, I don't tend to think of these objects as hallowed artifacts belonging to a different realm. Artworks can be transporting and transformative, but they are made by people. The individuals who make this stuff are not fundamentally different from any other humans. My exposure to artists and making helped make art relatable for me and has also deeply enriched my experiences with it. Throughout my professional life, I've wondered: How could I bring some of that to people who didn't luck into a childhood art class with Lonnie Holley?

That's where these assignments come in. In 2014, I left my job as a curator to make a video series called *The Art Assignment* with PBS Digital Studios. Rather than working out of the basement of an art museum, I began to travel around the country, visiting a wide range of artists at various stages of their careers and asking them to give you assignments. Many of the prompts that appear in this book were drawn from the video series, along with a number of newly commissioned ones. All of these artists have offered prompts that relate in some way to their own ways of working, be it an activity they've tried and liked in the past or an idea they are currently exploring. It could be a technique they use on a daily basis or something they've never tried but always wanted to. Following their lead, you'll invent imaginary friends, collaborate with people you've never met, and become someone else (or at least try). You'll construct a landscape. You'll declare a cause. *You'll find your band.*

In all cases, these assignments were made with you in mind. You don't have to know how to draw well, stretch a canvas, or mix a paint color that perfectly matches that of a mountain stream. This book is designed for artists at every stage, from seasoned makers to those for whom the act of picking up a pencil causes anxiety. It is also made for those who may spend a fair bit of time on the internet, creating and consuming a not-insignificant amount of media through screens.

Making art and being a member of technological life are not mutually exclusive endeavors. As you explore these assignments, I encourage you to use the tools available to you in a way that feels natural, shifting between making things with your hands and using technology to inform, instruct, and circulate your work.

You will find that many of these assignments were made with the hope that you might share your work in real life or online, putting it out into the physical world or allowing the social internet to be your art venue, community, and support system, all in one. Throughout the book, you'll find a selection of responses to these assignments that will perhaps jump-start your own creative process and promote the sharing spirit. If you don't feel comfortable showing your work, that's perfectly fine. Sometimes you are your own best audience. But if you're so inclined, I invite you to share your responses to these assignments on your social media platform of choice, tagging your post with #youareanartist. By using the hashtag, you can share your work with me, find and enjoy the art that others make, and participate in the building of a new, more democratic art world of our own making.

There are no deadlines for these assignments—unless you'd like to give one to yourself, or a teacher has assigned you one of the activities in this book. (If so, stick to it! Deadlines can be the best motivators.) Regardless, keep in mind that you may experience a period of uncertainty between reading an assignment and formulating a response. Initially, you may feel uninspired, only to see an amazing reflection in your phone screen and jump at the opportunity to capture it (see page 182, "Off"). Or you might be moving to a new place, and the process of figuring out where to set up your work space will become an artwork in itself (see page 229, "Conjure a Studio"). You might be visiting your aunt and decide to mine her collection of vintage cookbooks (see page 107, "Sorted Books"). Perhaps you need to entertain a child (see page 67, "Paper Weaving") or figure out a way to see your friend who lives far away (see page 111, "Meet in the Middle").

The point is, these assignments can be part of the normal course of your life. They aren't meant to function in a sheltered world apart, where time, responsibilities, and budgets don't exist. I encourage you to follow these instructions but also to deviate, adapt, and make them work for you. This book contains many voices, but the one you're seeking is your own. Supremely talented artists are sharing their insights and approaches with you, but your challenge is to filter the assign-

ments through the lens of your own experience and make something that reflects the way you see the world.

Art assignments are not a novel concept. They are an integral part of early childhood education in many parts of the world and are often the way we first learn about color, pattern, math, science, feelings, and how to be a communicative being in the world. Instructions and assignments have played a significant role in art history since the 1950s. Yoko Ono's 1964 book *Grapefruit* offers up a panoply of instructions, including "Listen to the sound of the earth turning" and "Stand in the evening light until you become transparent or until you fall asleep." Throughout this book, you'll find references to artists from the past who have done something similar in nature to the activities at hand. Think of them as friends or spirit guides from different generations and moments in history. These artists were, like you, individuals who looked at the world they faced, used the materials and tools they had, and tried to make something that reflects their experiences.

Today, Lonnie Holley is widely recognized not only for his visual art but also for his innovative work in experimental music, which he travels around the world to perform. He has also given me another assignment, one that I'm sharing with you, which you'll find at the end of this book. What Holley gave me as a kid, and what he's giving us now, is the permission to make. He's giving us a slight prod to look around, realize the resources we already have, and make something from them, for our own sake and for others'.

My hope is that you'll come to see art as something made by human beings and that you, being human, can make, too. Thankfully, art isn't like the other disciplines. There is no set of knowledge or list of techniques that one can master to become an artist. It's a state of mind, and it's a decision.

Say it with me: *I am an artist.*

I don't need art supplies, lots of cash, a mind other than the one I currently have, skills other than those I already possess, or a network of influential contacts. I can experience the world thoughtfully and make things to put into it. *I am an artist.*

You don't need anything other than a will to make, and—perhaps—a prompt. Here are a few to get you going.

SURFACE TEST

Kim Beck (b. 1970)

When Kim Beck doesn't know what to do, she tends to either look up or look down. Looking up has led to projects investigating and involving power lines, street signs, billboards, and skywriting. Looking down has resulted in works about grass, potholes, and invasive weeds, those oft-maligned plants that grow where they're not wanted and that Beck has urged us to reconsider through drawings, installations, murals, and a book.

Looking down has also prompted Beck to scrutinize the ground itself, a practice that first began in her studio building in Pittsburgh. She noticed how the concrete floors in her studio bear traces of the building's former life as a factory for mining-safety equipment. Divots, cracks, and stains record that history and set the stage for the new kind of "work" that happens there. Beck began making rubbings of the floor, spreading out newsprint paper and dragging a crayon or colored pencil over it to record the different textures she found. From there, she wandered farther afield, making rubbings of fragments of asphalt, roadways, and dirt around Pittsburgh, and then in West Virginia. Beck paid attention to the way different pieces of ground touch each other and the way the sidewalk meets the grass. Anything that disrupts the order, like bumps, cracks, scrapes, or irregularities of any kind, she is attracted to and records.

Beck started to think of these rubbings as "surface tests," which she would bring back to her studio to pin up on the wall and think about. Some of these she translated into a series of Risograph prints, layering various textures and arranging them into groupings. As with her past work, they can be thought of as meditations on the surfaces and structures that make up our world, be it asphalt and concrete or dirt and grass. Beck considers a rubbing to be a kind of alternative snapshot. Rather than capturing a place the way a photograph does—through light and time—a rubbing creates a record of a place through texture and touch. For Beck, a rubbing is the most realistic depiction of space you can create, much more so than a photograph. While it might

look like an abstract field of static when it is done, a "surface test" is a direct textural mapping of a site. It is a representation of the ground beneath your feet, the spot of earth that fixes you in space and time.

Where are you? What piece of ground is beneath your feet? How might you make a recording of it in a way that surpasses the visual?

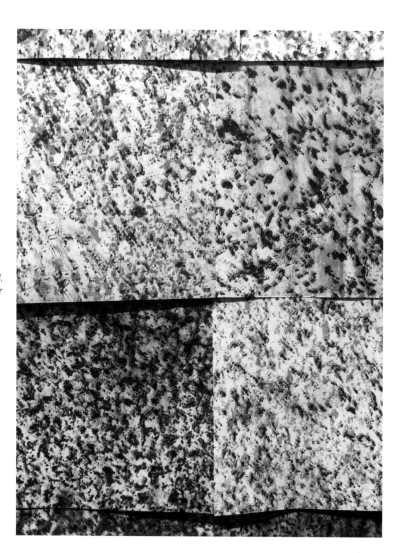

Kim Beck, Surface Tests, *2018,*
Risograph on paper

YOUR TURN

The ground is so much more than that place we direct our attention when we are trying to avoid eye contact or not trip. It is full of information, visual and textural, and carries traces of what has happened there. It's time to channel Kim Beck, go on a walk with your eyes cast downward, and pay close attention to the overlooked and banal surfaces and structures of your life. Whether you are in a place you know very well or are just visiting, you'll make a real and lasting record of a spot of ground and your time there.

1 Get a large piece of paper and a crayon.

2 Find a piece of ground that you respond to in some way, because of how it looks, the texture, or the significance of the locale.

3 Make a rubbing by placing the paper on the ground and dragging the crayon slowly, repeatedly over it.

4 Take a picture of the rubbing in the place where it was made.

TIPS/CHEATS/VARIATIONS

▶ Inexpensive paper like newsprint works well for this. Anything that is thin enough to record all the bumps and scratches beneath it while still being strong enough to stay intact. Larger sheets will give you room to work, but smaller can be okay, too.

▶ Standard kids' crayons will work if you peel off the paper and hold them horizontally to the ground. Fancier artist crayons, pastels, or sticks of graphite can be effective, too. If you use a smudgy tool, apply a spray fixative when you're done. It's a clear spray that will keep your marks where you intended them.

▶ Text on manhole covers, plaques, and headstones can make for an interesting rubbing, but don't overlook less exciting surfaces. You don't know what kinds of effects you're going to get until you actually make the rubbing. So, do a lot of tests! Try this in many places and see what you like best.

▶ When you've made a rubbing you really like, remember to leave it where it is and take a photo of it in place. Use rocks or whatever you have on hand to hold your paper to the ground as you take the photo. Take your time and photograph it from different angles until you have a picture of it that you really like. This image is part of the piece, not just documentation, and will communicate something about the site and give clues to the viewer (a table leg, your keys, or a dog's paws).

▶ Try layering rubbings from different sites onto the same paper. Vary the color of your crayon for each site. Take a photo at each site and document the developing image.

▶ Do this as an exchange with someone you know who lives far away. You make a Surface Test where you are and send them the rubbing along with the photo, and they do the same.

RESPONSE

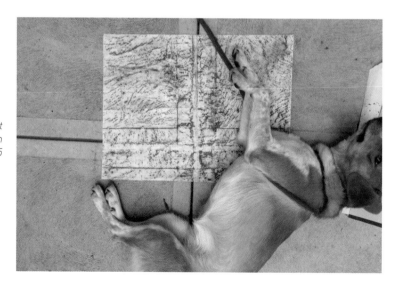

Kim Beck's Surface Test made near her home in Pittsburgh with her dog, Addie, 2015

BECOME SOMEONE ELSE

T. J. Dedeaux-Norris (b. 1979)

In 2010, T. J. Dedeaux-Norris was hanging out with some friends when they came up with the idea of transforming her into a male persona. They fashioned a mustache using a few snips of Dedeaux-Norris's hair, bound her chest, and then all went out to get groceries. As they walked down the street together, Dedeaux-Norris felt relatively comfortable and was surprised when no one seemed to notice her. But as soon as she turned down a grocery aisle and found herself alone, she suddenly became self-conscious, asking herself: "Do I walk differently? Do I talk differently? Do I use my own voice? What do I do?"

While Dedeaux-Norris didn't even go so far as to change her clothes for this experiment, these small adjustments to her appearance nevertheless caused an internal shift. It felt less like a radical change and more like she had tapped into an aspect of her persona that already existed. Instead of feeling "pretty," she felt "handsome." The experience also deepened her understanding of the friends she was with, who are transgender and were each at different stages of transition.

Dedeaux-Norris posted pictures of her new look to her Facebook page, without caption, inviting a range of responses from family and friends ("aaaHAA! You look like a nerdy dude!" and "LOL, Cuz you are making my day!," among others). Those who knew her well couldn't have been surprised. While Dedeaux-Norris had begun her career as a musician and rapper, her focus had shifted to art after posing for a photography project for a friend. She often puts her own body to use while making art, developing characters and personas that she brings to life through performance, photography, and video.

For her ongoing work *The Meka Jean Project*, Dedeaux-Norris takes on her childhood nickname and behaves in ways she normally would not: acting impulsively, putting on performances, and collaborating freely with others. In live performances, installations, and a film, you can follow Meka Jean as she visits new cities, has new experiences, and attempts to improve and empower herself. Dedeaux-Norris explains that taking on this alternate persona, set loose from societal

expectation, allows her to access a part of herself that is more open and not yet self-aware about gender, race, identity.

In her art and through this impromptu experiment with friends, Dedeaux-Norris has adopted personas based on facets of her life and identity, scrutinizing for herself and her audiences the history, labels, and stereotypes she has carried with her as a young woman of color. What are the histories and labels that follow you, and how might you adopt a new persona to explore them?

T. J. Dedeaux-Norris, still from Meka Jean—Too Good for You, *2014, digital print*

YOUR TURN

Taking selfies is easy. Becoming someone else is a little bit harder. Give some focused thought to the ways you already present your identity and the things you've worn or experiences you've had that have challenged the way you see yourself. This is an introspective exercise, but with potentially wide-ranging and outward effects, offering insight into your persona and how you present yourself to the world. You can try this among friends or make it a solo endeavor. Your transformation can be big and obvious or small and subtle. You are your own guide. But to which "you" are we referring?

1 Take a selfie.

2 Change one thing about yourself—your physical presence, your clothes, your tone of voice, the way you approach others, anything.

3 Go out into the world and interact with people.

4 Take another selfie documenting your transformed self.

TIPS/CHEATS/VARIATIONS

▶ Physical aspects can be the easiest to change (hair color, clothing, accessories, makeup), but consider how you might adjust your attitude, your tone of voice, the way you walk, or how you interact with others.

▶ What do you own that you never wear because in it you "don't feel like yourself"? Give it a try. What do you see in a thrift store that excites or repels you? Pick it up and put it on.

▶ Feeling uncertain? Try various adjustments alone and in the safety of your home, observing yourself in the mirror and imagining what it would be like to interact with others.

▶ Consider using a medium other than photo or video to capture your experience if you've changed something less physical/obvious. A journal entry, drawing, or sound recording might be a better outlet for your findings.

▶ Try changing the same thing and sharing it in different parts of your life or around different people you know. Does the experience vary at all? Are you more comfortable in one place or another? Is it easy to change something while you're alone but then hard to maintain it around your friends, your family, or strangers?

HOW DO YOU PERFORM YOUR NEW SELF THAT YOU ARE BECOMING?
—T. J. DEDEAUX-NORRIS

HISTORY AS YOUR GUIDE

Adrian Piper, The Mythic Being, *1973, video, 8:00. Excerpted segment from the film* Other Than Art's Sake *by the artist Peter Kennedy.*

In 1973, Adrian Piper began walking the streets of New York City wearing a wig, a fake mustache, and mirrored sunglasses. Calling this alter ego the Mythic Being, Piper enacted a series of performances to see, in her words at the time, "what would happen if there was a being who had exactly my history, only a completely different visual appearance to the rest of society." While performing, Piper recited mantras drawn from her teenage journal, or acted aggressively, cruising women and staging a mugging. The performances extended to the streets of Cambridge, Massachusetts, and the *Mythic Being* series (1973–75) grew to include photographs, drawings, and a series of advertisements printed in *The Village Voice.* Through this project, Piper explored her personal history and identity as a black, female artist (although she retired from being black in a public announcement in 2012), as well as her public's expectations concerning race and gender. With each deployment of the Mythic Being persona, she paid careful attention to both the external perceptions of the audience and her own internal experience, explaining: "I find that when I put on the garb, somehow it transforms the nature of the experiences that I'm thinking about."

IMPRINT

Sopheap Pich (b. 1971)

When Sopheap Pich was attending art school in Chicago and wanted to make art, he went to the art supply store and bought brushes, paints, stretcher bars, and canvas. But a few years later, when he returned to his birth country of Cambodia, there were no art supply stores. So he went to the hardware store instead and bought powdered pigment, house paint, and glue. Pich experimented mixing these materials together and making paintings with them, some successful and others less so.

It wasn't until he picked up some rattan and set about making a sculpture with it that Pich felt a real connection between a material and his hand. Rattan was widely available in the area for making wicker furniture and baskets, and Pich shaped the pliable material into organic forms, many informed by his traumatic childhood recollections of Cambodia's Khmer Rouge period, as well as the country's ancient traditions and contemporary struggles. Using rattan as well as bamboo, burlap, beeswax, resin, and metal wire, Pich shaped his sculptures into a seated Buddha and forms resembling internal organs and plant life. The grids that form the underlying structure for these works also led Pich to explore the abstract possibilities of the grid alone, through geometric sculptures and wall reliefs.

In all of his works, Pich explores the limits and possibilities of these locally available materials. While rattan is more malleable, bamboo is stronger and more rigid. When using bamboo strands for his sculptures, Pich became interested in the bamboo as an object in itself. And so he decided to cut a stick in half, dip it in a paint made by combining earth pigments with gum arabic (the sap of certain acacia trees), and press the mixture onto paper. It created a line, which Pich appreciated as having a quality not related to his hand but unique to the bamboo itself. He then made the mark repeatedly across the page, each line deviating from the first in fascinating ways, due to variations in paint density and pressure, and the irregularity of the bamboo surface. Pich liked that he was only able to control the process to some degree, let-

ting the material determine the overall feeling of the work. This material experimentation led Pich to create numerous drawings using the same technique, forming what has become a substantial body of work.

What are the materials that surround you? And how might you explore their limits and possibilities? As with Pich's bamboo drawings, this assignment asks you to focus less on your own gesture and more on allowing a material to speak for itself.

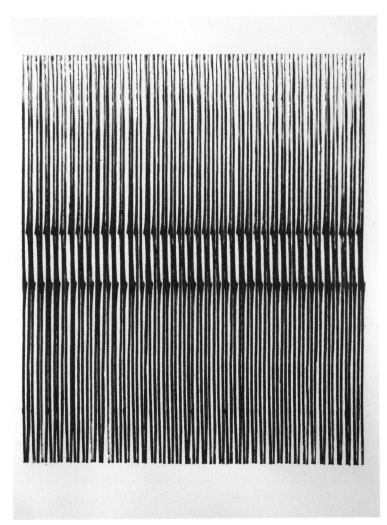

Sopheap Pich, Civitella Vertical Rays #16, *2013, natural pigment and gum arabic on Canson paper*

YOUR TURN

You don't need art supplies to make art. For this, you'll need to survey what's available around you and select objects and materials that you want to play with and know more about. Be resourceful and experiment broadly, trying this with a number of objects, until you hit upon a mark that you want to make again. And again, and again, and again.

1 Choose an object you find interesting that is able to be cut.

2 Cut it to make a flat surface.

3 Dip the cut surface in any kind of paint or pigment and press it to a piece of paper repeatedly to make an imprint.

TIPS/CHEATS/VARIATIONS

▶ When choosing an object, consider texture, shape, internal structure, and any attributes that might make for an interesting imprint. It can be natural or artificial, but be sure to pick something both intriguing and physically possible to cut in half.

▶ Use a saw, knife, blade, or scissors, and be sure you're creating a flat surface. You might need to shave or sand down the surface to even it out. Please be careful, and don't cut yourself.

▶ You probably have some paint around somewhere. Use leftover house paint, ink, or hair dye, or mix up a pigment using dirt, plants, or food. Using nice paper can elevate your finished product, but printer paper or something retrieved from the recycling bin can work just as well.

▶ Remember that a single imprint of an object might not be that interesting, but persevere to see what happens when you make the mark repeatedly. Use trial and error to test different orientations of the object, patterns, and concentrations of paint. If it's just not working, try another object.

▶ You might want to measure out even distances across your paper in pencil to use as a guide when printing your object.

▶ Accidents can be happy ones. If your hand slips, or the object drips paint where you don't want it to, just keep going and see how it looks when you fill the paper with marks.

▶ Make a bunch of these. You'll become more familiar with the materials and better able to achieve effects you like.

ART IS SOMETHING THAT I DON'T KNOW, BUT I'M NOT SCARED OF IT.
—SOPHEAP PICH

DRAWING WHAT YOU KNOW RATHER THAN WHAT YOU SEE

Kim Dingle (b. 1951)

In the early 1990s, Kim Dingle began making paintings of little girls in frilly white dresses, bobby socks, and black Mary Janes, who stomp, scowl, fight, climb fences, and drink wine at a wine bar. The children she depicted have attitude, grievances, and agency. Into the 2000s, Dingle's misbehaving young ones were painted perched atop school desks, vomiting, and pulling each other's hair. They showed up in an installation wearing hoodies and Converse All Stars, standing defiantly alongside a ripped painting and crumpled cans of Red Bull. By the 2010s, she felt she was done with the subject matter.

Dingle had made a wide variety of other work, too, using a range of materials and exploring numerous topics. For one series, she asked teenagers to draw the United States from memory and used their drawings as the basis for oil paintings on panel, foil, and standard-issue emergency blankets. In 2017, Dingle made a series titled *Home Depot Coloring Books*, for which she purchased sections of widely available oriented strand board and treated it like a paint-by-numbers canvas. She carefully applied colors to define all the wood strands that had been pressed together to form the board, yielding vibrant abstract compositions.

When her dealer proposed that she make yet another series involving the anarchic little girls, Dingle scoffed, saying, "I could paint them blindfolded!" And then it occurred to her that she could do just that. She turned on some music; set herself up with paper, paint, and a brush; tied a scarf over her eyes; and popped a knit hat over that. With a friend on hand recording video, Dingle set about making her painting. She worked from muscle memory, beginning with a girl's head, face, and hair. When the brush ran dry, she kept her hand where she had stopped while reloading the brush and started back in the same spot (or thereabouts) to describe the rest of the body. When she was

finished, Dingle stepped back, removed her blindfold, and exclaimed exuberantly: "It looks like me!"

She repeated the exercise several times, each attempt as scary and nerve-rattling as the last. Several of her figures were so hideous she could barely look at them. But for the most part, Dingle was surprised and delighted by what she'd made. It made her laugh, and her art dealer displayed the works in a solo exhibition in 2018.

What do you know so well—or think you know—that you could paint it blindfolded? What might happen if you tried?

Kim Dingle, Untitled (where did you get your shoes), *2017, oil on Plexiglas*

YOUR TURN

We're not going to force you to paint here. You can "draw" with whatever materials you have on hand, be they Magic Markers or a sablehair brush and fine oil pigments. The idea is to free yourself from the shackles of what you think something should look like and discover what you actually know about it. Leave your doubting, controlling, conscious mind behind, and let your unruly subconscious come out to play.

1 Find two pieces of paper, a drawing implement, and a blindfold.

2 Blindfold yourself and draw your home. Remember to draw what you know about something rather than just what you see.

3 Put the blindfolded drawing out of your line of sight before removing the blindfold.

4 Remove the blindfold and make a second drawing of the same subject.

5 When the second drawing is finished, compare the two. Which is more expressive?

TIPS/CHEATS/VARIATIONS

▶ Bigger paper might be better for this, as it will give you more room to operate. But small, standard-size paper can certainly work, too. Experiment with different drawing implements and see what works best for you. Don't have any art supplies? Try lipstick on a mirror, or house paint on an old piece of cardboard.

▶ Your "home" can be anything, be it a house, apartment, yurt, or tent. You can also interpret this more widely and can choose anything that you know well—your own face, a partner's, your cat, or your father.

▶ Try the assignment several times and see what happens. If you tried it sitting down at a table, tack your paper to the wall and try it standing up. Unhappy with what you've made? Keep at it until you've made something that interests or amuses you, or even disgusts you in the very best of ways.

▶ This is an excellent exercise to do with others. Try it with your family members or roommates and see how widely divergent your results are. Help each other secure the blindfolds and keep you from cheating. Compare your results and laugh at them together.

A BRIEF INTERVIEW WITH KIM DINGLE

WHAT'S THE RIGHT MIND-SET FOR TRYING THIS ASSIGNMENT?

THE MIND-SET ONE WOULD HAVE MOMENTS BEFORE YOUR FIRST SKYDIVE.

WHY SHOULD SOMEONE DO THIS? WHAT'S THE POINT?

WHAT'S THE POINT OF HAVING A NEW AWARENESS YOU DID NOT HAVE BEFORE?

NEVER SEEN, NEVER WILL

David Brooks (b. 1975)

Albrecht Dürer (1471–1528) had never seen a rhinoceros, but that didn't stop him from drawing one anyway. He based his image on an eyewitness account and a rough sketch from someone who had seen the exotic animal in person in 1515 in Lisbon, Portugal, during a stop on its journey from India to Italy. The ship sank before arriving in Rome, but the rhinoceros became famous regardless, the subject of a widely distributed woodcut by Dürer. His intricately detailed creature combined true-to-life elements with fantastical ones, including scaly legs, body plates like a suit of armor, and an extra horn.

David Brooks was thinking about Dürer's rhino in 2014 when creating a series of sculptures that give form to animals he has never seen. Brooks selected mammals off the list of the world's most critically endangered species, including pygmy hippos, hairy-nosed wombats, and Sumatran orangutans. But rather than make photographic likenesses of them, he explored how he might represent them more viscerally. Not as abstract ideas, but as actual beings with weight, that have a physical existence in the world. And so he began assembling blocks of solid aluminum and marble into stacked compositions, with forms determined by the amount of material needed to equal the average weight of a mature adult of each species. He made custom crates to hold each sculpture and to be displayed along with it, with the species name, average weight, and silhouette stamped on the exterior. Latching on to the verifiable fact of mass, Brooks created works that remind us of the physical reality of these animals and make tangible their impending disappearance.

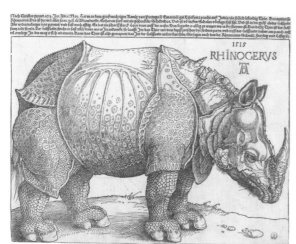

Albrecht Dürer (1471–1528), The Rhinoceros, *1515, woodcut*

The extinction of an entire species is something very difficult to grasp, like climate change, mass migration, and many of our world's most pressing issues. How do we represent issues that are too vast to

think about, much less comprehend? In a world where we often find ourselves swimming in articles and images describing important and pressing concerns, how can we internalize the things we cannot see firsthand?

Brooks asks you to apply this same way of thinking to something you've never seen and probably never will—be it as weighty as Ebola or as seemingly light as your mysterious upstairs neighbor. Here you're challenged to do important work: to contemplate your place in the world and in time, and imagine the expansive network of materials and beings of which you are a part.

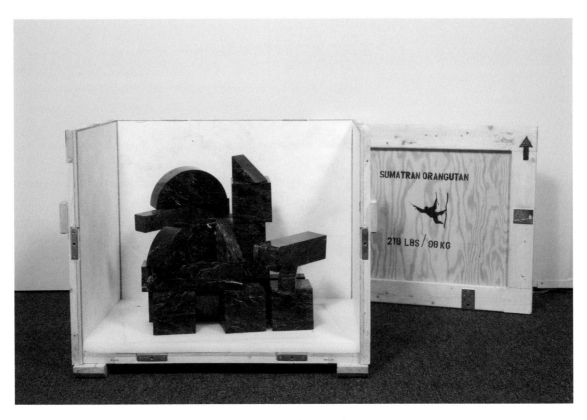

David Brooks, Marble Blocks—218 lbs.—or Sumatran Orangutan (Indonesia), *2014, 218 pounds of verde antique marble, stainless steel pins, wood crate, stencil paint, Tyvek, hardware, packing material*

YOUR TURN

There are just two steps for this assignment, and both will likely require your focused attention. Or at least some spread-out, but diligent, mulling. Do not rush through the mulling. This is a rare and important opportunity to consider what it is in life that you will see and not see, and consider how you might understand what you cannot visualize.

1 Think of something that you know exists but that you've never seen and probably won't see in your lifetime.

2 Articulate that something in any medium you like.

TIPS/CHEATS/VARIATIONS

▶ "Articulate" can mean anything, from making a sculpture or Claymation video to composing a written account. If your subject is immaterial, how has it been represented, or not represented, before? And if it's physical, what are the materials you do and do not associate with it?

▶ Your something doesn't have to be fantastical or far-reaching. It can be close to home but still inaccessible or invisible. Or it can indeed be distant, mythical, invisible, or otherworldly! Make a list of ideas and let it grow before you commit.

▶ What do you know about the something you've identified? Or what do you think you know? Do some research and consider what information is available about it, and what things we may never know.

▶ Try out a few different ways of representing your subject. One idea might sound great in your head, but then something might be lacking in the execution. Do the obvious thing, and then do something else.

...sponses:

...ting a Möbius strip out of typewriter ribbon to represent
 a black hole
- An abstract, mixed-media representation of the mental
 fireworks a good book can set off
- A musical composition that articulates seeing the back of
 one's own head
- A painting of a person you know exists but have never met
 and likely never will

RESPONSE

why-in-the-night-sky, April 5, 2014, 11:38 pm,
Tumblr post.

*It's a portrait of my father, who I have never met
or seen a picture of. All I know is that he is of
British descent with brown wavy hair.*

QUIETEST PLACE

Jace Clayton (b. 1975)

In Jace Clayton's first mixtape as DJ /rupture (*Gold Teeth Thief*, 2001), there's a section where the beat stops, the rapper says "stop," and Clayton holds the record for several seconds, allowing the pause to become uncomfortably long. It is a radical gesture in a club context, where the general rule is that the beat must always go on. The beat does return, but not before the audience is thrown off and stops dancing. It isn't the only moment when Clayton upends expectation and riffs off the name DJ /rupture in *Gold Teeth Thief*, a three-turntable mix that combines tracks by artists from around the world and from dissimilar disciplines, backgrounds, and styles.

When he DJs, Clayton draws from a collection of more than two thousand tracks on his computer, ranging from recordings of Egyptian *mahraganat* musicians and Auto-Tuned Moroccan wedding songs, to Dominican merengue, Whitney Houston, and the Wu-Tang Clan. By engaging an array of technologies and techniques, Clayton mixes recordings into multilayered compositions that weave together disparate global styles and create complex (and danceable) new narratives. Through music as well as his writing, Clayton explores the hugely varied landscape of musical culture today, defined by unprecedented access to tracks and mixing software, and yielding what he has described as "an insane abundance of sound."

It should come as no surprise that in Clayton's frequent travels and performances as a DJ, composer, and multidisciplinary collaborator, he has developed tinnitus. This perception of ringing in his ears, even when there is no other sound present, has made him more sensitive to noise than ever before. His interest in silence has become even stronger. When living in Barcelona, Clayton loved to walk everywhere, especially at night. He challenged himself to find the quietest routes he could, marveling at how much more he noticed around him the less noise he encountered.

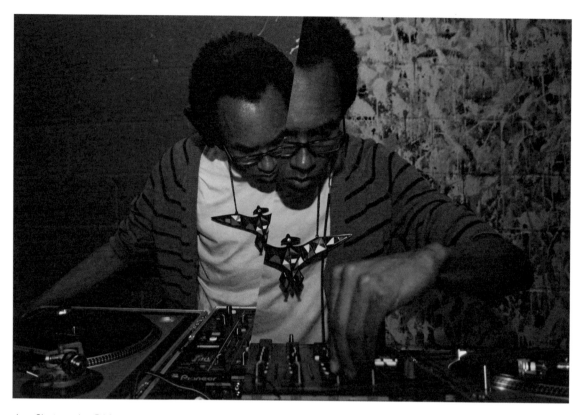

Jace Clayton, a.k.a. DJ /rupture, May 4, 2012. Photo by Erez Avissar.

Usually, when you're going for a walk, you're progressing toward something. You have a destination in mind, whether it's a beautiful vista or that gem of a record shop. But with this assignment, Clayton asks you to seek out what might be the most mundane and unspectacular of places, and take a walk guided by listening.

YOUR TURN

These steps will likely take you on a path you've never been on before, and expose parts of your town or city you don't normally see. While you may spend a lot of time being forward-looking and productive, this activity forces you to pay attention in the present, become aware of the soundscape around you, and appreciate the quiet that exists—if you can find it.

1 Go outside and walk in the direction that is the quietest.

2 Continue until you're in the quietest place possible.

3 Take a moment to absorb the silence.

4 Document your quietest place with a photo or short video, or write about it.

TIPS/CHEATS/VARIATIONS

▶ This was conceived as a solo enterprise, but you can bring a buddy. Just be silent together in your search and talk about it after.

▶ Nature is loud. You will likely need to discover this for yourself, but it is. Consider indoor as well as outdoor spaces.

▶ Keep in mind that many camera microphones are terrible at capturing sound. A light wind that you can barely hear in person sounds like a freight train when recorded by some devices.

▶ There are numerous ways you can document your quietest place.
A few:

 • Single photo of the place
 • Single photo of yourself at the place
 • Short video (stationary or panning, with or without you in it,
 or action camera strapped to your head)
 • Sound recording on-site
 • Sound recording of you talking about what you hear (and
 don't) on-site
 • Journal entry noting what you hear
 • Sketch or rendering of the place
 • Comic or animation

THERE IS NO SUCH THING AS AN EMPTY SPACE OR AN EMPTY TIME. THERE IS ALWAYS SOMETHING TO SEE, SOMETHING TO HEAR. IN FACT, TRY AS WE MAY TO MAKE A SILENCE, WE CANNOT.

—JOHN CAGE, "EXPERIMENTAL MUSIC," 1957

CAPTION CONTEST

David Rathman (b. 1958)

David Rathman's watercolor and ink paintings provide relatively minimal information but tell stories of remarkable depth. He depicts a wide range of subject matter—old cars, helicopters, basketball hoops, boxers, cowboys, guitars and amplifiers—all set in atmospheric landscapes. Over the top of many of the images, Rathman writes carefully selected bits of text and phrases. His writing is a bit shaky, idiosyncratic, and it meanders across the page. Sometimes the words are his own, and other times he inserts lines drawn from movies, books, or songs.

The lines of text interact with the images in curious and varying ways. "I'm holding on for that teenage feeling" floats in the ether above a beat-up 1960s-era Ford Mustang. Silhouettes of cowboys facing off in a desolate field are paired with the words "Back from luck to the same mistake." The characters in some of the scenes appear as if they are speaking; other times the narrator's voice feels detached and unseen, like they are commenting from afar. Some of Rathman's phrases are lighthearted and funny ("My vices were magnificent"), others forlorn and foreboding ("Burnsville girls don't tell"). These small bits of text completely transform the image, directing and redirecting your attention and interpretation of the scene.

In this digital world, it's rare that your handwriting is called into service. Like your voice, your handwriting style communicates information about you. And it's your distinctive mark that's being requested here, along with your singular perspective. How might your words enhance, amend, adapt, or subvert the meaning of an image?

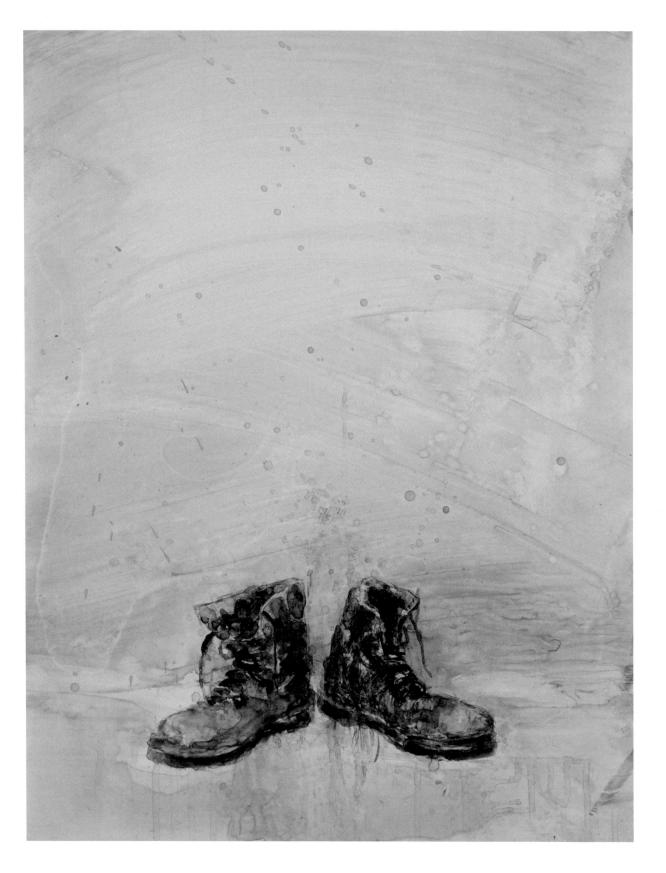

YOUR TURN

On page 27, you'll find a reproduction of a painting of a pair of old army boots. David Rathman would like for you to write something—anything—on top of it. You can approach this from the traditions of cartooning, internet meme culture, graphic design, hand-lettering, album art, or none of the above. This may be the most straightforward prompt in this book, but it allows ample room for interpretation.

1 Look at Rathman's painting.

2 Add text, preferably handwritten, on top of the image. Use your own words, or pull a quote from a book, movie, meme, song, or saying.

3 If you're so inclined, take a photo or scan what you've added and share it. You can also carefully cut out the previous page and present it in any way you like.

HISTORY AS YOUR GUIDE

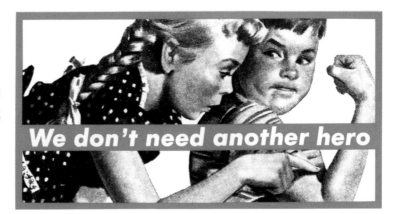

Barbara Kruger, Untitled
(We Don't Need Another Hero), *1987,*
photographic silk-screen/vinyl

Artists throughout history have mobilized the power of text to inform and direct the reading and interpretation of their art. In the late 1970s and early 1980s, a group of artists emerged who shared an interest in examining and questioning the soup of advertising imagery that Americans had been swimming in since the middle of the twentieth century. They came to be called the Pictures Generation, and from this group emerged Barbara Kruger (b. 1945), who has made a career out of incisive pairings of image and text. *Untitled (We Don't Need Another Hero)* is exemplary of Kruger's signature style, aphoristic statements typed in Futura Bold set atop found black and white imagery. For this work, Kruger joins in perfect dissonance an image of children's storybook characters Dick and Jane with the title of a Tina Turner song written for the 1985 film *Mad Max Beyond Thunderdome*.

MAKE A RUG

Fritz Haeg (b. 1969)

Before Fritz Haeg decamped to a revived commune in Northern California, he lived in a geodesic dome on the east side of Los Angeles. The dome was Haeg's home and also his place of work, where he welcomed artists and community members for workshops and events, involving collective movement exercises, book discussions, lessons in radical gardening, and much else. It was here that Haeg evolved his technique of hand-knotting strips of old T-shirts and bedsheets into giant, colorful rugs. On his own or with the help of many, rug making is just one aspect of Haeg's abiding interest in how we live and make a home, which he explores not only in his own domestic spaces, but also in the notoriously cold, formal spaces of art museums.

Haeg honed this method over time, scavenging old textiles and experimenting with crocheting, knitting, and making clothing. He put his hand-knotting technique to use for his series *Domestic Integrities*, which began with the creation of two rugs, spirally stitched by volunteers and collaborators who added local textiles to the rugs as they traveled from city to city. Inside museums, the rugs became what Haeg calls "Domestic Integrity Fields," or sites for the presentation of goods and materials gathered from nearby land and gardens. Local contributors brought bread, pickles, flowers, and homemade remedies to present atop the rug, and visitors were invited to take off their shoes and make themselves at home.

It is precisely this idea of making oneself at home that is at the core of this assignment. Making a rug can be either a communal activity, with materials and labor shared among a group, or a solo endeavor, added to as time allows and textiles accumulate. Your rug will be a field for activity, no matter how you put it to use. It will be not only a document of your past, made up of formerly loved T-shirts and fraying bedsheets, but also a site where new experiences unfold and new histories accumulate.

The rug that once graced Haeg's geodesic dome has followed him to his new home several hundred miles north, where it warms a cabin floor.

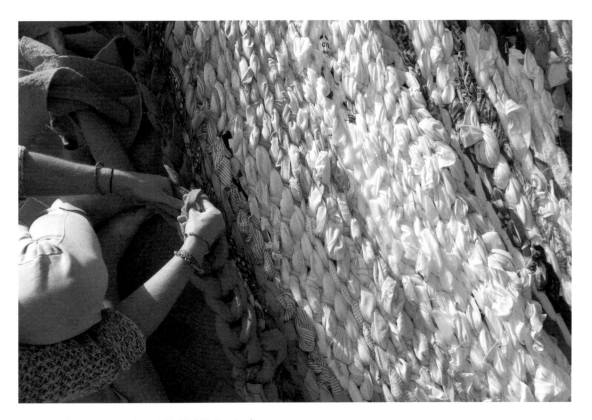

Fritz Haeg, Domestic Integrities A05, *2013, Walker Art Center*

YOUR TURN

Have a stack of old clothes too worn or too beloved to give away? Make them into a rug. And don't let a lack of crafting expertise stop you from giving this a try. It may seem awkward and lumpy at first, but as you add more stitches the rug relaxes and resolves into shape. You'll get a feel for it as you go.

1 Gather old textiles, such as T-shirts, sheets, towels, fabric scraps, anything.

2 Cut the textiles into strips of relatively uniform width or density, tying them together to make longer segments.

3 Using the technique illustrated opposite, make a rug.

4 When your rug is finished, live on it and make it part of your story.

MAKE A RUG TECHNIQUE

1. Cut your available fabric into strips of approximately the same width and join them to create one very large strip.

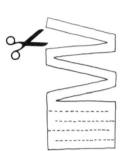

2. On one end, make a loop knot and pull it tight.

2A 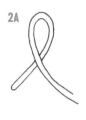 2B 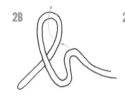 2C 2D

3. Place your fingers through the loop and pull the longer piece of hanging fabric through it, just enough to make a new loop of the same size.

4. Repeat this 4-5 times, casting on 4-5 stitches.

5. Take your last loop back to the first one, grab on to both loops, and bring the hanging fabric strip through both of them together, pulling it through to make another loop.

6. Cast on another stitch, as you did in step 3.

7. Take that loop and join it onto your slowly forming circle, grabbing onto a previously made stitch and pulling your hanging fabric strip through both loops to form a new loop.

8. Alternate casting on stitches separate from the rug with stitches joined to the closest loop on the outer edge of the circle.

9. When your rug gets large enough, you can stop casting on stitches and join every new stitch you make to the outermost edge of the circle.

10. Continue until you run out of fabric. Add on to it when you have more fabric.

TIPS/CHEATS/VARIATIONS

▶ Diversity of materials is to be embraced. Use a wide range of colors and textures, and trust that it will all come together into a work of great beauty.

▶ Enlist a friend, neighbor, parent, or grandparent who likes to work with their hands. Someone who knits, crochets, or crafts can be a great help in getting you going.

▶ Be sure you don't knot your rug too tightly, or you will end up with a giant bowl instead of a flat rug. You want it tight enough so that it holds together, but loose enough that you can add stitches to it easily. If you start too tight, just unravel and begin again.

▶ Your rug will be thick. Don't panic. This is as it should be. Once the rug reaches a few feet in diameter, you'll bask in its depth and coziness. You'll have to fight your dog for a spot on it, so really the larger the better.

▶ This is a superb communal activity, be it with family, roommates, a group of friends, or in a classroom or office setting. One person will need to get it started, but as it grows, more and more people can gather around its edges and work at the same time.

▶ This is an equally wonderful activity to do on your own. Get your rug started and then take your time adding to it as new material accumulates in your life. It may start as a small mat and expand over the years to fill a room.

▶ While it may look convoluted in a diagram, the technique is very easily learned with the material in front of you. If you're making it with a group, pass along the skill to someone new before you take a break (not that you'll want to).

HISTORY AS YOUR GUIDE

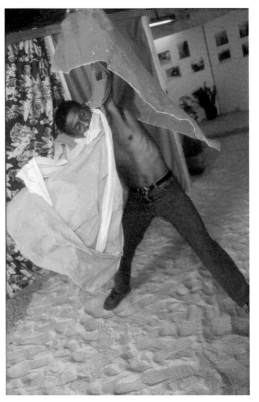

Nildo of Mangueira wearing Hélio Oiticica's P4 Parangolé Cape 1, *1964. Photo by Andreas Valentin.*

Although he started out making paintings in the 1950s, Hélio Oiticica largely abandoned the practice after becoming involved with the School of Samba in the Mangueira favela of Rio de Janeiro, Brazil. He began making capes, flags, banners, and tents from all sorts of painted textiles and materials, each meant to be worn or carried while dancing to samba music. For Oiticica, the garments were a way of releasing color from the flat plane of the wall and unleashing it out into the world. He called the series *Parangolés* (1964–79) after the Portuguese word for sudden states of agitation, confusion, or celebration—precisely what they were intended to instigate. Like Haeg's *Domestic Integrities* rugs, the garments of *Parangolés* are not meant to lie dormant in hushed galleries but must be activated by use. Both artists' works come to life with the participation of others, experiences as dynamic and multisensory for those performing them as those enjoying the spectacle.

CUSTOMIZE IT

Brian McCutcheon (b. 1965)

Brian McCutcheon grew up spending a lot of time in his uncle's garage, watching him build and repair cars. When McCutcheon turned sixteen, he bought and fixed up a "$400 beater" of his own, which he credits as his first true experience in sculptural making. Through the process, McCutcheon discovered he liked to fabricate things, an impulse he would put to use in his study of pottery and eventually his art practice.

McCutcheon's interest in the auto industry carried through when he began to make sculpture, reading *Hot Rod* magazine on the side and applying industrial resins and auto paints to abstract forms. However, he soon discovered his attraction to objects that he recognizes and that have a built-in identity that others recognize, too. During a residency in Omaha, Nebraska, McCutcheon explored the sculptural potential of a Weber grill. After being asked to numerous cookouts where men proudly tended their grills, he began thinking about the identity of this object, a cooking implement that—in his view—had been coded as masculine. He considered how men in the Baroque period expressed themselves through extravagant dress, and assessed the ways men ornament themselves today, sometimes through the decoration of their cars.

So he bought the recognizable kettle model of the Weber charcoal grill and set about altering it, affixing side pipes and carburetor filters and giving the grill a customized muscle-car paint job. During the process, he considered the historical role of decoration in traditional craft objects like pottery, which often served to convey stories and identify the culture from which the object came. Probing the grill's function and role in contemporary culture, McCutcheon transformed this most everyday of objects into something spectacular, while also questioning outmoded gender roles concerning who cooks where and with what.

McCutcheon's altered grill challenges us to consider the true use and value of an object, beyond its function. While he has gone on to

explore a wide range of objects in his work, from lawn chairs to space probes, McCutcheon consistently locates the resonance in manufactured materials and uses it as a jumping-off point for his work. How might you interrogate the objects that surround you and remake them into something extraordinary?

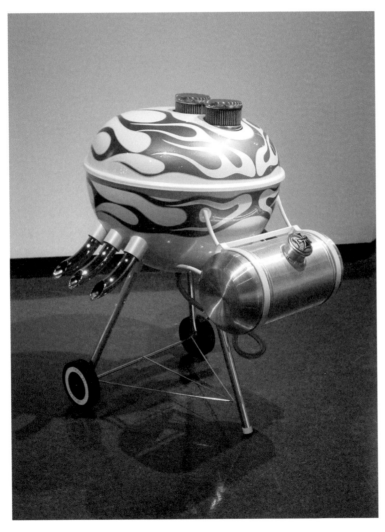

Brian McCutcheon, Trailer Queen II, *2003, Weber grill, speed parts, steel, automotive paint*

TIPS/CHEATS/VARIATIONS

▶ Use a chair, toaster, box of tissue, houseplant, or any object that speaks to you. McCutcheon once customized his shop's forklift, after identifying it as a thing that gets thoroughly abused and overlooked. He disassembled it, stripped and reworked the body, primed it, and gave it a custom paint job. Suddenly, it was a star, admired and appreciated by all.

▶ Interrogate your object. Conduct a mock interview, asking it questions like: What is your job? Are you good at it? Who uses you? What do people think of you? What are the stereotypes that follow you? Then think about how you might highlight or subvert one of those characteristics. Perhaps your toaster could be refabricated to make ice?

▶ Use more than one object if you like. Disassemble two or three things and refabricate them together.

▶ Are you willing to render your object nonfunctional? Consider this. McCutcheon's grill can't be used because it would blister the paint. If

you're okay with not being able to use your object anymore, go for it! Cut the legs off your chair. If it's something you need or share with others, customize it in a way that retains its use.

▶ Past responses to this assignment have involved:
 - Replacing the bristles of toothbrushes with steel wires and tiny pearls
 - Giving a calculator glasses, a mustache, and a bow tie
 - Painting over a bathroom scale's indicator wheel with a rainbow pattern
 - Adding tassels, feather trim, and lace to a breast pump

▶ Ask yourself: How can I enrich the environment I live or work in, or enrich the life of someone who sees it?

HISTORY AS YOUR GUIDE

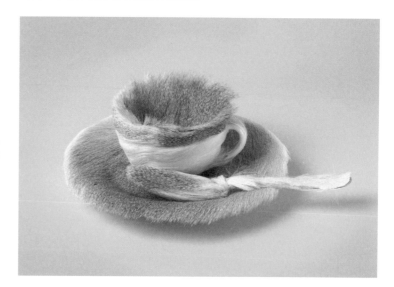

Meret Oppenheim, Object, Paris, 1936, fur-covered cup, saucer, and spoon

As the story goes, Meret Oppenheim (1913–85) was having lunch with Pablo Picasso and Dora Maar at the Café de Flore in Paris when Picasso admired the fur-covered bracelet Oppenheim was wearing. "You could cover anything with fur," Picasso remarked, and Oppenheim shot back, "Even this cup and saucer." The exchange remained at the back of Oppenheim's mind, and when asked by André Breton to participate in the first Surrealist exhibition of objects in 1936, she set about making the absurd proposition a reality. From a department store, she purchased a teacup, saucer, and spoon, and proceeded to take them home and cover them in fur. She was among a number of artists at the time, including Salvador Dalí and Marcel Duchamp, who arranged found objects in unexpected, irrational combinations. Under the banner of Surrealism, the objects were intended to summon unconscious thoughts and desires. Oppenheim's creation took a common, inanimate object, washable and appropriate to drink tea from, and transformed it into a bizarre, animal-like thing. That which was proper, ladylike, and serviceable became wild, sensuous, and completely inappropriate for drinking. Anyone for tea?

EXQUISITE CORPSE

Hugo Crosthwaite (b. 1971)

When you are a muralist from Mexico, a heavy tradition precedes you. Hugo Crosthwaite's large-scale wall drawings speak to his experience growing up and living in the border city of Tijuana, combining imagery drawn from observation and his imagination, as well as mythology and history. The greats of Mexican Muralism (Diego Rivera, David Alfaro Siqueiros, and José Clemente Orozco) also addressed history, but in a much more targeted way, commissioned directly by the government to tell the stories of Mexico's revolution and past. Crosthwaite's works include a blend of figures from the past and present but leave ample room for invention as well as abstraction. Also, unlike his Muralist predecessors, his approach is largely spontaneous and intuitive, not carefully plotted out and planned.

Crosthwaite identifies less with painters and more with poets, whose process seems more in line with his own, stringing words along until a narrative begins to unfold. He builds his drawings and paintings detail by detail, a kind of improvised storytelling. What results is a collision of beauty and darkness, realism and abstraction, which Crosthwaite feels is reflective of the chaos and mixture of cultures in Tijuana.

While his home base is in Mexico, Crosthwaite travels often and spends parts of the year in Los Angeles and in Brooklyn. In 2016, when he was in Chicago for a residency, Crosthwaite found himself surrounded by a community of artists who came from many different places. He wanted to figure out a way to make something with them and remembered the game the Surrealists played called Exquisite Corpse (see "History as Your Guide" on p. 45). After locating an available blank wall, Crosthwaite climbed a ladder and began by drawing a face, and then covered up all but an edge of it before inviting another artist to add to it. That artist added their own contribution and covered all but a sliver, and another artist was invited to do the same. The process repeated until nine artists had added to the wall, and the

final work was revealed, a single surface that brought together diverse stories, materials, expertise, and experiences.

For Crosthwaite, this exercise embodies community. You are able to see only a fraction of what is happening around you, but you are invited to contribute to the endeavor nonetheless. You bring your stories, others bring theirs, and you find a way to knit them all together. What emerges is inevitably strange, surprising, and revelatory.

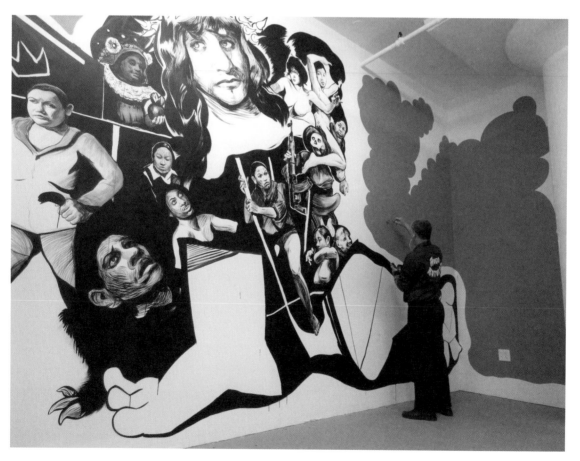

Hugo Crosthwaite, Heroic Procession, *2016, at Mana Contemporary Chicago*

YOUR TURN

The pressure is off for this one. You and your collaborators are equally responsible for the results and equally powerless to control them. There's no need for any consistency between artists and styles; in fact, the results improve the more wildly divergent the contributions. Let yourself experiment here and try a different style or material. Enjoy this opportunity to play, work intuitively, and marvel together (or laugh) over this thing that you never could have created alone.

1 Find a drawing surface and gather a group of friends.

2 Start a drawing and when finished, cover up or fold the drawing so that all but a sliver of it is hidden from the next artist.

3 The next artist works off of the clue left by the previous artist, and the process repeats until everyone has drawn.

4 Reveal the collaborative drawing.

TIPS/CHEATS/VARIATIONS

▶ Adapt the game any way you like, based on how many people you have and what tools are at your disposal. Try this with a cocktail napkin, a pen, and a friend or two, or a giant roll of paper, paints, and an entire class of first graders. Or take a cue from Hugo: take over a wall in your home and make it a collaborative mural.

▶ It doesn't have to be a body. That's one way to approach it, but subject matter of any sort will work, even abstract designs, words, or numbers.

▶ When it's your turn, really do work off of what you can see of the previous drawing. Use that as a starting point, and go in any direction you like.

▶ Be careful to leave just the right amount of your drawing visible to the next artist. Too much will spoil the surprise, and too little won't give them enough to work from. And make it hard for the next artist to cheat and look at what you've done!

▶ If your friends are far away, do this by mail, or even digitally. For the latter, create an image file, and carve off a sliver of it to send to the next artist. You determine the rules, sizes, and formats.

▶ Figure out a way to share the finished work with all participants. Frame it and let each player keep it for a year at a time, or scan the final product and distribute the image.

RESPONSE

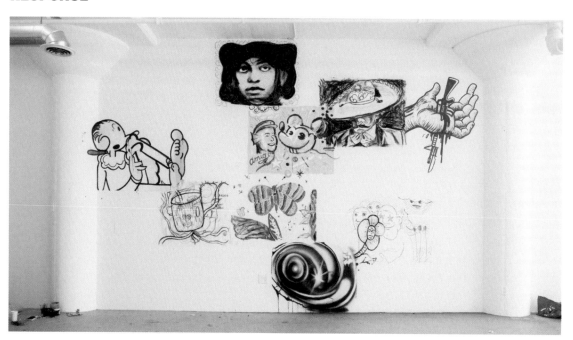

Hugo Crosthwaite, Exquisite Corpse, *2016, at Mana Contemporary, made with Chema Skandal, Candida Alvarez, Miguel Aguilar, Rodrigo Lara, David Leggett, Eric J. Garcia, Diana Solis, and Katherine Desjardins*

HISTORY AS YOUR GUIDE

Joan Miró, Man Ray, Yves Tanguy, and Max Morise (from bottom to top), Exquisite Cadaver, 1927, game of paper folded in four, each artist working on their section without seeing the other sections and knowing only the title

In 1925, French poet André Breton was hanging out in Paris with some of his Surrealist artist friends when they decided to play the game Consequences, wherein players write a phrase onto a piece of paper, fold it to hide what they've written, and pass it along to the next player to add their own phrase. It was among several spontaneous writing techniques the Surrealists adopted to tap the unconscious and break free from rational thought. One of their first games resulted in the phrase *"le cadavre exquis boira le vin nouveau"* ("The exquisite corpse will drink the young wine"), and the name stuck. When they adapted it into a drawing game, they called it Cadavre Exquis (Exquisite Corpse). The Surrealists loved the fantastical, distorted, and absurd figures that resulted, played the game regularly, and established a tradition that continues to this day.

SYMPATHETIC OBJECT IN CONTEXT

Genesis Belanger (b. 1978)

On a table, a hot dog peeks hesitantly out of a zippered pouch. Next to it, an oversize ashtray holds an equally oversize and droopy cigarette. A stately vase anchors the center of the table, holding a bouquet of flowers with a mouth, a finger, and two noses mixed in. Something has happened here, but we can't be quite sure what. An upturned fedora offers more clues: plump fruits, a shapely carrot, a single breast, and an iced doughnut with sprinkles and a bite missing.

None of these objects can be consumed, however. They are clearly and resolutely ceramic, rendered in pigmented porcelain and stoneware by Genesis Belanger, who crafts and fires each item before arranging them into compositions and presenting them on minimal furniture. They are lifelike but simplified. The scale is off, and the colors are desaturated, predominantly pastels and neutrals. Belanger draws on her experience as a prop maker for advertising campaigns to build worlds around the objects, carefully crafting intriguing and enigmatic stories. Before finding the curious spread of objects described above, visitors to an art fair first passed through a set of tall drapes, one held open invitingly with a tieback shaped like an ear. The room was softly lit by lamps in the form of a woman's torso with pink lampshades substituting for heads, also sculptures by Belanger. This particular installation was inspired by spaces of exclusivity, like the gentlemen's clubs of old, where politicians and barons of industry would mix, mingle, and determine the fates of many, while also indulging in food, drink, and women. In this uncanny world, people are objects and objects are people.

Belanger's work is as influenced by *The Simpsons* as it is by Surrealism. Her process begins with an idea and is followed by an intense period of looking, often at the incredible volume of imagery that the internet provides. Borrowing details from numerous images, from

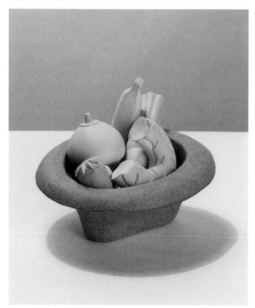

Genesis Belanger, Motivated and Dapper, *2017, stoneware and porcelain*

artworks to pop-up ads and old TV shows on YouTube, Belanger makes a loose sketch that serves as shorthand as she renders the objects in clay. Once formed and fired, she sets the objects into thoughtful juxtaposition, the story shifting with each adjustment, addition, or subtraction. In Belanger's words, "The objects become single words that can be structured into a sentence any way you choose."

The psychological effect of her work is complex and not quite nameable. These objects are familiar but strange, recognizable but unsettling. Using the language of everyday forms and the tactics of advertising, Belanger builds new worlds to show us the peculiarity of our own. What kind of story could you tell by pulling from the already strange and remarkable world around you?

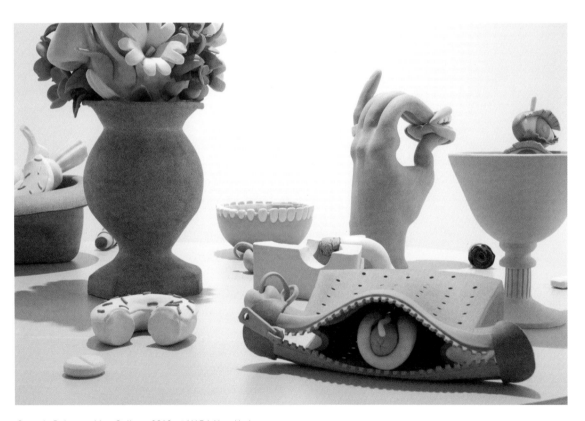

Genesis Belanger, Mrs. Gallery, *2018, at NADA New York*

YOUR TURN

Raid the fridge. Rifle through drawers. Unearth the objects that speak to you. When you start to think like Belanger, you begin to see the dramatic potential in the everyday items around you. You've had a lifetime of education from looking at advertising, and it is time to use those tactics to tell whatever tales you like and represent whatever feelings and desires call to you.

1 Choose an object or a small group of objects that embody a human quality. For example, a sneaker with attitude, a happy banana, or something less definable.

2 Construct a context for your object. Consider lighting, props, and anything else that will magnify that human quality.

3 Photograph your object in this context.

TIPS/CHEATS/VARIATIONS

▶ Details are important. If your story stars a banana, should it be green, yellow and unblemished, or bruised? Not just any banana will do.

▶ Select a surface and a background for your object. It could be a tile surface and a marble background, or a wooden surface and a wallpaper background. What do you want these key elements to reference? If you'd like the space to look inviting, perhaps your surface/background is the seat of a car or a clean, fluffy bed.

▶ Bring in supporting items to create context and fill out your story. If you want the atmosphere to feel safe and warm, put your favorite things near it, or what you imagine your object's favorite items to be. Is it a cup of coffee and a cigarette? Headphones and a guitar pick? Remember that each item changes the story. A toothbrush and toothpaste might communicate daily ritual or good hygiene, but put a bottle of booze next to them and the story quickly morphs.

▶ Use your own body or a friend's as a prop if you like. Perhaps a hand cradles your object and acts as a pedestal.

▶ Lighting is critical when photographing. Belanger often likes her objects to look as if they're lit by a bright window, so she uses directional light to create harsh contrast. Think about the size of the shadow and where it falls. Perhaps you'd like to give your object a candlelit glow. How can lighting help underline the quality you're after?

▶ Obvious but worth noting: things closer to the camera are going to appear dramatically larger than things farther away. Even in a shallow space you can create an exaggerated sense of scale. Put your hero object closer to the camera and the supporting objects farther away.

▶ Let the human quality shift as you work. Don't force an eggplant to be happy if it looks jaded instead. Allow the quality to reveal itself as you arrange, set the stage, and photograph your objects.

▶ Look at advertising for inspiration, whether online, in magazines, or on the train. Observe how certain objects are accentuated through placement, context, and lighting.

SELF SHAPE

Tschabalala Self (b. 1990)

When Tschabalala Self starts a painting, she first makes a line drawing. From there, she builds up the surface of the canvas by sewing on pieces of fabric, paper, debris, and deconstructed parts of old paintings that she collects in her studio. Her subjects are often figures, but they are not portraits of people she knows. They are generally characters Self imagines, developed through the accumulation of shapes. She considers the scale of various features, exaggerating characteristics that can carry psychological weight—hands, feet, lips, and buttocks. Piece by piece, the shapes come together to make a whole.

Her characters are active and self-possessed. They walk, they pose, they stop at the bodega to get a soda. They're aware of being looked at, and they gaze right back at you. Self's stated concern is with the iconographic significance of the black body in contemporary culture, and her figures—with skin represented by numerous colors and textures— seem to care not at all about that. In Self's words: "Their role is not to show, explain, or perform but rather 'to be.'"

Self became increasingly aware of the representation of women of color when she was in middle school in New York City, taking the train to school. She noticed that the newsstands, plastered with magazines, tended to have covers featuring hypersexualized women of color on the outside of the stand. But the equivalent images of white women were less accessible, kept inside the stand. Self saw a similar dynamic play out in everyday life. When it came time for her to make her own images of people of color, she sought to hold a mirror to the images pop culture was circulating, and also present alternatives.

While her figures are not self-portraits, Self does see the sum of her entire body of work as a reflection of her own multidimensional personhood. With this assignment, we are asked to consider the significance of our own bodies as symbols and icons. What are the ways that your body is politicized, and what would you do if given the power to represent yourself? If you were a shape, what shape would you be?

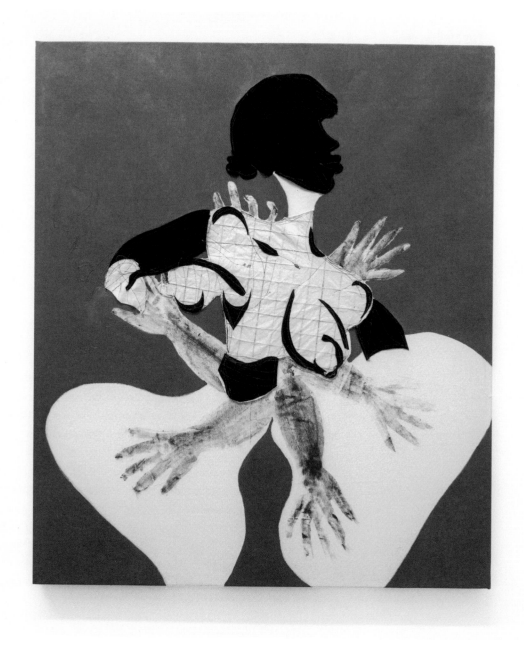

Tschabalala Self, Get'it, *2016, acrylic, Flashe, handmade paper, and fabric on canvas. Photo by Maurizio Esposito.*

YOUR TURN

We're used to creating avatars for social media, presenting curated versions of ourselves for public review and aligning with existing movements. But this time you're asked to represent yourself beyond what you look like in a photo, and as more than the things you like, consume, or support. Consider this an opportunity to shrug off the symbols others might impose upon you and create a form that is entirely, uniquely your own. How do you see yourself? And how do you want others to see you?

1 Make a line drawing of a shape that represents you.

2 Fill in the object with color, pattern, or a combination thereof.

TIPS/CHEATS/VARIATIONS

▶ What do you associate most with yourself? Be it a part of your body or something outside of yourself, like an activity or passion. Lean away from existing cultural signs, but if you can't resist, try Prince's approach and combine existing symbols to make a new one of your own.

▶ Put pen or pencil to paper and see what happens. Feel free to make it as abstract as you like. If you don't want to draw, pick up some scissors and a newspaper, or start to play around in your favorite photo or graphics app and see where it takes you.

▶ Create more than one. Maybe your first few shapes don't look right, but your seventh is outstanding. Complete the assignment now, and then do it again in a year to see how it (or you) changes.

▶ Scour your desk or recycling bin for bits of material to fill your shape. Cut up an old T-shirt or riffle through your miscellaneous drawer. Take clippings from an old journal or sketchbook. Look for colors, patterns, and textures that appeal to you or that reflect a part of your history.

▶ Make er again wonder what image you will choose to represent you.. .ny forum, online or off. Print it on a T-shirt, make it a custom bookplate, hang it on your wall, or find other ways to incorporate it into your life.

RESPONSE

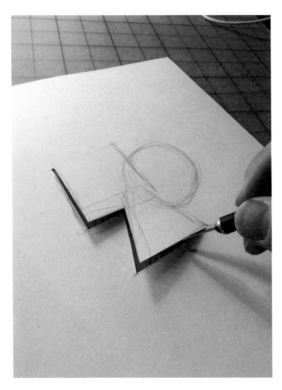

Nathaniel Calderone, Three simple shapes (I am my Perspective), *2016, cut paper and photographs*

THE MUSTER

Allison Smith (b. 1972)

In 2002, Allison Smith saw an exhibition of early American militia gear at Sotheby's auction house in New York. It contained not the plain uniforms you might envision, but flamboyant and brightly colored ensembles involving pink flamingo plumes, gold appliqués, beaver-skin hats, and cheetah-skin saddles. Beginning in the seventeenth century, wealthy members of volunteer militias in the American colonies often outfitted themselves in elaborate finery. Rather than solidifying the group around a single identity, these getups were an expression of each soldier's distinctive approach to patriotism and personal style. It was the opposite of camouflage.

Smith had these uniforms in mind when devising a series of events two years later. She had grown up in Northern Virginia, steeped in the history of the American Revolutionary and Civil Wars, and was often taken to living history museums, historic homes, country fairs, and re-enactments. After attending art school in New York City in the early 1990s, ensconced in discussions around identity politics, Smith began looking to the field of historic reenactment as a kind of intriguing parallel art world, in which identities are performed and hand-making is extremely important. Smith had an idea that would bring these worlds together and conceived her own version of a historical reenactment. Instead of re-creating a battle that pitted two sides against each other, she staged a muster, or a gathering of troops for the purposes of inspection, critique, exercise, and display.

Taking on the role of Mustering Officer, Smith organized the event around a question: What are you fighting for? She issued a "Call to Art!," inviting everyone she knew to fashion their own uniforms and build campsites that reflected each of their own causes. The first *Muster* was held among a smaller group at Mildred's Lane (see "Scramble Scrabble Dinner," p. 219), but the second and largest of the events involved 125 enlisted participants and thousands of spectators. A project of the Public Art Fund, the 2005 *Muster* unfolded at Fort Jay on Governors Island, the former national military post in New York Harbor. Amid

canvas tents, hay bales, and the sound of drumming, participants in the *Muster* declared their causes, fighting for forgiveness (Gayle Brown), hope and geometry (Sara Saltzman), the power of pink (William Bryan Purcell), and a huge range of other convictions. Enlistees fought for the rights to be scared (Gary Graham), to paint (Albert Pedulla), and to sing sentimental songs in full (Rachel Mason). They fashioned handmade uniforms, took up props, constructed tents, organized activities, and proudly displayed banners and flags.

Through the Muster, Smith marshaled the voices of many, who boldly and publicly declared their disparate causes. She provided an occasion and forum to proclaim rather than protest. The question is: What are you fighting for?

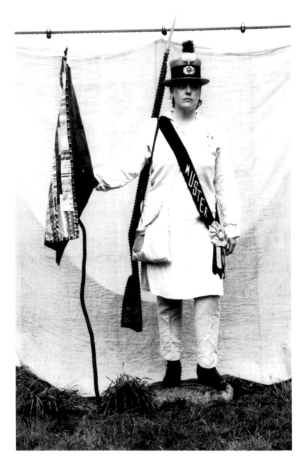

Allison Smith as Mustering Officer at the 2004 Muster in Pennsylvania.
Photo by Bob Braine.

YOUR TURN

We want you! This is a chance to think beyond what you're fighting against and assess what is actually worth fighting for. Smith gives us the opportunity not only to articulate a cause but also to consider the ways it might be performed and made visible to others. Summon your courage, marshal your convictions, and accept this invitation to muster!

1 Declare your cause, in a few words or a full-on manifesto.

2 Fashion a uniform out of materials you have at hand.

3 Take a picture of yourself in uniform in front of a neutral background.

TIPS/CHEATS/VARIATIONS

▶ Your cause can be sweeping or focused, serious or playful, universal or intimate. Devote time to devising a cause that you can really rally behind. Conduct research on military uniforms and historical figures, take notes, and sketch out possible directions.

▶ Like a personal mission statement, the declaration of your cause should be well considered. Even if it's only one sentence, make sure it's precisely the message you'd like to convey. Reread and edit it, and consider whether and how you'd like to give it form (printed on paper, in a flyer, posted to social media, etc.).

▶ Muster independently or with others. Assemble a volunteer militia by gathering friends or classmates and inviting them to muster with you. Organize workshops to share your ideas, pool resources, and craft uniforms. Decide on a date to muster together.

▶ Your uniform need not be formal or expensive, or involve a talented seamstress. Dig through your closet or visit a resale shop. Find

secondhand uniforms to adapt into your own. What props might help express the cause?

▶ Take advantage of online tutorials to learn basic sewing stitches or how to make a simple banner or flag. Ask your crafty aunt or uncle to help you carve or cobble together your props. Scour your mom's attic to find garments to modify.

▶ How you document your mustering is almost as important as the mustering itself. Use your best camera, and set up an area with good lighting and a considered backdrop. Stabilize your camera with a tripod, or ask a friend to be your photographer.

▶ What have others bravely fought for? To name a few: libraries, body hair, balance and joy, the right to party, intellectual freedom, sunshine and rainbows and equal rights, elves, destigmatization of nonbinary individuals, bringing an end to the infamous narrative of Islam vs. the West, being understood, and the future.

ARE YOU READY TO DEVOTE YOUR TIME, ENERGIES, BLOOD, AND TREASURE TO THE DECLARATION OF YOUR CAUSE? FOR THE OPPORTUNITY IS NOW AT HAND, NOT ONLY TO MAKE YOUR VOICE BE HEARD BUT TO RECEIVE AMPLE REWARD FROM YOUR COMRADES FOR THE SERVICES YOU RENDER IN THE FIELD. —ALLISON SMITH, "CALL TO ARMS," *THE MUSTER*, 2005

BLOW UP

Assaf Evron (b. 1977)

The act of looking, both with one's eyes and photographically, is at the core of Assaf Evron's work. Before he became an artist, Evron studied philosophy and was a photojournalist for an Israeli newspaper. Those experiences inform and inflect his art, which examines the way we see the world, and the distinction between the reality we observe with our eyes and the one we see through camera lenses and screens.

Evron employs photography in his work, along with a wide range of materials and media. For a series inspired by Renaissance thinker Leon Battista Alberti's theory of linear perspective, Evron put to use an XBox Kinect. This game console motion-sensing device projects infrared light into three dimensions, allowing it to map movement and the space around it. Rather than use the Kinect to play games, Evron directed it toward carefully composed still lifes made of everyday objects, and then used an infrared camera to capture how the device "saw" his arrangements. The photographs that resulted are brilliant purple expanses of color, with points of infrared light delineating the forms placed in the Kinect's field of vision. Through these images, we are able to see as the device sees.

The assignment Evron offers us is inspired by the 1966 movie *Blow-Up*, directed by Michelangelo Antonioni. The film follows a fashion photographer in London as he wanders into a park and surreptitiously takes photos of a man and woman he sees in the distance. Later, in the darkroom, when he inspects the photos, he realizes he may have also captured an image of a dead body. He blows up the image again and again, and then returns to the spot to see what he can find.

In photography—whether your lens is trained on a political protest or a family reunion—there is often a notion of urgency, or a need to capture the right moment or angle. But with this assignment, we are called to meditate on the everyday, the obvious, and the nonmoment. Evron asks us to take a closer look at the things we don't see because they are there all the time, and to register the ways our cameras and recording devices construct different ways of seeing.

Assaf Evron, Visual Pyramid After Alberti #102, *2014, archival pigment print*

YOUR TURN

Staring into a screen isn't a task we tend to take seriously. Let's assume for a moment that the images technology provides us are as worthy of time and attention as the night sky or a painting. The average amount of time a person spends looking at a single artwork in a museum is less than thirty seconds, and Evron prompts us to spend considerably more time on a photo we snap with very little deliberation. We begin to see how the act of looking is neither simple nor straightforward, and that much is revealed and also obscured by the lenses of a camera and of our own eyes.

1 Go to a public place you pass daily and take a photo that is almost random, not too close and not too far.

2 Go home, look at the photo on a screen for three minutes, and see what kinds of details reveal themselves.

3 Return to the original location and take photos of the details you noticed.

4 Compile your original photo, the detail photos, and a sentence about your findings or observations.

TIPS/CHEATS/VARIATIONS

▶ Don't overthink your first photo. Make sure it's a place you pass often but tend not to look at closely, and capture a wide enough shot to include some details to entertain you later.

▶ Ideally, you'll do your concentrated looking on a larger screen than your phone or camera. Set a timer for three minutes, and do not cheat. Use the zoom function if you like. And if time passes quickly, spend longer.

▶ Three minutes of looking can be very challenging. Think of it as a kind of meditation. Likewise, you will get better at looking the more often you do it with intention, and your looking endurance will build.

▶ Bored? Good! Boredom can be productive. You never know what kinds of thoughts or images might float up if you allow yourself this experience.

▶ Not able to focus? That's okay. Return to the image another day, or next week, and try the task again.

▶ Use your best camera for your second round of picture taking, and take care in selecting and composing your shots.

▶ When writing about your findings, consider what you thought about during your three minutes of looking, and what it felt like to experience the scene closer up in person, after looking at it for so long on a screen.

WHENEVER THE INTENSITY OF LOOKING REACHES A CERTAIN DEGREE, ONE BECOMES AWARE OF AN EQUALLY INTENSE ENERGY COMING TOWARDS ONE THROUGH THE APPEARANCE OF WHATEVER IT IS ONE IS SCRUTINIZING. —JOHN BERGER, *KEEPING A RENDEZVOUS*, 1991

RESPONSE

*View from Assaf Evron's studio
(his three-minute photo)*

Follow-up detail shots by Assaf Evron

WHITESCAPES

Odili Donald Odita (b. 1966)

When Odili Donald Odita was a kid, he would tag along with his mom to garage sales. He remembers looking at all the stuff and appreciating the spread of many colors. Over time, Odita started to associate colors with specific time periods. Sixties colors looked like this; seventies colors looked like that. When he began studying art, he noticed Cubist color looked one way (muted browns and grays), and Pop Art color looked another (flat, bright hues). He observed how approach to color differed between painters, or even within a single artist's body of work over the course of a career.

Color and the interaction between colors are now at the core of Odita's work—large-scale abstract paintings made with acrylic paint on canvas, on panel, or directly on the wall. He begins with a drawing and maps color onto it using his own system of codes. The colors are hand mixed and determined intuitively, reflecting Odita's breadth of experiences and travel around the world. When he lays down the colors, he's never sure exactly what it will look like. One color next to another creates a certain vibration, and if he changes either one, the composition gives off an entirely different feeling or mood. Although some of the colors he uses may appear to be the same, Odita never makes the same color twice.

The metaphorical resonance of this is not lost on him, nor is it coincidental. Odita sees color as a reflection of the complexity of differences that exist in the world between people and things. His vibrant compositions are about form and color and pattern, but only insomuch as they represent the human condition and the specificity of context, be it social, cultural, political, or geographic.

Amid all this talk of color, it may seem strange that we're now to focus on white. But Odita's exercise challenges each of us to reconsider what we think we know about color, and acknowledge the very personal nature of the thoughts colors provoke and the memories they trigger. We begin to see color not as fixed or absolute, but as an idea that is utterly relative, contingent, and changing.

Odili Donald Odita, The Conversion, *2016, acrylic on canvas. Photo by Karen Mauch*

YOUR TURN

This is not a test. Consider this an opportunity to cast aside the narrow range of color names you learned to identify as a child, and embrace a wider and more nuanced understanding of color. This one you can get up and do right now.

1 Find a white object and place it next to another white object.

2 Observe how the two colors change when viewed side by side.

3 Describe the difference you see through words, drawings, or photos.

4 Then change the lighting and take note of how the colors change.

5 Name the colors you observe in the new lighting.

TIPS/CHEATS/VARIATIONS

▶ No special supplies needed for this one. Stroll around your room or office. Sift through a closet, miscellaneous drawer, or attic. Use whatever you have at hand to assemble a variety of "white" items.

▶ Try not to get intimidated if you aren't an expert at describing colors. Look at your objects for a while and let your eyes adjust. What do you really see? Is one yellow-white or bluish, another slightly pink?

▶ Pay attention to how you document your observations. A camera will "read" your whites differently than your eyes will, and that is worth noting. If you're writing about your findings, what does the "white" of the paper look like, or of your screen?

▶ To change the lighting, you can obviously turn the lights on and off, but you can also bring in a new lamp, reposition it, or try a different lightbulb. You can also arrange your objects where there's plenty of natural light and see how it changes throughout the day.

▶ Have fun with your color naming. This is your opportunity to pretend you're a paint color namer, but with the option of making it entirely personal and possibly meaningful only to you.

HISTORY AS YOUR GUIDE

Josef Albers, Interaction of Color, *plate IV-4, 1963, Yale University Press*

Josef Albers's *Interaction of Color*, first published in 1963, remains an indispensable resource for artists. Albers trained at the Bauhaus school in Germany in the 1920s, taught at Black Mountain College in the 1930s and '40s, and landed at Yale University in 1950 as the chairman of the department of design. By the 1960s, Albers was ready to compile his extensive expertise into this manual, which clearly presents complex color theory. He explains in the book's second chapter: "Colors present themselves in continuous flux, constantly related to changing neighbors and changing conditions." The book is illustrated by color studies including the above, which demonstrates color relativity with the help of an explanatory (and also poetic) text:

> The inner smaller violets are
> Factually alike.
> But the upper one appears to refer to
> The outer lighter violet at the bottom.

PAPER WEAVING

Michelle Grabner (b. 1962)

Michelle Grabner's son came home from kindergarten one day and presented her with a blue and red paper weaving. The activity was meant to help him learn to operate scissors, manipulate paper, and build fine motor skills. His weaving was simple, but also a revelation. Grabner decided to make her own and then made many more.

For Grabner, weaving is a way of creating a pattern. And whether she's meticulously rendering paintings that reproduce the repeating designs of gingham fabric and paper towels, or making bronze casts of crocheted and knitted blankets, pattern and repetition are near constants in her work. Grabner identifies patterns in the materials that surround her in daily life, from kitchen textiles to garbage can lids, and transposes them into paintings, sculptures, and installations. Sometimes the information these materials provide is basic, such as a checked design, and sometimes it's more convoluted, like an elaborate wallpaper. What Grabner appreciates in patterns of all kinds is that they represent ordered information.

Lingering in these systems of order is a critical aspect of her work, and Grabner embraces the boredom that can be involved in her highly repetitive process. She listens to soap operas, baseball games, and serial television shows with recurring characters. When immersed in making, Grabner thinks about when the pattern pulls, resists, veers from course, or breaks. Her mind runs through the math at hand, and how slight variations in color and pattern can generate startlingly beautiful complexity.

More than twenty years after her son brought home his paper weaving, Grabner is still at it. While she creates a wide range of works, this activity remains both foundational and immensely productive. It allows her to find order in the vast ocean of information that moves through her life and to linger in that order for a while. She invites you to experience the same.

Installation view of Michelle Grabner, Weaving Life into Art, 2015, *at the Indianapolis Museum of Art at Newfields*

YOUR TURN

This exercise often appears in introductory art and design courses, as well as in kindergarten. But it's one that can be enlightening and productive regardless of your age or where you are in your art practice. It's deceptively simple, and you'll be surprised by how intricate and unexpected your pattern can get as soon as you veer even slightly from a basic over-under pattern.

1 Find one sheet of paper to use as your base. Make evenly spaced cuts into it, stopping before you reach the edges so the perimeter of the paper remains intact.

2 Find other sheets of paper to cut into strips.

3 Weave the strips into the base paper, making a pattern as you go.

TIPS/CHEATS/VARIATIONS

▶ Work with at least two colors, if not more. Make your base paper one color, and then pick one or more different colors for your strips.

▶ Precision counts. Measure out even slits on the base paper with a straight edge and make pencil marks before you cut, leaving a border of at least an inch around the edge of the paper. An X-acto knife is helpful here, but you can also work with a box cutter or scissors. Then make strips from another color (or two or three). These can vary in width but should be longer than the slits in your base paper.

▶ When your prepared base paper and strips are ready, work from the side of the paper with the pencil notations. Keep in mind that your pattern will be in negative when you flip it over.

▶ Take your first strip and weave it in, keeping the pattern consistent (e.g., under two, over one, under two, over one . . .), and pull it down

to the ends of the base paper slits, making sure it's flat and doesn't buckle. For your second strip, change the number pattern (under one, over three, under one, over three . . .) and then pull it to the bottom of the paper. For the third strip, either change the number pattern again, or return to the first strip pattern, pulling it down each time so that it sits tightly against the previous strip. Continue on, keeping the pattern consistent. You decide how simple or how complicated it gets.

▶ Check your emerging pattern on the reverse as you work. If you don't like it, pull the strips out and try another pattern. Or not! Be surprised when you do the final flip.

▶ When the base paper is filled with tightly packed strips that are still lying flat, trim the strips so that they don't extend farther than the edge of the base paper. Tack down each end with long pieces of tape. Flip it over, and appreciate the unexpected places a consistent pattern can take you.

▶ Rules were made to be broken. Use printed paper, photographs, or old artworks cut into strips. Insert your strips at a diagonal. Go nuts. This is your assignment.

Student Alice Hubbard's beauty form made with the fourteenth gift, Providence, United States, c. 1892

In 1837, Friedrich Fröbel (1782–1852) founded a school for young children in Germany, and he called it "kindergarten." He formulated his approach after working to organize and classify the collection of a mineralogical museum in Berlin. Fascinated by the shapes of crystals, Fröbel became convinced that investigating the natural laws that caused their growth would unlock the mysteries of a higher power. He concluded the same natural laws must govern the growth of humans. And so Fröbel designed a set of twenty tools that would teach children to recognize natural forms, which he referred to as "gifts," including building blocks, colored paper, mosaic tiles, and gridded tables. The fourteenth gift was paper weaving, allowing tiny hands to devise abstract patterns that point to countless processes and structures in the world around them.

VEHICULAR PALETTE

Jesse Sugarmann (b. 1974)

Jesse Sugarmann's first car was a 1981 Plymouth Horizon TC3. He has since owned close to two hundred vehicles, of numerous makes and models, supporting himself for many years by buying used cars and repairing them for resale. Sugarmann was in graduate school studying art when he realized he was spending more time scanning classifieds and online listings for cars than he was actually making new work. It became clear what he needed to do: make shopping for cars part of his art practice.

Post-realization, Sugarmann began creating works involving cars as both material and the subject of critical exploration. For his 2013 work *We Build Excitement*, he opened unsanctioned dealerships for Pontiac (the General Motors division that was shuttered in 2010) and outside them erected temporary monuments of Pontiac cars propped up on lengths of steel pipe. Photography and video document what Sugarmann calls "automotive performances," or what happens when these monuments are set into motion in a kind of choreographed car crash. The related video work also features laid-off assembly-line workers who re-create the movements of their former jobs, as well as car accident victims who pantomime their crashes. What results is emotionally complex, both honoring individuals and their fraught relationships to cars, and addressing the shifting, precarious nature of the American auto industry.

Sugarmann's artwork looks at the way the automotive industry has shaped his own identity as well as others'. In 2016, he set out to better understand how cars have played a role in his life and his family's by creating a vehicular genealogy. He began by calling family members and asking them to tell him about every car they've ever owned, in the order that they've owned them. The conversations naturally evolved into wider narratives, charting different periods of their lives, revealing self-images, aspirations, and changing tastes. He took detailed notes and decided to represent his family's vehicular history by making a tartan fabric pattern that charts the colors of each car owned. Every

stripe in the pattern is a car; its width corresponds to the length of time the car was owned. Sugarmann built the pattern in Photoshop (every four pixels equals a year), duplicating and rotating it to form a warp-and-weft pattern. He then had the image printed onto a woven blanket, visualizing his family's identity through the cars they've all owned.

What is your vehicular genealogy? What might you learn by delving into the past of your relatives? How do your aesthetic choices compare to those of your family members or diverge from prevailing styles and trends? What might you find when you take a closer look at this most mundane but often most prevalent aspect of your life?

Jesse Sugarmann, production still from We Build Excitement (Pontiac, MI), *2013, digital video, 35:00*

YOUR TURN

Many of us spend a considerable amount of time in cars. Why not use this reality to discover more about the people with whom we share DNA and/or life experiences? Consider this a relatively safe topic of discussion to explore with people whose values or political persuasions may not align perfectly with yours—and an ingenious way to create an unconventional family portrait.

1 Talk to family members and develop a list of all the cars they've owned or driven and when.

2 Select a time frame for your data, be it your lifespan, from when your grandmother got her first car to now, or any specific date range.

3 Choose an element or aspect of the car to focus on (color, door handle, engine, headlight shape, name, etc.).

4 Come up with a data visualization system that assembles these elements in a meaningful way.

TIPS/CHEATS/VARIATIONS

▶ What if you live in a big city, use public transportation, and have never owned a car? Same with your family members? Instead, consider primary modes of transportation or what car people wished they'd had. Or consider other items that might reflect your family's evolving style and aspirations. Addresses, homes, or more specifically, front doors. Occupations? Spectacles?

▶ Be prepared to take good notes or record your conversations with family. Probe. Ask follow-up questions. Request photos. Embrace your inner investigative journalist.

▶ Think through the many different aspects of a car that might be your focus. Beyond color, there's the shape of the car's body, headlights,

spoiler, or hood ornament. Did the cars have names? Mine your interview notes for unexpected details.

▶ Ideas for data visualization are everywhere. Look out for charts and graphs; analyze your own notes to see how you recorded the information. Make it low-tech if high-tech feels uncomfortable. Just use pen and paper. Or print out pictures of each car, have a pair of scissors handy, and see where that takes you.

▶ Think about an inventive way to share what you've done with your family. Make a commemorative print to share with them during the holidays, photo-printed mug, custom calendar, or PowerPoint presentation for sharing live and with commentary.

RESPONSE

A sample of Jesse Sugarmann's Vehicular Palette family tartan

VIRTUAL SEESCAPE

Gina Beavers (b. 1974)

Gina Beavers's art changed dramatically in 2010. She had been making hard-edged abstract paintings and was unenthused about them, especially after admiring several racks of T-shirts in a store with screen-printed abstractions on them. Beavers liked the shirts better than her own paintings, and, at $5.00 each, they were not only cheaper but easier to make. So challenged, she returned to her studio to see if she could make something that appeared more handmade, something that couldn't be accomplished by a machine. A friend had dropped off some acrylic paints for her to try, and she started experimenting by building up thicker layers of paint. Around this time another event happened, this one cataclysmic. Beavers got an iPhone.

Instead of directly observing the world around her as artists had for centuries, she began doing what everybody else was: looking at her phone. What she found delighted her. Images, endless images. All the ones you'd expect to find, plus many more you wouldn't. Beavers started noticing a lot of food photography in her social media feed, and was particularly intrigued by a friend's post of some short ribs he was making. She appreciated how abstracted the brown rib forms appeared against a blue cloth and set about painting them. Instead of maintaining the flatness of the original image, Beavers built up the canvas with acrylic medium to make the forms and textures pop off the canvas. She began following the hashtag #foodporn and painted any image that struck her as interesting, from a pile of chicken and waffles on a platter to an oozing blueberry pie in an aluminum foil pan. Falling somewhere between painting and sculpture, Beavers's relief works appear simultaneously hyperrealistic and charmingly, gloppily handcrafted. They are tactile, heavy, and resolutely physical, the antithesis of their fleeting source material.

Pulling freely from the infinite landscape of images available online, Beavers has made paintings of bodybuilders flexing for mirror selfies, dice-themed nail art, a hoodie printed with Van Gogh's *The Starry Night*, and copious step-by-step makeup tutorials. She uses photo collage

apps to arrange her found images into multipicture compositions. For one work, Beavers Googled "creative lip art" and took screenshots of an image featuring lips with zippers. She then used photo editing software to multiply and layer the image, drew the image onto a panel, and began the work of building up the surface several inches thick with acrylic medium. When she was happy with the relief work (and, at long last, it was dry), Beavers painted the surface to make it look as much like the collaged image as possible. Along the way, she likes to take photos of her work in process, closely observing how it appears on-screen as well as in real life. About the work, Beavers has said: "It lives online and in person, in the same two ways as we do."

Acknowledging our dual existence in online and offline worlds, Beavers offers an assignment that calls us to pay attention to the vast sea of weird, arresting, and tantalizing images that wash over us every day, and recognize their extraordinary potential.

Gina Beavers, Zipper Lips, *2018, acrylic and foam on linen*

YOUR TURN

You know that standing in a room with an object is different from seeing that object on a screen, and yet the difference is easy to forget. For this exercise, your raw material will be your recent history of internet searches and saves, be they intensely personal or aggressively mundane. You captured these images for some reason, and now you have the chance to transform them into something more considered—aware of their thin, digital existence—and lasting.

1 Find a screenshot you have saved to your phone that intrigues you.

2 Manipulate the photo on your phone in any way you like, using your phone's photo editor, third-party photo editing, social media, or a collage app.

3 Create an artwork in real life using any material in any dimension based on your final manipulated image.

TIPS/CHEATS/VARIATIONS

▶ The idea is to work from a photo you did not create, so choose an image that someone else made and shared, and that called to you for some reason. If you don't have something like this on your phone, look through your computer or other device and see what you find. Alternately, conduct an image or hashtag search with random terms that amuse you, like "jean shorts" or "cat ramp." Scan beyond the product shots to find the delightfully bizarre image that's just right for you.

▶ Don't seek out the beautiful or artful image. A "bad" image might be just what you want for this. Terribly composed, poorly lit, or confusing? Give it some attention, and subject it to some editing and layering in order to make something beautiful out of it.

▶ Use any photo editing app or software as long as it is easy and fun. Fancy photo editing skills are not needed here. Zoom in on your image

and crop it. Distort the image using a fish-eye effect, or collage to-gether multiples of your image into the shape of a heart or star. Plug your image into preset interiors or landscapes. Use "artistic" filters in unexpected ways. (Beavers has done all of these.) Attach "stickers," or work in text, emojis, clip art, or whatever the kids are doing these days.

▶ Invoke Jasper Johns's 1964 note to himself in his sketchbook: "Take an object / Do something to it / Do something else to it. [Repeat.]" Except your object is an image. Keep going with your photo manipula-tions until it gets interesting.

▶ While you're editing your image, think about what kinds of art ob-jects you like to make. If you're a painter, what kind of visual effects might you enjoy painting? If you make graphite drawings, convert your image to grayscale. If you're a collagist, manipulate your image into flat forms that could be more easily translated into cut paper. Consider inversions of scale, making an enormous papier-mâché sculpture out of a microscopic image.

▶ Really like your digital image and feel like you don't need to make a real-life object from it? Present it on a tablet on a stand, or print your image on good paper at an interesting or unexpected size. Use a photo printing service to emblazon it on a mug, tote bag, or product of choice.

A DEFINITION APPROPRIATION

/ah-pro-pree-ay-shon/, noun

In art history and practice, "appropriation" refers to an artist's act of using preexisting images or objects to make new art. In the process, they might transform the original in ways large or barely noticeable. The Cubists are often credited as the first to do this, appropriating text and images cut from newspapers into collages in the 1910s. But throughout the twentieth century, artists actively pulled from the growing glut of media made available, from magazine clippings to machine-made objects, Campbell's soup, television adver-tisements, and beyond. Call it homage, borrowing, copying, stealing, or whatever you like, appropriation has served as a valuable and subversive tool for artists for over a century. Beavers is of a long lineage of appro-priation artists, expanding the practice into the wild world of online imagery.

COPY A COPY A COPY

Molly Springfield (b. 1977)

When Molly Springfield was in graduate school working toward a master of fine arts degree, she often found herself in the library making photocopies. She was studying the history of Conceptual Art and conducting research about the intersection of art and language. This interest stemmed from the drawings she was making at the time of notes she had kept from when she was in high school. These were the kind scrawled on ruled notebook paper, folded into rectangles, and passed covertly between friends during class. Springfield rendered the folded, crumpled notes in high detail using graphite on paper, showing every crease and shadow, and only fragments of intelligible text.

It was this close consideration of the physical reality of words on a page that led Springfield to see her accumulation of photocopies in a new light. After graduating, she set to work on a new series of drawings that took as their subject the photocopies themselves—not just the words they communicated and the meanings behind them, but the material properties of text on a page. Springfield represented every intricacy of the photocopied image, including frayed covers, fanned page edges, the shadowy region in the middle of a spread where words curve and disappear, and the dark abyss beyond the book. Each reproduction is 1:1, meaning that if the photocopy was eight and a half by eleven inches, the drawing was, too, with no visual effects appearing in the drawing that were not created first by the photocopier. Springfield was making copies of copies.

Although her practice has evolved, Springfield's fascination with text as image prevails, and the photocopier remains a central player in her process. She has become well acquainted with the machine, able to finagle its settings to yield delightfully complex distortions. And yet, she still never really knows what kind of an image is going to emerge. The photocopier provides parameters Springfield embraces, enlarging only 400 percent at a time, allowing only so much darkening, and accepting only certain sizes of paper. Details get lost in the process of reproduction, and irregularities are amplified. She enjoys

the indeterminacy and speed of the photocopying process, which contrasts considerably with the laborious, slow, and often painful process of transcribing the image to paper.

In an age when much of the information we consume is transmitted through screens and devices, Springfield's work exposes what is lost when we make the leap from analog to digital, and the particularity of the technologies that make it possible. How can we better understand these processes of reproduction that are often difficult or impossible to see? How can we use the technologies of yesterday to comprehend those of today?

Molly Springfield, Untitled (Dear Reader), *page 3 of 3, 2011, graphite on paper, 27.5 x 21.5 inches*

YOUR TURN

We are surrounded by outmoded technologies at various stages of use and decline, and also new technologies, whose idiosyncrasies and limitations will only become apparent with the passage of time. This assignment asks you to seek out a photocopy machine, that stalwart presence of offices and libraries that (as of this printing) has survived despite the odds. While it's still in our midst, let's use it to meditate on what happens as objects become images.

1 Select a page from a book (or other printed media) and make a standard photocopy of it, without adjusting any settings.

2 Make a photocopy of the photocopy and, if you like, adjust the settings by enlarging, reducing, mirroring, playing with contrast, etc.

3 Repeat step 2 until the original has been transformed into a new image, very much removed from the original.

TIPS/CHEATS/VARIATIONS

▶ You can choose a text at random or use one that has personal significance. It can be text alone, or text plus image, or image alone. Select a page from a book you loved or hated, or find one that you've made notes in (marginalia are good!). Start with your passport, a grocery list, album liner notes, a meaningful letter you received, or something pulled from a magazine or newspaper. You won't be able to recognize the source text when you're done, but you'll know what it was.

▶ Consider the size of your source text, the quality of the paper, the font used, and the physical condition of the volume. Maybe your battered copy of *Roget's Thesaurus* will make for a more interesting image than a brand-new art book.

▶ Where can you find a photocopier? Look for them in a public library or your school, or ask a friend or family member if you can use the one in their office. Visit a local copy shop, if you have one, and give yourself a small budget to experiment.

▶ As you photocopy, play freely with the settings and embrace the distortions that occur. It's okay if your hand or shirtsleeve enters the frame. In fact, you might want that to happen! If you don't like the direction in which your image is heading, push through and see if copying it five or six, or even sixteen more times will yield something interesting.

▶ If you can still read your text clearly, you haven't taken it far enough. Make it abstract, and copy your copy more times than you think is necessary.

▶ Select only one image as your "final" work, or show every step in the process. You might want to show only your first and last copy, or perhaps your tenth is better than your fifteenth and is the one you'd like to share.

▶ Yes, you can use a scanner or camera, but understand that the manipulation should happen between you and the device's settings and not through aftereffects or image-manipulating software. Look for the glitches and anomalies in whatever copying device you use and embrace them.

▶ To document your finished work, be aware of that process as well. Pin your final copy on the wall and take a head-on photo in good light using your best camera. Back up so that the camera lens distorts your work as little as possible. Create a best-quality scan of the final copy, or scan all of the steps and make digital files showing each step of the process.

▶ Take it a step further and make a drawing of your image in graphite or in colored pencil. Create a painting of it, or re-create it through collage. See what happens if you try to translate the flat image into a sculptural form or animate it digitally.

COMBINATORY PLAY

Pablo Helguera (b. 1971)

On a routine visit to a used book store, Pablo Helguera came across a book published in 1936 titled *Gamle gårdanslegg i Rogaland*. It was beautiful, filled with photographs of what looked to Helguera like an archaeological site. The book was written in Norwegian, a language he doesn't know, but he bought it anyway. With the book in his possession, Helguera discovered he did not want to understand it and decided to translate the book nonetheless, without any knowledge of the meaning behind the language it contained.

Helguera found this act of strategic mistranslation to be highly entertaining, akin to guessing at the meaning of a sign while traveling in a foreign country where you do not speak the language. He set about reading the words of the book and interpreting them according to what they sounded like in English or Spanish. Through this process, Helguera began to write his own poetic interpretations of the images in the book, and eventually paired them with the images to create a series of sixty-five prints titled *Rogaland* (2012). (He later found out that the book, by Jan Petersen, explores the archaeology of Middle Ages farming villages in modern-day Norway.)

For Helguera, the book was not an end in itself but a point of departure. The source text was a tool for unlocking new meanings and interpretations, independent from the originating author's intentions. That same year, Helguera devised a performance called *The Greater American Play* that similarly used existing literature as a springboard for new work. He gathered participants and printed photocopies of the scripts of beloved American plays: Tennessee Williams's *A Streetcar Named Desire* (1947), Arthur Miller's *Death of a Salesman* (1949), Thornton Wilder's *Our Town* (1938), and Eugene O'Neill's *Long Day's Journey into Night* (1956). Together, they wrote a new script collaboratively, cutting the photocopies into lines of dialogue, pulling two lines from one script, two lines from another, and so on, until they felt they had a play. They gave it a title, *A Long Streetcar Salesman's Death into Our Night Town Named Desire*, and performed it.

This new work fused dissimilar narratives and placed well-known lines in an unfamiliar order and context. It was nonsensical at times, and very funny, creating an entirely new reality out of four discrete plays that had been created many decades earlier. The process was a theatrical version of collage, taking existing entities, each interesting on its own, and placing them into unlikely juxtaposition.

Helguera's combinatory acts generated surreal, strange, and astonishing outcomes, inconceivable without the deliberate misuse of their source materials. What sources might you mistranslate? And to what unforeseeable destinations will they take you?

Pablo Helguera, The Greater American Play, *2012 (pictured: Caroline Woolard)*

YOUR TURN

Everything old is new again. This is your chance to perform a bit of alchemy, mixing together a little of this and a little of that, to create something entirely new. Helguera provides us a recipe, of sorts, whereby we commingle words and ideas from different eras and disciplines to concoct a novel work of art. Gather your favorite, most adventurous coconspirators and discover how you can magically transform several things into one.

1 Bring together a small group of collaborators.

2 Each collaborator selects a play or screenplay.

3 Take turns reading lines from the plays, weaving the scripts together as you go, or write a script that weaves together parts of your plays, alternating every two or three lines or as you see fit.

4 Give it a title, and perform it.

TIPS/CHEATS/VARIATIONS

▶ Visit a used book shop and see what you can find. Plays are ideal, but consider ones you've never heard of, or look for ones from time periods you are less familiar with. Screenplays are great, too, with similarly finite bits of dialogue. You can also consult your library's collection of plays and use your phone or a scanner or photocopier to make a copy of the script.

▶ Nonscripts can work, too. Look for novels that have a good amount of dialogue. But really any kind of text can be used as a source: textbooks, poetry anthologies, religious texts, cookbooks, newspapers, instruction manuals, etc.

▶ If you go the impromptu route, you could assemble a selection of plays ahead of time and then gather everyone around a table to choose

one. Take turns reading, and embrace not knowing what will happen. An audience can enjoy this experience, too, where the material is new for everyone.

▶ Not happy with the outcome? Try it again, combining the same source material in different ways.

▶ If you go the more considered route, gather your collaborators for a script-writing session. Have everyone bring a printed, disposable copy of their play, cut each into segments, and rearrange the dialogue either randomly or very carefully and strategically to construct a narrative. Work together to plan the performance by assigning roles, creating costumes, arranging a set, and inviting an audience. Make a program. Rehearse. Perform!

▶ Try this with plays in a language you are learning and with others who know the language or are learning, too.

▶ Not so keen on theater? Make a combinatory song by bringing together the lyrics of two or more songs. When you have your new lyrics, create original music to go with it and perform your song.

NEWS PHOTOGRAPHER

Alec Soth (b. 1969)

When Alec Soth was fresh out of college, he got a job as a photographer for a small suburban newspaper. On his first day, he was sent to cover a film crew that was in town shooting a movie featuring Keanu Reeves. Soth was intimidated and kept his distance, using a telephoto lens to capture what he could. Finally, at the end of the day, the star generously waved over the unseasoned photographer, and Soth got his picture.

While that first day was equal parts terrifying and exciting, most of the days following would sound quite dull in their description. Soth covered city council meetings and new business openings, sometimes a local fire. He documented the daily life of a community, taking pictures of businesspeople holding oversize scissors at a ribbon-cutting. Soth came to see photography as a kind of ritual act, recording the ordinary moments of life that still contain important information and become increasingly compelling with the passage of time.

Years later, after Soth's career as a photographer was firmly established, he came to a kind of artistic crisis. He had been lugging his large-format, eight-by-ten film camera on road trips around the United States, creating photographic series along the Mississippi River (*Sleeping by the Mississippi*, 2004), in the Niagara Falls area (*NIAGARA*, 2006), and around the country, documenting people living off the grid (*Broken Manual*, 2006–2010). Soth's lens had been firmly trained on others, but he nevertheless felt like his work was too much about himself. So he called up his author friend Brad Zellar and asked if he would go out on assignment with him. They would function like a newspaper reporting team, with Zellar as the writer and Soth as the photographer. Zellar agreed, and the two ventured out to cover stories of their choosing.

For their first gig, Soth and Zellar opened a newspaper and pointed at the first story they saw. It was about a cat that had been rescued from a freeway interchange by a police officer on Christmas Day. They followed up on the story, visiting the shelter where the cat was kept until its owners retrieved it, meeting the cat, interviewing its owners,

collecting quotes, and taking photos. For another story, Soth and Zellar covered a meeting of the local Optimist Club, a small group of older folks listening to a guest speaker present about overpopulation. It was depressing but also exhilarating, giving Soth a window into a world he never would have encountered otherwise. The two expanded their investigations around the country, documenting their outings through printed dispatches that pair Soth's images with Zellar's captions.

For Soth, taking on the role of photojournalist has been an effective way of pushing himself out into the world again and again, to access other communities and experience new things. What new world might open up for you, if only you were given the nudge to go out there and explore it?

Alec Soth and Brad Zellar, page from Dispatch #2, 2010

Leo Gilman. Union Station Barber Shop, Utica

"This shop has been in continuous operation since 1914. The fellow who owned it for 67 years called me one day and said, 'Leo, I'm dying of cancer and my worst fear is that this place will close. I want you to take over the shop.' What are you supposed to say to that? You know how many people were angling for this spot? None.

"I decided I wanted to be a barber on December 7, 1970. Absolutely no regrets. I get to hear all the stories, and to the best of my knowledge nobody's yet figured out how to get a haircut on the internet. God only knows how many kids heard their first cuss word in here."

YOUR TURN

With the dawn of the social internet, many of us have become comfortable broadcasting our own lives, charting what we eat, watch, and buy. Let's turn that impulse to report outward. Pretend like it's your first day on the job as a photojournalist for a newspaper, and Alec Soth is the managing editor. Attend an event you would never go to, or follow up on a story that sounds really boring. You never know where it might lead you.

1 Become a newspaper photographer for a day. Pick one story from a news source, nothing dramatic, something small, like a local woman's hundredth-birthday party.

2 Follow up on the story with the goal of gaining access to a source or angle that wasn't covered. Look for something unusual, and let that carry you to the story.

3 Take a picture that tells that story.

4 Write a text to accompany the picture that shares something that isn't obvious and will push the viewer in a slightly different direction.

TIPS/CHEATS/VARIATIONS

▶ Pick up a free neighborhood newspaper, explore the calendar of a community website, or scroll your social media listings. Select something, anything, either at random or an event that stands out to you as aggressively uninteresting. The task is to find the interesting story within it.

▶ Do your research beforehand. Read what there is to read, consider possible sources to interview, and identify locations to visit. Look up the history of the site and what's going on in the vicinity.

▶ Have a plan. Know your destination, plot your route, and account for stops along the way, like where you're going to eat lunch. If something

better catches your eye, go after it. You still wouldn't have found it if you didn't have that first destination in mind.

▶ You don't need a fancy camera for this. Use whatever you have to take photos, make videos, and/or record audio. Have a plan for taking notes, whether it's a notepad or your phone.

▶ Once you're on the job, think of what a photojournalist would normally shoot, and then look just slightly askance. Like if you're covering a ribbon-cutting, think about what happens before or after the giant scissors cut the ribbon. Maybe you get the guy walking away with the scissors or loading them into the trunk of his car. Looking at something a bit askew can reveal an entirely different side of the story.

▶ Assume people want to talk to you. Ask a lot of questions, and don't be afraid to ask personal ones. Many will be flattered by your interest and can be wonderful sources of information. Hang around longer than is strictly necessary. If you're in the front room of a business, ask if you might see the back room. Don't worry about wasting people's time. That's when the story might open up. If someone doesn't want to talk, don't be pushy. Thank them for their time and move right along.

▶ Consider using a tripod. Not because you need it necessarily, but because it is a way to slow down the process. If you're taking a portrait, you'll have just a little bit longer to engage with the sitter and develop a rapport.

▶ Don't neglect the written component. Even the most basic details like name, date, and location are critical to a photograph. Small bits of information have a large effect on the way a photograph is read. You can add voice to an image, complicate the story, or nudge the meaning of the photo in an unexpected direction. Think of the caption as a way to communicate what can't be seen in the photo.

▶ Be brave and do this on your own, or pair up with a friend and divide the duties between the two of you. One of you is the photographer, the other acts as the reporter, and you collaborate on the assignment.

THE ART OF COMPLAINING

The Guerrilla Girls

The Guerrilla Girls are expert complainers. They've been doing it very effectively since 1985, when they first organized and began distributing posters and stickers around New York City. A group of feminist art activists, the Guerrilla Girls had become increasingly aware that the art they were seeing in galleries and museums in New York City wasn't necessarily the best of what was around. And after an ineffectual 1984 demonstration outside the Museum of Modern Art, protesting a survey exhibition that included only thirteen women artists out of more than one hundred fifty, they decided to try a different approach.

Their posters name names and use information, statistics, and humor to expose gender bias, racism, and corruption within and outside of the art world. In bold black type, one of their first posters, from 1985, clearly lists the names of galleries that were showing no more than 10 percent women artists, or none at all. A 1989 billboard asked: "Do Women Have to Be Naked to Get into the Met Museum? Less than 5 percent of the artists in the Modern Art sections are women, but 85 percent of the nudes are female." They updated the figures in 2005 and 2012, noting little to no improvement. Using the language of advertising, the Guerrilla Girls seek not only to point fingers but to change minds through the intrepid deployment of facts and sometimes outrageous visuals. Calling themselves "the Conscience of the Art World," the group has produced hundreds of posters, billboards, books, stickers, animations, and actions—about not just art, but also politics, film, war, and more.

The members of the group are anonymous, wearing gorilla masks in public and choosing the names of women artists from the past as pseudonyms. This decision was made to keep the attention on the work instead of their identities, with the added benefit that founding member "Frida Kahlo" once explained: "If you're in a situation where you're a little afraid to speak up, put a mask on. You won't believe what comes out of your mouth."

Although their work is now part of museum collections around the world, the Guerrilla Girls continue to cast their critical gaze upon the

inequities they see around them. For this assignment, they ask you to use the culture of now to find your own way to creatively complain about the world as you experience it.

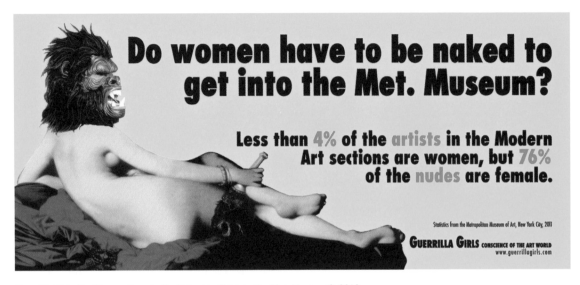

Guerrilla Girls, Do Women Have to Be Naked to Get into the Met. Museum?, *2012*

Guerrilla Girls, Pop Quiz Update, *2016*

YOUR TURN

You're going to complain anyway, so why not do it well? Resist the urge to hastily type out your latest gripes on whatever social media app is in front of you, and consider an alternative approach.

1 Think of something you really want to complain about.

2 Communicate your message in a unique, unforgettable way.

TIPS/CHEATS/VARIATIONS

▶ Spend some time coming up with what it is you want to say and to whom you want to say it. Think about it for days, weeks, or months, and pay attention to the ways people around you broadcast their ideas. Make notes, take pictures, and give yourself time to craft your strategy.

▶ Large problems may be difficult to address, but smaller aspects of an issue can be more feasible. How does a widespread problem manifest itself in a given community? What is it that you, in particular, are able to see that others might not?

▶ Try it out. Find test audiences who will give you an honest opinion. If it doesn't strike a chord, try something else.

▶ Be funny. If you can make someone who disagrees with you laugh, it might just be your opportunity to penetrate their consciousness.

▶ Consider both physical and virtual spaces to present your complaint. It can be tough to get noticed on the internet and in a world where people are often staring at their screens. Where are the places that their attention might be captured, and when might you capture it?

▶ Complaining is a good place to start, but not to end. See this assignment as a springboard for other actions, making a difference not all at once, but over time.

Christine de Pizan, Le livre de la Cité des Dames (The Book of the City of Women), *1405*

At the age of twenty-five, Christine de Pizan (1364–1430) found herself widowed with children to support, and she became a copyist and writer to support her family. She achieved renown for her ballads, poems, and allegories, as well as her vociferous objection to the popular thirteenth-century poem *Roman de la rose (Romance of the Rose)*, which depicts women as wanton and immoral seductresses. She countered with her allegory *Le livre de la Cité des Dames (The Book of the City of Women)*, in which the narrator falls into a trance and three women, personifying Reason, Rectitude, and Justice, visit her and instruct her to build an entire city populated by strong, virtuous women throughout history. Told entirely by women and about women, de Pizan's story used tropes and techniques fashionable in medieval France to counter the prevailing narrative of women as illogical and inferior. By rooting her tale in Christian morality, de Pizan got away with her harsh complaints about patriarchal society and highlighted women for their skills in discourse and peacemaking.

WALK ON IT

Kate Gilmore (b. 1975)

Kate Gilmore loves a challenge. For past works, she has jumped rope in hot-pink high heels on a board perforated with holes (*Double Dutch*, 2004). She has kicked, punched, and elbowed her way through a Sheetrock wall, outfitted in a dress, pantyhose, and patent leather heels (*Walk This Way*, 2008). She has filled ceramic pots with hot-pink paint and lugged them to the top of a tall plywood structure, only to drop and break them, sending their contents spilling out in a splattered pile (*Break of Day*, 2010). These arduous processes are documented through video and shared with audiences, sometimes along with the sculptural remains of her actions.

Gilmore also gives challenges to others in her work. She has enlisted five female performers to don floral-print dresses and attack and dismantle by hand an enormous block of raw clay (*Through the Claw*, 2011). She has hired performers to stomp and pound on red enamel cubes for hours at a time in an art gallery (*Beat*, 2017), and to work in shifts to walk on top of a public podium in New York's Bryant Park (*Walk the Walk*, 2010). For the latter work, participants wore a uniform of yellow dresses and beige shoes, and walked in any way they chose during the workday hours of eight thirty a.m. to six thirty p.m.

Whether they are acted out by the artist or performers, in front of an audience or for the camera only, Gilmore's performances give form to a multitude of feelings and frustrations. They raise questions about how women in contemporary society are expected to dress, act, work, and behave. As these self-constructed obstacles are overcome through struggle, we're led to question the nature of work itself, and of art "work" in particular. Must art be the result of physical and emotional struggle? Must the serious artist be serious, wear black, and avoid using "girly" colors?

Gilmore now asks you to set up a challenge and overcome it. In the process, you'll be called to think about the many assumptions we make about how art gets made and who makes it. What are the ways in which your body can make art? Using what colors and wearing which

shoes? Alone, or with others? Through this assignment, you'll begin to understand how all art is the result of some kind of performance. Just as a landscape painting is a record of the brushstrokes that brought it into existence, what you're about to make will be a record of the time that you spend with it and the actions that bring it to life.

Kate Gilmore, Walk the Walk, *2010, performance. A project of the Public Art Fund.*

YOUR TURN

This is a finite list of terms, but there are infinite ways they can be executed. You will bring your own ideas about material, color, and effort to this activity, and your results will be different from anyone else's. Whether you approach this on your own or with friends, the focus here is on the experience of making. A physical product will certainly come of it, but let the process be your guide.

1 Find a big piece of wood or board.

2 Paint it heavy with a color that you love.

3 Put on a fabulous pair of shoes and walk on it.

4 When it looks cool, you're done.

TIPS/CHEATS/VARIATIONS

▶ Finding a board is better than buying one. If there isn't one lying around where you live, sift through a dumpster or recycling bin. The larger the better.

▶ This is the perfect opportunity to use leftover house paint or partially dried, past-due art paint. If you don't like the colors you have, try mixing them to create new ones that you do. If all else fails, buy new. And paint the board in whatever way you like.

▶ Should the board be wet or dry when you walk on it? Either works. A dry board will allow you to create marks by wearing down the surface (and not ruin your shoes), while a wet board will very clearly show immediate evidence when you walk on it (and likely ruin your shoes).

▶ Many kinds of shoes can be "fabulous": heels, work boots, cleats, ballet slippers, roller skates, any kind of footwear you love. Barefoot is cool, too.

▶ Create this in one go or over time. Consider leaving the (dry) painted board in a thoroughfare of your house, and allow marks to accrue over the course of weeks or months as you and those you live with walk over it. Or make your board, and then let it be a dance floor for your next party. Have this be an activity at your next reunion and the resulting board be a record of your time together.

▶ Present your finished work. Hang it or lean it against a wall, letting it be a painting/sculpture/installation that bears evidence of your past performance.

RESPONSE

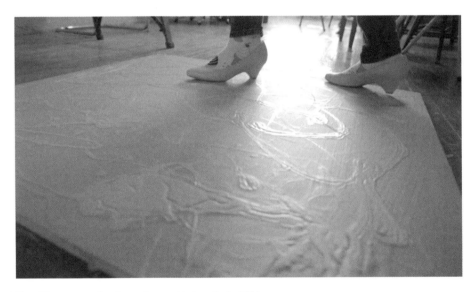

Kate Gilmore executing the assignment in her studio, 2014

HISTORY AS YOUR GUIDE

Bruce Nauman, Dance or Exercise on the Perimeter of a Square, *1967–1968, 16 mm film, black and white, sound, 400 feet, approximately 10 minutes*

In the winter of 1967–68, Bruce Nauman (b. 1941) found himself alone in his San Francisco studio and decided to make some 16 mm films. For this one, he used masking tape to make a square on the floor and marked the halfway points on each side. Nauman then set a metronome to tick on the half second and spent the next eight minutes moving in a methodical sequence of half-length paces around the square. He wore a neutral expression, a T-shirt, and jeans, and when he completed his self-determined sequence of movements, the film ends. Newly graduated from art school, he had recently concluded, "If I was an artist and I was in the studio, then whatever I was doing in the studio must be art." Nauman's film, along with others that recorded analogous studio-based actions, tested the limits of this belief and set the tone for future works, which "became more of an activity and less of a product."

PROPOSALS

Peter Liversidge (b. 1973)

To begin his work, Peter Liversidge sits down at a typewriter and writes proposals for what he might like to do. Some are straightforward and relatively easy to execute, such as "I propose that we should walk together," which he submitted in 2017 along with more than forty other ideas to Bonniers Konsthall in Stockholm, Sweden. Others are purely speculative, such as "I propose to dam the Thames and flood the City of London." Still others are impractical but still realizable, such as when he proposed to lodge an eighteenth-century cannonball in a wall of the Aldrich Contemporary Art Museum, and succeeded in making it happen for his exhibition there in 2017.

These proposals are not orders to action but invitations, which can be summarily dismissed, quietly contemplated, or fully brought to life. In the summer of 2016, Liversidge proposed to write a choral piece to celebrate the opening of a new extension at Tate Modern in London. And he did just so, gathering more than five hundred singers from around the city to sing a cycle of songs written in response to the building and its history. The songs were derived from conversations with construction workers, gallery staff, visitors, and local residents, and the piece was performed only once, on Saturday, June 18, 2016, during the building's public opening.

The typed proposals are often gathered into collections and reprinted in books, or are framed and hung in galleries alongside and among selected realizations of the proposals. These realizations may involve sculpture or performance, or may entail a direct response from their viewers ("I propose to ask you to draw a bear from memory"). The artist is as happy for each proposal to be acted upon as he is for it to be left hanging on the wall. Sometimes the imagining is enough, with the action of the piece taking place invisibly and through the thought processes of those who encounter them.

Liversidge's proposals encourage us to consider what is possible and impossible, reasonable and absurd, and are dynamically inclusive of their audience and the places they're exhibited. In fact, Liversidge's works need *you* in order to exist.

Peter Liversidge, The Bridge (Choral Piece for Tate Modern), *June 18, 2016, choral performance at Tate Modern*

YOUR TURN

A proposal is just the beginning. It is a starting point for new things to happen. The art that will unfold from here is a collaboration between you and Peter Liversidge. You'll bring your own perspective to it, and your realization of this work will necessarily differ from anyone else's.

1 Select one, two, or all three of the proposals on the following pages.

2 Respond as you see fit.

TIPS/CHEATS/VARIATIONS

▶ Don't forget: Peter is as happy for the proposals to be unrealized as he is for them to be realized, and sometimes merely contemplating the idea is enough.

▶ If you'd like, find a way to document your response. Write down your thoughts about the process, take a photo, make a video, or draw a comic reflecting your experience.

▶ Share the proposals with some friends, execute them separately, and gather to talk about your varying experiences.

▶ After you've responded, ask yourself some questions:
 - Why did you choose the proposal you did?
 - What made you want to actually go through with it?
 - What does your choice of proposal and the way you executed it say about you?
 - How might others have responded differently to the same proposal?
 - Who do you think is responsible for this work? Is it you? Should it be the artist?

PROPOSAL FOR THE ART ASSIGNMENT,
www.theartassignment.com/episodes/assignments/
October 2016.

I propose to invite the reader of this proposal to dress as their
parents.

Peter Liversidge.

PROPOSAL FOR THE ART ASSIGNMENT,
www.theartassignment.com/episodes/assignments/
October 2016.

I propose that the person reading this proposal should imagine that
their feet are in a mountain stream.

Peter Liversidge.

PROPOSAL FOR THE ART ASSIGNMENT,
www.theartassignment.com/episodes/assignments/
October 2016.

I propose to invite the reader of this proposal to assist further in
Samuel Johnson's attempt to discredit Bishop Berkeley's theory of the
non-existance of matter. Bishop Berkeley put forward the theory that
there are no material objects, only the idea of those objects in our
minds. It was not Bishop Berkeleys intention that it should just rel
-ate to visual perception but to perception in any of the five senses.
When samuel Johnson responded to this theory; of the non-existance of
matter he did so declaring: ' I refute it thus ! ' as he spoke those
words he kicked a large stone.
I request that the reader of this proposal leave their home, place of
work and go out and find a stone. Once that stone has been located
they should kick it back to the place they have just left. On the way
taking one photograph of the stone where it is found, one on the way,
and one once it has arrived to the place it has been kicked.

 Peter Liversidge.

SORTED BOOKS

Nina Katchadourian (b. 1968)

When Nina Katchadourian was in graduate school, she paid a visit to the home of a classmate's parents in Half Moon Bay, California. She was there with other students to spend a week in the house and make art with what they found. Intrigued by the home-owners' personal library, Katchadourian immersed herself in their books, scanning the titles, and sorting and arranging them into stacks. She aligned the book spines so that their titles could be read in order as short phrases, and also took photographs of the groupings. It was an intimate exercise, learning about a couple through their merged library, and one that for her felt like a form of portraiture.

In the years since, Katchadourian has visited libraries around the world, both public and private, in each instance putting to use this pro-cess of cataloging, stacking, and photographing the spines of books. In 2014, she mined the private library of the late author William S. Burroughs (1914–1997) in Lawrence, Kansas, where he spent the last sixteen years of his life. Many of the books in Burroughs's library did reflect his reputation as a countercultural icon fixated on drugs and darkness, but others revealed the author's softer side and deep af-fection for cats. In this case, Katchadourian's book sorting paralleled nicely with the "cut up" technique that the author himself put to use, assembling new texts from fragments of existing writings.

Katchadourian's process has remained relatively consistent, with slight variations along the way. First, she combs through the entire library and makes lists of the titles she finds interesting, noting pat-terns and themes to form an overall picture of the collection. Duplicate copies are almost always noteworthy. From her lists, she identifies the titles that jump out at her, writes them on index cards, and then ar-ranges and rearranges the cards to see which titles fit well with each other. The phrases that result are sometimes complete sentences, other times poemlike fragments, and on occasion form entire stories. Next, she moves the actual books into stacks, taking into account the typography and physical presence of each book before determining

the final arrangements. As a last step, she photographs them, and on a few occasions has installed the stacks themselves in and around the library.

A book stack Katchadourian created in 1996 beautifully encapsulates her art practice in general and this activity in particular. She paired only two books, posing a question with the first, *What Is Art?*, and answering with the second, *Close Observation*. She challenges us to heed the call.

Nina Katchadourian, Only Yesterday, *from the series* Kansas Cut-Up, *2014* (Sorted Books *project, 1993 and ongoing), C-print*

YOUR TURN

When do you visit someone's home and not gravitate toward the book-shelves? There is so much to glean. Aside from the content of the books themselves, a library can be a window into the interests and pasts of your hosts. Think of this as a great excuse to indulge your curiosity about someone you know or would like to know better. Or to escape the social awkwardness of a party. You can consider this assignment the beginning of a conversation of sorts, between you and the books of the library you select, and—later—with the people with whom you share what you've made.

1 Choose a person you know or would like to know better.

2 Ask permission to peruse their library and then explore it thoroughly.

3 Create three stacks of books that form a kind of portrait of the person, aligning the book spines so that their titles can be read in order.

4 Photograph each stack.

TIPS/CHEATS/VARIATIONS

▶ Consider asking a relative, friend, teacher, or neighbor. Seek out someone of a different generation and discover books you've never heard of. Or if you find yourself a houseguest somewhere, ask to explore your host's books and use the opportunity to leave them with your photos as a thank-you.

▶ When working with a large library, start by writing or typing a list of the titles of interest to you. Use that document to experiment with combinations of titles. Then go back and pull the books when you're ready to try out your combinations.

▶ Make note or take a picture of the original locations of the books you pull, and be sure to return them to their original locations when you're done. Be respectful and don't cause a mess.

▶ Read the titles out loud as you sort your book clusters, making sure the grouped titles have a rhythm and flow.

▶ Consider a mixture of humor and seriousness in your stacks. Allow some to be more playful and some more earnest, keeping in mind the subject of your portrait.

▶ Be sure to take into account the typography of the title and the other text present on the book spine. Katchadourian often left-aligns the titles so that a clear phrase emerges.

▶ You will be tempted to use your own books to respond to this assignment, creating a self-portrait. This is okay, but I still encourage you to try it with another person's books, too. You can also consider doing this in a public library or that of an institution where you have access, perhaps yielding a portrait of a city, town, or school.

YOUR MIND WILL ANSWER MOST QUESTIONS IF YOU LEARN TO RELAX AND WAIT FOR THE ANSWER.

—WILLIAM S. BURROUGHS, *NAKED LUNCH*, 1959

MEET IN THE MIDDLE

Douglas Paulson (b. 1980)
and Christopher Robbins (b. 1973)

The first time Christopher Robbins and Douglas Paulson met, it was in 2008 in a raft in the middle of a lake in the southern Czech Republic. At the time, Robbins was living in Vranje, Serbia, and on the lookout for artists he considered to be "Auto-Interventionist," like himself. He used the term to describe those who make art as a means of intervening in their own lives. And Paulson, who was then working in Copenhagen with the art collective Parfyme, fit the description.

Robbins reached out, and Paulson proposed they meet up in the middle. Somewhat jokingly, Robbins took him literally and identified the exact midpoint between them, which was in the aforementioned lake in the southern Czech Republic. That was precisely what Paulson had in mind, so they decided on a date and time and devised rules for the meet up:

- No communication getting there
- Robbins brings lunch
- Paulson brings drinks
- Don't be late

They documented their preparations and journeys on parallel blogs, detailing routes and supplies, and posting pictures, videos, and thoughts about the process (Paulson: "What if he can't find it? What if he doesn't come? How long do i wait?"). Paulson brought an inflatable raft to make it to the identified point in the lake, Robbins swam to meet him, and the two shared lunch on board before cold and rain brought them back to shore.

The challenge was a means of forced adventure, allowing each artist ample room to interpret and innovate around given constraints. For Robbins and Paulson, who have artistic practices independent from each other, the concept was a useful starting point for generating new work. They each framed the project separately and used slightly different titles to describe the same event: *Meet Me Halfway* (Robbins)

and *Let's Meet Halfway: Lunch on a Lake, Somewhere in the Czech Republic* (Paulson).

Robbins and Paulson have used this same excuse to seek adventure on multiple occasions, including in 2013, when they were living much closer to each other in the United States. That time, they met high up in a tree in a stranger's yard in New Rochelle, New York, with the express purpose of emboldening you to seek your own adventure.

Douglas Paulson and Christopher Robbins meet in the middle in a tree in New Rochelle, New York, 2013

YOUR TURN

This is an assignment for the cautious as well as the intrepid. It can be executed on a sprawling, international scale, within the boundaries of one neighborhood, or even between rooms of a single house. Every step along the way, you will make decisions as you reconsider the spaces you inhabit and paths you do—and do not—traverse on a daily basis. Boundaries may be crossed, walls and property lines negotiated, and buildings explored or avoided. In an age of unparalleled access to information and technology, Meet in the Middle requires a tremendous leap of faith, as you surrender your means of connectivity and put your future in the hands of another. Choose wisely.

1 Select a friend and calculate the exact geographic midpoint between you.

2 Once you've agreed on the midpoint, decide on a date and time to meet there.

3 Once the decision is made, do not communicate until you meet.

4 Document your journey and experience in whatever way you see fit, using photos, video, text, drawings, etc.

TIPS/CHEATS/VARIATIONS

▶ There are websites that will calculate your geographical midpoint for you, or you can figure it out yourself with a paper map, drawing a line between your locations and marking halfway.

▶ Be inventive and make your own rules. Robbins and Paulson decided to share a meal at their midpoint, but you and your friend might like to do something else. Use your geographic location and time of day as a guide to inform your adventure.

▶ This can be accomplished with more than one friend. It makes the calculation more tricky, but you can meet in the middle with a whole group of people. One variation is to calculate midway points sequentially, starting with two people, and letting each new person pull the midpoint in their direction.

▶ Nobody said your journey has to be epic! One artist responded by meeting her newly crawling baby halfway down the hallway of their home.

▶ Please do not trespass, break any laws, or endanger yourself. Use your best judgment in deciding on the meeting point. You can remain faithful to the spirit of the exercise by selecting a spot adjacent to, but not precisely on, the exact point. When Robbins and Paulson calculated the midpoint for their New York meetup and identified it as the roof of someone's home, they decided to meet in a tree at the edge of the property instead. (Still trespassing! Don't do that!)

EACH FRIEND REPRESENTS A WORLD IN US, A WORLD NOT BORN UNTIL THEY ARRIVE, AND IT IS ONLY BY THIS MEETING THAT A NEW WORLD IS BORN.

—ANAÏS NIN, MARCH 1937, *THE DIARY OF ANAÏS NIN*

HISTORY AS YOUR GUIDE

Marina Abramović / Ulay, The Lovers, *March–June 1988, performance, the Great Wall of China, 90 days*

After hearing that the only human constructions visible from the moon were the pyramids and the Great Wall of China (which isn't true, by the way), artistic collaborators Marina Abramović (b. 1946) and Ulay (Frank Uwe Laysiepen, b. 1943) made plans to walk toward each other from opposite ends of the wall, meet in the middle, and get married. But in the eight years it took to plan the event and secure permission from the Chinese government, their relationship deteriorated. They decided instead to perform the walk, but their meeting in the middle would mark the end of their collaboration. Over the course of ninety days, they each walked 2,500 kilometers, and at their meeting point embraced and said goodbye.

FIND YOUR BAND

Mark Stewart and Julia Wolfe
of Bang on a Can (est. 1987)

Mark Stewart was at a picnic once and a car alarm kept going off. After it sounded for what felt like the tenth time, Stewart's wife, Karen, leapt to her feet and improvised a dance to it. Every time the alarm went off after that, everyone at the party danced, too, with laughter and delight. A multi-instrumentalist, singer, composer, and instrument designer, Stewart was inspired by what had occurred and went home and wrote a tune about it. He titled it "The Siren Song: The Rehabilitation of an Urban Earsore." A jarring noise, seemingly universally loathed, had been reframed into something joyful.

Every summer Stewart joins other innovators and pioneers of experimental music to share similar techniques with young composers and performers at the Bang on a Can Summer Music Festival at MASS MoCA, in North Adams, Massachusetts. There he leads a workshop called the Orchestra of Original Instruments, where attendees gather to discover new sounds and make music from such humble and unexpected materials as sump-pump drainage tubes and nail files. Musicians who have had rigorous and formal conservatory training are encouraged to pick up random and various objects to see what kind of sounds they might make. A length of hose, for instance, can create a beautiful pitch when swung around slowly like a lasso, modulating as it's thrown around the room.

Composer and Bang on a Can cofounder Julia Wolfe likens this kind of resurrection of sound to Jimi Hendrix's embrace of electric guitar feedback in the 1960s. The previously undesirable sound effect was used by Hendrix intentionally, transforming feedback into something able to be harnessed and masterfully deployed. Wolfe emphasizes the importance of listening in this process, of noticing the sounds that are around you and realizing that inspiration can come from anywhere.

Stewart and Wolfe have collaborated on an assignment that promotes the ideals set out by Bang on a Can, the performing arts organization that routinely unites them. They are asking you to listen, and to discover the unlikely noises around you that might be resurrected and catalyzed into something new.

Mark Stewart in the exhibition Gunnar Schonbeck: No Experience Required, *2017, at MASS MoCA, North Adams, Massachusetts. Photo by Jason Reinhold.*

YOUR TURN

You can go through life and be annoyed by all the unwanted, unsummoned noises around you: horns honking, car alarms, construction, air-conditioning. Or you can embrace those sounds, absorb them, and respond to them instead. The world is your symphony.

1 Go through your day and notice all the sounds around you.

2 Choose a sound or a group of those sounds to be your band.

3 Join the band! Hum, clap, sing, drum, or make your own sounds to accompany it.

TIPS/CHEATS/VARIATIONS

▶ Pitch and rhythm are everywhere: your fan, the dishwasher, cicadas chirping, a jackhammer, rain, wind, a nearby conversation, the train, your footsteps, the whir of a highway. Remove your earbuds and listen attentively to what's already there.

▶ Anything can be an instrument, be it your voice, a rustling trash bag, the surface of a desk, a box of cereal, or this book. Something very simple can create a beautiful or satisfying sound.

▶ You don't need musical training for this. Begin by whistling, tapping your toe, or speaking a phrase in different ways. Start simple and expand. Shout, create animal noises, or make the sounds of a water drop or a cork pop with your finger and mouth.

▶ If someone told you that you can't sing, they are almost definitely wrong. If a car alarm can be reframed, so can your voice. Try this alone, and be as generous with listening to your own voice as you are with the other sounds you are paying attention to out in the world.

▶ Take it to the next level and build your own instrument. Gather objects lying around the house or in the trash, see what sounds they make, and combine them into a never-before-heard marvel of sonic engineering.

▶ Record or document what happens. Keep the recording to yourself or share it with others. See if your recording might become someone else's band or the beginning of a new collaboration.

HISTORY AS YOUR GUIDE

John Cage performing Variations VI, *Washington, DC, 1966. Photo by Rowland Scherman/Getty Images.*

Revolutionary composer John Cage (1912–1992) said repeatedly, "Everything we do is music." We see this demonstrated by his *Variations*, intended "for any number of players and any sound producing means," and in his legendary composition *4'33"*, in which a performer is directed to produce no intentional sounds for four minutes and thirty-three seconds. Cage composed for a wide range of instruments, implements, and everyday sounds: radios, electronic circuitry, conch shells, the sound of sipping water, and a piano "prepared" with bolts and rubber bands lodged between its strings. Preferring to listen to the sounds of traffic on Sixth Avenue in New York, Cage gave away his own piano, didn't listen to records, and rarely went to concerts. "You call it noise," Cage once said, "I call it music." (Nota bene: Cage did attend several of Bang on a Can's early events.)

CONSTRUCTED LANDSCAPE

Paula McCartney (b. 1971)

Paula McCartney is not the kind of photographer who goes out in the world to capture a scene that already exists. She conjures an image in her mind and then goes into the world to construct it.

Her way of working was inspired by a visit to the Bronx Zoo, where McCartney was immediately captivated by the bird habitats in the aviary. She marveled at the individual rooms filled with copious natural light, painted backgrounds, and fabricated boulders, as well as plentiful real plant life and, of course, living birds. The rooms were half natural, half human-made. If she ignored what was in her peripheral vision, McCartney could be transported from the Bronx to a lush Costa Rican jungle. She began taking black and white photographs at the aviary, framing close-range views into the habitats that give only subtle clues, such as a garden hose propping up a plant, that what is being viewed is not entirely authentic.

Following the *Bronx Zoo* series McCartney inverted this approach, venturing into naturally occurring landscapes and inserting fake wildlife. In past walks through the woods, McCartney would observe birds from a distance but never document them. They were always too far away, and never in a position that made for a good composition. And so she purchased fake songbirds from craft stores and placed them onto tree branches precisely where she wished they were. McCartney photographed the "birds" on her own terms, when the light was just right, taking time to carefully compose the image. Upon first glance, the pictures are compellingly realistic, but when observed closely and one after another, their fabricated subjects become apparent. A real bird would never allow her to get that close. A wire can be seen wrapping the bird's foot around a branch. Slowly, you realize the constructed nature of the scene, and that what you are observing is not a living creature but dyed feathers glued to foam.

The goal of McCartney's work is not to deceive but to encourage you to question what you see when you look at any photograph or experience any landscape. Nearly every environment we encounter is

constructed in some way, whether it is as blatant as a city block or as inconspicuous as a nature preserve. McCartney's way of working explores this ambiguous territory between the natural and the unnatural, and her assignment encourages you to venture out and do the same.

Paula McCartney, Bird Watching (Aqua Tanager), *2004, C-print*

YOUR TURN

You don't have to be satisfied by the world as it is. Go out there and construct the one you want. Let your mind wander. Imagine a landscape instead of waiting for one to appear before you. You don't even need to leave your house to give us photographic evidence of worlds that exist outside of it.

1 Think about a landscape you'd like to construct, and gather materials that might re-create its elements, some natural and some human-made.

2 Arrange the materials on a surface and create a backdrop.

3 Photograph your landscape from many angles, adjusting the lighting and arrangement of materials as you go.

4 Select the most compelling photo as your final image.

TIPS/CHEATS/VARIATIONS

▶ Use materials and objects you have on hand: a few rocks, a shell, houseplants, leaves, packing material, spare paper. Raid the pantry for substances that might re-create snow or sand, like flour and sugar. Use a photograph of a place you've been as a backdrop, or tear a page from a magazine.

▶ Find a good surface where you can build your landscape, like a tabletop against a wall, or construct your scene inside a box. Think about what is visible behind your objects, whether it's a window or a poster on the wall.

▶ This can be done inside or outside. Grass or dirt can be great surfaces to start from, but beware of uncontrollable elements like wind and living creatures.

▶ Consider your lighting. Construct your landscape near a window, taking into account the time of day. Move lamps around to create shadows and points of focus. Bring in a flashlight to create multiple light sources.

▶ Move things around and try numerous arrangements of your elements, all while checking the view through your camera. Your scene is going to look totally different through the lens than it does in real life.

▶ Take lots of photographs, adjusting your angle and the settings of the camera as you go. Move elements in and out of the frame, and adjust your lighting. Photograph it at different times of day. Think of your beginning pictures as practice.

▶ Remember scale. Think about where you are in relation to your objects, and use scale to transform a small rock into a monumental cliff face. Make a puddle look like a large expanse of sea. Conversely, make a larger object look smaller than it is by shooting it from far away.

RESPONSE

Paula McCartney's constructed landscape for this art assignment, 2015

HISTORY AS YOUR GUIDE

James Nasmyth and James Carpenter, Normal Lunar Crater, *plate XVI from*
The Moon: Considered as a Planet, a World, and a Satellite, *2nd. ed. 1874.*

When the above image was published in 1874, no one had suc-
cessfully taken such a detailed photograph of the moon's surface.
Indeed, neither had the creators of this image. Scottish industri-
alist James Nasmyth (1808–1890) had retired from a successful
career inventing machine tools to pursue astronomy. He built a
telescope that allowed him to see at great magnification and set
about making detailed observations of the moon with his collabora-
tor, British scientist James Carpenter (1840–1899). They published
a book of their findings and illustrated it with images including
the one above of lunar craters. Working from notes and drawings
made while looking through the telescope, Nasmyth and Carpenter
crafted plaster models that re-created the surface they observed.
They then lit the models from low angles and photographed them
from above. The resulting images were convincing and remarkably
accurate, transporting viewers to this faraway land that would not
be visited by humans until nearly one hundred years later.

NATIVE LAND

Wendy Red Star (b. 1981)

When Wendy Red Star left the Apsáalooke (Crow) reservation in Montana, where she grew up, to attend college a four-hour drive away, she enrolled in a Native American studies class. Some of the first topics covered were the policies imposed upon Indigenous Peoples by the United States government. Red Star was fascinated. Here were the reasons, clearly articulated and presented before her, why she had lived on a reservation. It was a facet of her life that had been so normal she barely thought about it. Terms like "land allotment" that were regular topics of discussion back home seemed remarkable only now, as she learned about the 1851 Fort Laramie Treaty, which was the first effort to define the territories of eight Indigenous Nations, including the Crow.

As Red Star learned about the history of Indigenous Peoples more generally, her interest in her own tribe grew. It was Chief Sits in the Middle of the Land who was responsible for communicating the boundaries of Crow territory to the US government. He did so by explaining in an 1868 speech: "My home is where my tipi sits." Not to be interpreted literally, his description invoked the Crow method of tipi construction, which involves the setting of four foundation poles to create a square base. The remaining poles all rest on those four, and the hide or canvas wraps around that. Chief Sits in the Middle of the Land imagined one large tipi whose four foundation poles were placed on each of the major migration routes that Crow took throughout the season. He explained: "When we set up our lodge poles, one reaches to the Yellowstone, the other is on the White River, another one goes to Wind River, the other lodges on the Bridger Mountains. This is our land." Setting these points as the outer boundary, the Crow "tipi" encompassed 38.5 million acres.

When Red Star looked at the map of that acreage, she realized that Bozeman, where she was attending Montana State University, was within that boundary. (Today, the Crow Indian Reservation encompasses approximately 2.2 million acres.) She was exhilarated by this

revelation and wanted to share the news that this place—where she only came across Native students if she met with the Native Student Group—was Crow country. By this point Red Star was focused on a degree in sculpture and decided to recognize this Crow territory by setting up tipis of her own.

Red Star's parents helped her harvest lodge poles from the top of the Pryor Mountains on the reservation, laboriously stripping the bark from pine trees over thirty feet tall. They prepared several sets, each tipi requiring twenty-one poles, and transported them to campus. Red Star first built a progression of tipis outside of the art building and then disassembled and reassembled them along the natural pathways students had created across grassy areas on campus. She installed the tipis in various locations and in configurations that emphasized the four-foundation-pole process, concluding in an arrangement on the fifty-yard line of the university's football field. It was difficult and exhausting work, but joyful, as she knew that she was both honoring her ancestors and asserting a claim on Crow territory, if only for a short time.

Since then, research has remained the cornerstone of Red Star's artistic practice, which spans photography, sculpture, video, fiber arts, and performance. By asking simple questions, she stumbles upon surprisingly rich and resonant material, which she reframes and recasts into works that offer new perspectives on her own cultural heritage and the histories of Indigenous Peoples that we all share.

Wendy Red Star, Interference, *2003, lodgepole pine*

YOUR TURN

There is always more to learn, whether you were raised within an indigenous community or have never considered who previously occupied the land you now call home. This is your opportunity to better know the history of a place and the history of the people who live there now, settled there in the past, or may have been displaced from it to make room for your existence today. Take ownership of these histories, deepen your awareness of them, and promote what you learn to others.

1 Research the history of Indigenous Nations in your state, province, or region. This also applies if you reside within an indigenous community or reservation.

2 Narrow your search to learn about the specific indigenous communities that lived in your city or town, and study the history of the Native people who once occupied the land where you live. If you live within an indigenous community, study the history of the movement of your community, the shifting of borders and land allotment, or the other Indigenous Nations that may have occupied the land.

3 Using the following template as a guide, create a sign that recognizes the Indigenous Nation that occupied your immediate vicinity. Print as many copies as you like on paper or sturdier material.

4 Armed with your sign(s) and the knowledge gleaned from your research, go out into your community and find a location (or locations) where you can post your sign(s).

5 Take a photo of your sign in place, and post it to your social media platform of choice with #indigenousterritories. In your post, you can write about your research or personal acknowledgment of the Indigenous Territories that you live on.

TERRITORY

OF THE

APSÁALOOKE NATION

To create your sign, first create the border describing your state, province, or country. In the area of the Indigenous Territory you have identified, use an Arial or Helvetica font to state: "Territory of the [Indigenous Nation]."

TIPS/CHEATS/VARIATIONS

▶ A walk or drive around town may provide you with plenty of direction. Search for indigenous words or names on street signs, businesses, or landmarks. The name of your county, city, or state may be a place to start.

▶ Don't skip the second step of making a deeper, more localized search for information about the Indigenous Peoples who lived in your area. Find the information you can online, but also consider visiting the library or local museums as well. There may be advocacy groups in your area that would be glad to provide information.

▶ While you're reading, make note of the smaller details you find revealing. Perhaps it's a quote from a speech or a phrase in a treaty, law, or court case that strikes a chord. Maybe you decide to find out more about a prominent figure who intrigues you. Don't overlook recent history or current events, either.

▶ The template is straightforward for a reason. Please be careful not to use any images, fonts, clip art, or design elements that could be culturally insensitive.

▶ When placing your sign(s), you can do this guerrilla style or with more planning and permission. If you've made a more permanent sign, you might want to seek permission from your school, town council, or whoever "owns" the land in question. Or assume that it will be a temporary intervention, and let it live on through the photo and by sharing it with others.

▶ Consider where people are likely to notice your sign, or conversely, where it might blend in. Assume that some will be removed or lost to the elements, and replace them as you wish. Try several placements to see what works.

BODY IN PLACE

Maria Gaspar (b. 1980)

Maria Gaspar grew up in Pilsen and Little Village, on the west side of Chicago, and they are where she has built her career as an artist and educator. The neighborhoods have been the cultural center of the city's Mexican-American community since the 1960s, and home to an array of vibrant murals that adorn building exteriors, overpasses, and train platforms and embankments. As a young person, Gaspar was surrounded by these murals, as well as the artists, organizers, and volunteers who brought them to life through efforts that were often collaborative.

This deep-seated understanding of art as communal and integrated into public space is joined in Gaspar's practice by her interest in performance. Her mother worked as both a radio disc jockey and a professional clown during Gaspar's youth and demonstrated for her a way of thinking about the world with laughter, tenderness, and radical creativity. Gaspar didn't like it when her mother made her clown with her, but she grew to appreciate the experience nonetheless. And she has channeled it at many moments since, including in 2010, when she was the lead artist behind *The City as Site*, a series of public art projects created with nearby high school students. Gaspar worked with the students to become more aware of the architecture of their school and surrounding community, guiding them to engage with sites by positioning their bodies in ways that called attention to the singularity of the location. One group focused on a cold, dark viaduct that separates two communities, arranging their brightly clothed bodies within the X-shaped supports beneath it and capturing it in the photograph, enlivening a place they thought of as dismal and divisive.

Working independently, Gaspar made a series in 2009 in which she placed her own body into some of Pilsen's historic murals. After considering a few of their images, she selected her attire, chose props, and strategically inserted herself into the scene as a kind of live-action piece. By performing these actions and photographing them, Gaspar used her body to recover and reframe the murals, giving them new life.

Through both her collaborative and independent work, Gaspar has brought focused attention to structures and histories within her community that are often so large or omnipresent that they have become invisible to many. By exploring these places and considering their meanings, Gaspar forges new images that recharge these sites and begin to shift the narratives that follow them.

Maria Gaspar, Untitled (16th Street Murals), *2009, site intervention*

YOUR TURN

What are the locations in your community that are hiding in plain sight? Which ones feel oppressive, heavy with history, in transition, or invisible? Which ones strike you as joyful, calm, or uncontested? Gaspar gives us the chance to identify these places and reclaim them. The power is in your hands to push against the meaning that a given architecture imposes and overlay your own perspective. What can you see that other people might not be able to? And how can you help them see it?

1 Choose a location that is visible to you but seemingly invisible to others.

2 Think about the location and what it represents.

3 Use your body to make an intervention, creating a new story of that location.

4 Document your intervention.

TIPS/CHEATS/VARIATIONS

▶ Take a walk near where you live or work, or as part of your daily commute, paying careful attention along the way. Or peruse a map of an area you know fairly well. Look for areas or places you might not have noticed before and go check them out in person.

▶ Invite others to do this with you. Whether they simply act as camera operator or serve as a close collaborator, this can feel safer or more comfortable if you work in a group. Work together to pick a site, brainstorm ideas, and execute your ideas as a group. Be sensitive to everyone's comfort level.

▶ Write a list of words that describe the place. What does it look like? How does it make you feel? What did it used to be? And how is it used now? Consider how you might create a counternarrative to those

words or ideas. What behaviors are normal there, or abnormal? How could you situate your body to confirm those ideas or contrast them?

▶ Use clothing, costumes, makeup, accessories, or props as you see fit. Could you use the landscape as a prop? Is there plant life, detritus, or something already on-site that you could rearrange with your body? What are the shapes that exist there? Can your body parallel those shapes or oppose them?

▶ Improvise. You don't need to know what you're going to do before you get there. Play around, be silly, and try lots of different things. See how they look through the camera lens.

▶ Documentation is important. Consider the best way to capture your image, be it photography, video, animation, journal entry, or anything that makes the most sense for your action. And make sure you can get a good sense of the site around you.

▶ Have a good idea but can't bring yourself to do it? Make a proposal describing and illustrating what you would want to do there.

HISTORY AS YOUR GUIDE

Ana Mendieta, Untitled: Silueta Series, *1973, from* Silueta Works in Mexico, *1973–1977, color photograph*

Ana Mendieta (1948–1985) was born in Cuba and came to the United States as an exile at the age of twelve. She and her sister were settled in Iowa, and eventually she began making art. While traveling with fellow students around Mexico in 1973, Mendieta visited the Mesoamerican site of Yágul and embarked on her breakout *Silueta* series. Creating what she called an "earth-body sculpture," she lay nude in an open Zapotec tomb and covered herself in white flowers. Mendieta created another in the series back in Iowa, making an impression of her body in a field of grass. In La Ventosa, Mexico, she made an earth-body sculpture by forming a silhouette on the beach, filling it with red pigment, and letting it wash away. Mendieta took photographs and made films of what transpired, often documenting the traces left by her absent body. Displaced from her homeland and separated from her parents at an early age, Mendieta's actions symbolized, for her, a connection to the earth. Through her art, she found a way to dynamically restore her body's relationship to the world, if only for a moment.

STATEMENT

Dread Scott (b. 1965)

Dread Scott makes revolutionary art to propel history forward. This is the artist's stated mission, which he carries out by posing questions, issuing provocations, and presenting uncomfortable truths to a wide audience. While attending the School of the Art Institute of Chicago, Scott posed the question "What is the Proper Way to Display a U.S. Flag?" in an artwork that was included in a 1989 exhibition. The work consisted of a photomontage on the wall, which displayed the text of the title above an image of South Korean students burning US flags and an image of coffins draped in American flags. Beneath it, a wall-mounted shelf with a logbook invited the audience to write responses to the question. Spread out on the floor in front of the shelf was a US flag, encouraging those so inclined to step on it, but allowing others to contribute answers while standing to its side. The piece was hugely controversial, causing public outcry, protest, and even death threats against Scott. Then-president George H. W. Bush called it "disgraceful" (which Scott considered an honor), and the US Senate voted to ban it. While it was a dangerous time for the artist, the work was ultimately and undeniably successful, having sparked an intense dialogue about freedom, patriotism, and the right to dissent.

In the years since, Scott has created a wide range of works that challenge people to confront systemic racism and injustice. In 2015, after a police officer shot Walter Scott in the back after a traffic stop for a broken taillight, Dread Scott made a banner stating: "A Man Was Lynched by Police Yesterday." He modeled it after a banner displayed by the National Association for the Advancement of Colored People between 1920 and 1938. As part of their campaign to end lynching, the NAACP flew a banner outside of their national headquarters reading "A Man Was Lynched Yesterday" on days following such killings. With the addition of the two words "by police," Scott transformed the meaning of the statement and brought it squarely into the politics of the present. In July 2016, Scott's banner was hung outside of Jack Shainman Gallery in New York, in response to the police killings of Philando Castile

and Alton Sterling. Scott's updated banner draws a direct connection between the role lynch mobs played in the early twentieth century and the role of police today, and serves as a powerful protest to enduring racism and the disproportionate killing of black people by police.

Dread Scott mines the past and shows us how it has set the stage for the present. His artwork ignites often-painful but much-needed conversations about the most important social questions of our time. Scott propels history forward by giving us statements that are difficult to sit with and questions that are not easy to answer.

What is the revolution that you would like to see in the world? And how will you propel history toward it?

Dread Scott, A Man Was Lynched by Police Yesterday, *2015, nylon*

YOUR TURN

Our world is a complex place, and the people we share it with hold a vast array of opinions. Your job is to find what you believe in nevertheless. It's going to involve research, diligence, and a commitment to understanding your world more deeply. It's also going to involve a willingness to plant seeds of doubt, offend, and let your audience sit with uncomfortable ideas. In the end, you'll help others understand an issue from a slightly different angle and see some part of the world the way you see it. A worthy enterprise if ever there was one.

1 Think of a big social question that you care about that affects hundreds of thousands or millions of people.

2 Spend time researching the question, reading books and articles, and/or interviewing direct sources about it.

3 Come up with a statement (or phrase, quote, or question) of twelve words or fewer that identifies, gets to the heart of, or elucidates this big social question in some way.

4 Design a poster, flag, or banner that presents your statement and will enable people to think about your big question in new or unconventional ways. If you want to, you can add an image to the text, but it is not necessary.

TIPS/CHEATS/VARIATIONS

▶ Your research can take a lot of different forms: watching the news, reading books and articles, listening to podcasts, and/or engaging in discussions with other people. Get to know the issue deeply and understand why it is a contested question. Know thine enemy, and use their arguments against them.

▶ In the wise words of Emily Dickinson: "Tell all the truth but tell it slant." Don't just come out and say the idea directly. Figure out how to

say it in a way that others might not, taking it a step further or altering a common statement in an unexpected way.

▶ Don't be a jerk, but do be willing to offend people who you feel need to be offended. The cultural heroes of today who led the civil rights movement in the 1960s offended many people at the time.

▶ Try several approaches when determining the design and materials for your message: digital or physical, brightly colored or plain, shouting or quiet, large or small, or points in between. Pay attention to how your issue has been communicated historically. Consider pulling an aspect of that into the work, through writing style, design choices, or format.

▶ If you decide to include an image, don't use the first one that pops up in an image search. Find the one that is resonant to you, concentrates your issue, has tension in it, or is even incongruous with your statement.

▶ Afraid you're just preaching to the choir? Sometimes the choir needs to be preached to in order for them to effectively carry the message to others. Frame an issue in a way others might not think to say it. Travel a little bit outside of the choir's comfort zone, and bring them along with you.

▶ To share or not to share? That's up to you. Whatever platforms are at your disposal, consider whether and how your statement might be activated. Whether it lives in an art show or out in the world, consider the context when landing on your design and materials. Your statement can exist in several forms, and it can be adapted as situations, and new historical events, present themselves.

MEASURING HISTORIES

Sonya Clark (b. 1967)

In 2005, when textile artist Sonya Clark set about making a self-portrait, it seemed logical that she should use her own hair as raw material. Clark had used hair in her work before, calling it "the fibers we grow," and explored the head and hair as both an avenue for self-expression and also as a site where we negotiate gender, age, and race. In Clark's view, hair is already a self-portrait since it contains DNA, carrying with it not only essential information about an individual, but also the long legacies of our ancestors. So Clark decided to start saving all of the hair that she combed out of her brush and began felting it into a single, off-body dreadlock. She continued adding to it until it reached sixty-seven inches, a number that corresponds to her height, and also her birth year of 1967.

When Clark was working with a photographer to document what she'd made, she began to wonder how long a dreadlock would be if it didn't just measure her height or arbitrary birth year, but instead measured a lifetime. How long would a dreadlock be if someone grew one from infancy until, say, age ninety? Clark did the calculation and created a digital print that multiplied the original dreadlock image and stitched it together digitally to form one continuous dreadlock measuring thirty feet. She presented the print by unfurling it from a scroll, and also folded the lengthy image accordion-style and bound it into a book. It is a difficult task—impossible even—to grasp what an entire lifetime might feel like. But with this work, Clark explores what a lifetime might actually look like as if it were manifested in hair.

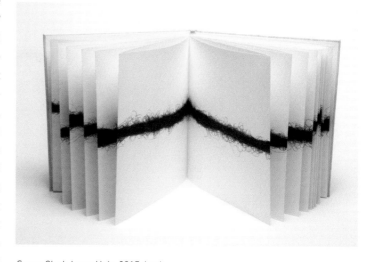

Sonya Clark, Long Hair, 2015, book

Clark put to use the strategy of measurement once more in 2016. Living at the time in Richmond, Virginia, Clark had begun to think about the city's history as the seat of the Confederacy, and also about Ghana, the area in West Africa where millions of people were enslaved and brought to the Americas. She measured the distance between Richmond and Accra, Ghana, and found it to be a little over five thousand miles. It is a vast distance to conceive of, and it is difficult to even begin to imagine the experience of traveling it in the hold of a ship, shackled to other people. She decided to measure the distance in gold, after Ghana's former name, the Gold Coast, given by European colonizers interested in the area for its natural deposits of gold as well as its slave trade. Clark took five thousand inches of gold wire, an inch for every mile, and spun it carefully around a spool made of ebony, the dense, dark wood usually found on the continent of Africa. It was a way of quantifying a distance and an experience that seems utterly unfathomable, and a reminder of the economic motivation that led to the treatment of people as a commodity.

Measurement has become a way for Clark to understand an idea just a little bit better, not to apprehend it completely. By giving form to a measurement and putting it out into the world, Clark offers others the chance to better understand it, too.

Sonya Clark, Gold Coast Journey, *2016, 18k gold and ebony*

YOUR TURN

So many things in life are unfathomable, but that doesn't mean we shouldn't try to fathom them. What part of your life, family, community, or world would you like to understand a little bit better? Whether lingering or long past, local or global, shared or deeply personal, that history deserves your consideration, estimation, and attempt at visualization. In the process, you're going to learn more about yourself, and you're going to find something about yourself that you can extend to others. What better reason to make art is there?

1 Think about an aspect of your personal or cultural history that you want to share but is difficult to imagine or conceive of.

2 Help someone understand this by selecting a material that will quantify, measure, bring to fruition, or actualize what that history is.

Or, do the reverse:

1 Take an action, something that you normally do, and the materials that you're most comfortable working with, and do that something as long as you can.

2 Then measure it, and figure out how that measurement lines up with something from your personal or cultural history.

TIPS/CHEATS/VARIATIONS

▶ This might not be one that you do in one day. Give serious thought to what the aspect of your history might be, write down your ideas, and let them marinate for a while. What do people not know about you? What forces, large or small, have shaped your life? What are the histories that you have been victim to or complicit in? Consider an aspect of your life or world that you'd like to know better.

▶ When you start to home in on the history that interests you, do your research. If it's from your personal history, look through old journals and photo albums, interview family members, and consult genealogy resources. If it's a larger topic, read about it deeply, and keep your eyes open for numbers and ways that history has been quantified. How long was the Trail of Tears? How many people were transported along the Middle Passage?

▶ Seek out a fact or single detail of that history that is particularly poignant or resonant to you. How many people in your family can you name? What is the distance between your house and your grandmother's? Sometimes an issue is too big to grasp, like climate change, but a small aspect of it is measurable, like the movement of the coastline in your town.

▶ Think about the materials that have been part of the history in question, or the colors or shapes that connect to it in some way. What is a material that you are intrigued by or like to work with? Consider inversions of scale: if the quantity you are measuring is large, think about small things that could measure it; if the quantity is small but still meaningful, use large objects or materials to actualize it.

▶ If the first strategy isn't working, do what you know. If you knit, knit for as long as you can in one sitting and see what that length corresponds to. If you paint, see how long a continuous brushstroke you can make. How long did it take you to make it? How long would it take to fill an entire page with marks? If you play the trombone, calculate how long it takes to exhaust your breath. What else happens in that amount of time? Measure how long you spend looking at a screen in an average day. What else could you do for that length of time?

▶ If your idea is going to take a while to execute, let it take its time. A sixty-seven-inch-long dreadlock doesn't form in a day.

HISTORY AS YOUR GUIDE

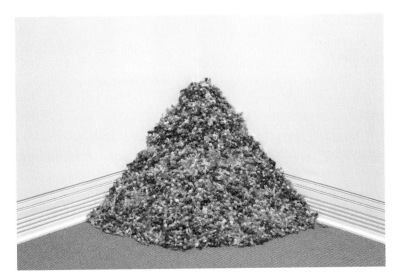

Felix Gonzalez-Torres, "Untitled" (Portrait of Ross in L.A.), *1991, candies individually wrapped in multicolored cellophane, endless supply. Ideal weight: 175 lb.*

Felix Gonzalez-Torres (1957–1996) made a series of works informed by the Minimalist strategies of artists like Carl Andre, who created simple arrangements of everyday materials like bricks. Gonzalez-Torres selected materials that look similarly out of place in an art gallery, individually wrapped candies, which he spilled onto the floor and spread into geometric shapes or mounded into a corner. For *"Untitled" (Portrait of Ross in L.A.)*, the ideal weight of the amount of candy is listed as 175 pounds, which can be understood to have a relationship with the body weight of his longtime partner, Ross, who died of AIDS-related complications the year the piece was made. The audience may choose to take a candy if they like, causing the pile to dwindle over time, much like Ross's body, which was gradually depleted by the devastating disease. In taking from the pile, you savor something sweet and ephemeral, and open up a number of potential associations and allusions: to the body of Christ, the millions of lives abbreviated by AIDS, the drugs used to treat it, fears of contagion, and our own complicity in the continuing epidemic. Gonzalez-Torres's works can be seen to measure a history both personal and monumental, and create a powerful demonstration of both presence and absence.

PSYCHOLOGICAL LANDSCAPE

Robyn O'Neil (b. 1977)

To look at a drawing by Robyn O'Neil is to get lost in an alternate universe. Many, if not all, of the elements are drawn from life—mountain ranges, trees, animals, little men in sweat suits—but they are otherworldly nonetheless. Rendered in graphite on paper (with occasional appearances of oil pastel), O'Neil's drawings bring together the conventional elements of a landscape, but in unconventional ways. Above a rollicking seascape, a tiny figure dangles from a suspended wire. A snowy mountain landscape looks almost realistic, save for the unnaturally symmetrical arrangement of its trees and figures. Tree stumps float in the sky above a field, along with neatly coiffed, detached heads and floating armies of identically dressed figures with fists raised against each other.

The scale and scope of O'Neil's drawings are epic, and their effect ranges from ominous to ethereal to apocalyptic. She plays with the placement of the horizon line, the direction and dispersion of light, and the scale of figures in relation to each other. A variety of mark-making techniques are deployed within a single drawing, contrasting heavily worked, detailed areas with loosely described expanses of space. These elements come together to create worlds in which rough narratives may begin to form, but where anything might happen.

O'Neil's drawing practice pulls from many sources, from cave painting to pre-Renaissance symbolism, Mayan creation mythology, and her childhood spent making oil paintings of Vermont scenery with her grandmother. She has synthesized these disparate approaches with a flood of imagery derived from her notes, observations, research, and active imagination.

Over time, she has learned how to masterfully construct a landscape that not only compellingly describes its subject matter but creates a mood: a pervasive sense of unease, mystery, possibility, and dread. What is the psychological state of mind that you might like to communicate? And how might you achieve it?

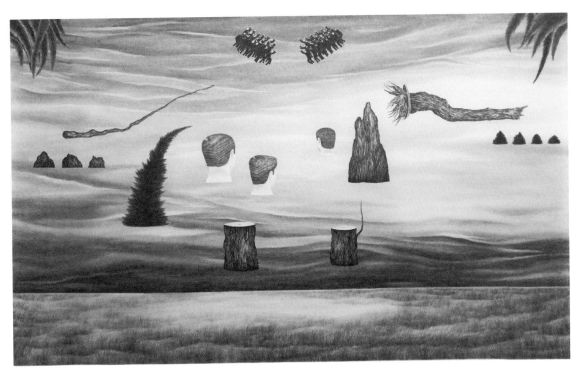

Robyn O'Neil, A Dismantling, *2011, graphite on paper*

YOUR TURN

Representing the world around us is a basic human impulse, as is evidenced by the earliest paintings we've discovered in caves. And from childhood, we learn to draw a line on a piece of paper, put a lollipop tree in front of it, and call it a landscape. But how do we learn to expand from there, adjusting and adapting the basic elements of a picture to infuse it with feeling?

1 Get a piece of paper, any size, and something to draw with.

2 Set the stage by creating a ground (a.k.a. the background), be it a grassy field, an ocean wave, the inside of your brain, or the plain surface of the paper.

3 Populate the ground with figures (animal, vegetable, mineral, or otherwise) and give them human characteristics.

TIPS/CHEATS/VARIATIONS

▶ Discard your drawing fears. The point is not to create photographic likenesses. Put pencil to paper anyway and give it a try. Use source images, or cut out figures from a magazine. Or trace your images. There is no such thing as cheating.

▶ Pay attention to the horizon line. One near the center tends to have a calming effect. A lower horizon line gives you a lot of room to work with the sky, and a much higher one gives you more space to play below.

▶ Consider a reductive approach. Use graphite or charcoal to fill the page with markings, and then erase to create your horizon line and selectively remove areas to set the mood. Then add figures over the top.

▶ Think about perspective. Is your viewer looking out from above or up from below? Are the figures to be far away in the distance or very close

to the viewer? Or do you want to ditch perspective and stack many stories and views on top of each other?

▶ Where are the expected places for the figures to be? How might you play with those expectations?

▶ Feeling stuck? Look up random image-search terms on the internet, like "ugly living room," "Dolly Parton," or "Vermont." Join two things you love, like a beachscape + your favorite comedian. For inspiration, watch your favorite show, read a book, take a walk, or sit outside and drink some tea.

▶ Give it a title, at either the beginning or the end of your process. This can help determine your direction (*Taco*) or expand on the meaning of what's already there (*Miserable Hawaii*). (Both real Robyn O'Neil titles.)

QUESTION THE MUSEUM

Güler Ates (b. 1977)

Güler Ates moved to London for the museums. She grew up in a rural area of eastern Turkey and remembers visiting Istanbul's Topkapi Palace as a child. It was filled with objects from the Ottoman Empire, but the palace's rooms, glass cases, and spotlights stood out in her mind more than its contents. When Ates went on to study architectural drawing and fine art in Istanbul, she admired the many accomplished paintings on view at the Museum of Painting and Sculpture but noticed that most seemed to be made by artists either from France or working firmly in the Western European tradition. During her first trip to London at the age of eighteen, Ates's visit to the National Gallery was a revelation. Surrounded by masterpieces by Cézanne and Van Gogh that she'd only seen in books, Ates felt like she might faint. She wanted to touch the paintings but refrained, and instead jumped up and down embracing her equally excited friend. The two talked about their experience for days and hatched a plan to return to London permanently.

Soon after, Ates did make her way back to London to pursue a degree in painting and found a job as a gallery assistant at none other than the National Gallery. Spending entire days in just one or two of its rooms, Ates got to know the collection well. Her education came not just through looking at the art, but through talking with the docents, curators, art historians, and visiting artists who frequently passed through. Ates asked questions, attended talks, and mined the resources of the museum's library and bookshop. As her familiarity with the museum grew, so did her questioning. Did the layout and arrangement of the galleries make sense? Were the museum's renovations truly "improvements"? Ates wanted to know more. When was the building constructed? By whom? With what money? As she studied art history in the galleries and at school, Ates wondered about the way the East was represented in art and architecture. Where did she fit into this history?

Ates's inquisitiveness extended into her work as she began to practice as an artist. When invited to create new work at London's Leighton House Museum in 2010, Ates was intrigued by the highly

distinctive Victorian-era building. The former home and studio of the artist Frederic, Lord Leighton (1830–1896), the house contains a dizzying array of styles. Quintessentially Victorian art and furnishings are nestled among architectural elements and decorations from Italy and the Middle East, including an "Arab Hall" with intricate mosaics and a golden domed ceiling. In her research, Ates learned that Lord Leighton would bring models into his home to pose for paintings, only allowing them to enter through a secret back door. During her residency at the museum, Ates brought in a model of her own to perform (through the front door), directing the model to inhabit its rooms both naked and draped in fabrics. This lone, mysterious figure hinted at the building's past and prompted visitors to inquire about what histories might be hidden in the home's elaborate decoration.

Since that time, Ates has been invited to explore a number of museums, collections, and libraries. Each time she works with a model and suitcases filled with fabrics to inhabit the spaces with a lone, ambiguously veiled figure, whom she photographs using only natural light. The figure's identity is concealed, but her presence activates and enlivens each space, provoking visitors to ask questions about our museums, expose their dormant histories, and reveal less visible aspects of the present.

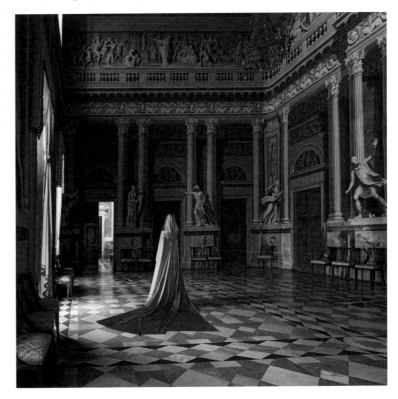

Güler Ates, Woman in Castello di Govone, *2018, archival digital print*

YOUR TURN

A museum is much more than its contents. Ates offers us a guide for exploring these institutions beyond the art and objects they display, encouraging us to think critically about these important but flawed keepers of our cultural heritage. With this assignment, you're asked to take on the role of astute and perceptive skeptic. Suppress the urge to be a passive beholder of beautiful objects, and question the entire organism that is a museum.

1 Visit a museum, gallery, or collection, and spend time exploring its spaces.

2 As you walk around, look carefully and ask yourself these questions:

- What purpose does the museum serve for its visitors?
- Who founded the museum? What is its stated mission? Is it accomplishing that mission?
- What style is the building? From what era? Who was the architect?
- Is there only one way to navigate the galleries, or many?
- How is the collection displayed? Why are certain objects grouped together? What is their connection to each other?
- How tall are the ceilings? What kind of lighting is there? What color are the walls? Is there seating? Where are the stairwells, water fountains, bathrooms, and exits? How does the design of the galleries make you feel?
- Focus on one object and find out where it came from. Who made it? What was its purpose? Was there any influence from other cultures? Imagine the journey of this object through time. How many owners has it had? How did it arrive at the museum and when? Can you find it mentioned in the bookshop or library? Is there a postcard of it?
- Where are the ticket desk, coatroom, bookshop, education center, and café, if they have them?
- Who funds the museum? How are sponsors acknowledged?

3 Think about these questions during your visit and after. With time, you will find the answers.

TIPS/CHEATS/VARIATIONS

▶ There are a lot of questions, but you can feel free to focus on just one or two that are particularly intriguing. Allow that question or two to guide your entire museum visit. If you are able to return to the same museum multiple times, divide the questions among a number of visits.

▶ Many museums are not free. Research in advance to see if you qualify for discounted pricing. Some museums have free admission days or times that you can plan your visit around. Bike to the museum or take public transportation to avoid parking costs. Skip the café and pack a lunch or snacks that you can check into the coatroom.

▶ The people who work in museums are there to help you. Seek them out and ask them questions. You'll be surprised by the wealth of information they can share. See if there is a free tour you can take, or ask in the library or bookshop for guidance on your research topic.

▶ What do the labels and gallery signage not tell you that you'd like to know? Let that be your jumping-off point for further research, be it in the galleries, in the library, or online.

▶ Bring a pencil and paper to take notes, or use a camera to take visual notes, recording architectural details, labels, signage, and objects. Check the photo policy first to make sure it's allowed, and never use a flash. Alternately, hold the questions in your mind and walk through the museum free-handed, sitting down afterward to record your thoughts and findings.

▶ This can be a great activity to do with a group or class. Descend on the museum with these questions on hand, disperse to explore them separately, and come together at the end to discuss your findings. Educators can ask students to write a paper or give a presentation about their object of focus. Or the questions can be divided among the students to be researched separately or in groups. Then each group can present their findings and the class can consider the answers to these questions together.

▶ Don't stress if you can't find answers. Sometimes the asking and the seeking is enough.

EMOTIONAL FURNITURE

Christoph Niemann (b. 1970)

Christoph Niemann has spent his life drawing. As a kid, he would compete with his brother over who could make the better drawing. The equation was simple: the more details and highlights, the better the drawing. It wasn't until Niemann went to art school and was exposed to Modernism that he realized the key to great art is sometimes withholding information. Conveying an idea successfully is often about including only the details that are absolutely necessary.

In his work as an artist, author, illustrator, and animator, Niemann applies this lesson consistently and with aplomb. In the wide range of art he has produced on assignment, as well as the drawings, books, and apps he makes independently, Niemann has honed his craft of including just the right amount of information. For his project *Sunday Sketching*, he begins with an object you might find around your house, places it on a blank sheet of paper, and makes a drawing around it. A baseball player's outstretched arm extends from a halved avocado, transforming it into a ball and mitt. Two bananas joined at the stem metamorphose into the hindquarters of a yellow horse. Each of these feats is accomplished with the careful application of ink—only as many markings as will communicate the idea, and not one more.

These operations are deceptively simple but made possible by considerable amounts of experience and experimentation, as well as frustration and perseverance. Niemann deploys techniques he's learned over time, like the power of scale and juxtaposition. By putting an object into context with other objects, he creates tension and tells stories. He has learned that the human face, while an incredibly effective tool for communicating emotion, can also be limiting, so captivating that you don't see anything else. Through inanimate objects, Niemann orchestrates high drama and conveys profound emotion.

How might you apply some of this Niemann magic to your own life, tapping into the emotive and expressive potential in the most everyday bits of the world around you?

Christoph Niemann, Sunday Sketch
(Horse), *2017, offset print*

YOUR TURN

You are the director of a drama, and your actors are pieces of furniture. Scan the objects that populate the rooms you inhabit and consider them anew. What emotions might they convey, either alone or through their juxtaposition with other objects? Then get moving, arrange and rearrange your furniture, and see what theatrics unfold before your eyes.

1 Arrange furniture in three different ways, conveying three distinct emotions:
 - envy
 - melancholy
 - confidence

2 Take three photographs, each documenting one arrangement.

TIPS/CHEATS/VARIATIONS

▶ These emotions aren't clear-cut. Envy can be benignly aspirational or excruciating. Confidence can be happy and positive or overwhelming and obnoxious. Consider what these terms mean to you. Ask yourself: What are the visible or physical components of this emotion? Is it big or small? Is it one or many? Sketch or write about your thoughts, and prime yourself to see these arrangements in front of you.

▶ Don't add faces to your furniture. No filters, and no type. You can lean your furniture, stack it, turn it upside down. Use scale and juxtaposition. Experiment as you photograph the arrangement, adjusting your angle to the objects and distance from them.

▶ Consider the background of your scene and move away any objects that distract from the emotion. Move the furniture to a different space if you need to. Lighting will affect the emotion your objects convey as well. Try not to rely on dramatic lighting to communicate the emotion.

▶ Try the assignment with smaller objects, like office supplies, kitchen implements, lamps, food items, houseplants, shoes, or little decorative objects (but nothing with a face). Dollhouse furniture works, too!

▶ Test out your arrangements on an audience and see if they work for them. Share them on social media, or show them to a coworker, friend, or little sister. They don't see it? Try it again!

▶ Devise your own list of emotions to convey: vexation, bliss, exhaustion, excitement, centeredness, disgust, satisfaction, terror, loneliness, shame, pity, love. Make up your own, or ask someone else to make a list for you.

RESPONSE

Christoph Niemann's Emotional Furniture, 2014

Envy

Melancholy

Confidence

LOST CHILDHOOD OBJECT

Lenka Clayton (b. 1977)

What if you were asked to create "one brown shoe" using materials you have around the house? What image pops into your mind? How would you create it? As it happens, that is not the assignment Lenka Clayton is giving you (although it is a good one), but it is one she has given before. In 2013, Clayton asked one hundred married couples to make brown shoes, each partner creating theirs separately and without discussing or sharing materials or plans. When they were finished, the couple revealed their shoes to each other and brought together a mismatched pair.

This single, straightforward prompt yielded wildly disparate responses. When participants envisioned "one brown shoe," they each summoned a clear mental picture of what that would be, which was almost always dissimilar from their partner's clear mental picture. Together, the pairs of shoes form a portrait of a marriage and tell a story of how distinct individuals come together to create a partnership. The scraps of materials that were joined together to create the shoes were unremarkable in many ways, but became meaningful in their juxtaposition and in the act of imagination they embody.

Clayton is known for her ability to suss out this kind of poetry in the most mundane objects and situations. She began a collection in 2014 titled *Spared Tyres*, of nails, screws, staples, and any sharp objects that she spots and retrieves from any road. And in 2015, Clayton gathered every object from a ShurSave supermarket in Pittsburgh that could be described as being a perfect sphere, including an orange, a turkey meatball, and a mothball (*Perfect Spheres from the Supermarket*). Beyond identifying humble objects and drawing them into connection with others, Clayton facilitates exchanges that bring new objects into being, such as *One Brown Shoe* and her 2017 project *Sculpture for the Blind, by the Blind*. For the latter, she invited people who identified as blind or visually impaired to listen to her description of Constantin Brancusi's *Sculpture for the Blind* (1920) and make their own version of it based on their interpretation of her description.

Our assignment is a similar kind of invitation—one that asks you to create an object based not on any visual information, but upon someone else's memory and verbal description. Clayton devised this prompt for a class she taught at Carnegie Mellon University, when it was early in the semester and the students didn't know each other very well. The prompt led them directly into a deeply personal discussion and exchange. By doing this assignment yourself, you will generate an object that may be humble, but that will also be a radical act of generosity and imagination.

Lenka Clayton, One Brown Shoe *(pair number 84, Terry Jackson and Chantal Deeble), 2013*

YOUR TURN

Two acts of making are going to happen here: the first in your mind, and the second with physical materials in real space. Get ready to listen closely, ask good questions, and let your imagination fill in any gaps of missing information. You'll take small threads of information and extrapolate them into an entirely new being, and be reminded that all art-making is a kind of gift-giving.

1 Interview someone about an object they owned and cherished as a child. Ask questions to understand its dimensions, material, texture, and form. Create a mental picture of that object.

2 Re-create the object as closely as you can using materials you have on hand.

3 Give the object to the person.

TIPS/CHEATS/VARIATIONS

▶ This works brilliantly if done in pairs, where two people interview each other about their lost objects and eventually have an exchange. However, it can still be an excellent one-way exercise. Consider it a lovely way to give someone a gift without spending any money.

▶ Ask a friend, family member, partner, or someone you've only just met. This could be a fantastic icebreaker for any new relationship, or for a classroom full of strangers.

▶ Interview the person in depth, and ask more questions than are necessary, beyond colors and materials. How heavy was it? Can they demonstrate its size? Who gave it to you? Or where and when did you make it? Where did you keep it? How did you use it? Where was the last place you saw it? Where did it go?

▶ When Clayton first issued this assignment, she didn't allow her students to take notes. They relied only on their memory and the mental image formed during the description. You can decide whether you want to do it this way, or take notes or record audio when the object is described.

▶ Take care to make the best object you can, and don't be afraid to try out new materials and techniques. The objects should look handmade, not perfect. Use old towels, cereal boxes, tape, string. Try sewing for the first time or using ceramics. Age the objects if need be by sanding them or dyeing them with tea.

▶ If you're doing this as a pair, make an event of your object exchange. Wrap or package it for the person. Have some refreshments. Open it at the same time, and then talk about how it differs from the original object. Take time to observe and appreciate the object you receive.

▶ This can be done from afar, whether over a phone or video call or through written communication. Have the person send you a written description of their lost object and then send it to them. If you can't send the actual object, take a picture and share it with them that way.

RESPONSE

Lenka Clayton's re-creation of Sarah Urist Green's lost childhood Lego house, 2015

Sarah Urist Green's re-creation of Lenka Clayton's lost childhood stuffed bear, 2015

SIMULTANEITY

Beatriz Cortez (b. 1970)

Beatriz Cortez found herself experiencing déjà vu as she looked out over the city of Los Angeles from the hiking trails of Griffith Park. She was instantly reminded of the similarly panoramic view of her hometown of San Salvador, El Salvador, from Los Planes de Renderos. Although the two cities looked nothing alike, Cortez paid attention to her profound sensation of simultaneity, or being in two places or moments in time at once. She began noticing the feeling in other parts of her life and exploring the concept in her work. Simultaneity emerged as an aspect of not only her own experience of migration, but also as something able to be experienced by anyone as they make sense of the world in two or more languages, or translate two or more technologies or cultural frameworks at once.

As part of her 2016 exhibition *Nomad World*, Cortez collaborated with Mauro González to create an interactive sculpture from a repurposed jukebox. A technology firmly of the twentieth century, the machine was originally designed to pull CDs from storage to play in its console. Cortez and González reworked the jukebox so that instead it plays sounds recorded digitally by Cortez during her travels through San Salvador. She edited each recording to a duration of one minute and programmed the machine to play the sounds of different landscapes, labeled with single words like "Rain," "Circus," "Parrots," "Fire," "Burial," and "Coffeeshop." *The Jukebox* allows older and newer technologies to coexist, and also invites viewers to enter into their own places of simultaneity, spurring the imagination, transporting them to other worlds, and evoking places they have visited in the past.

All of the works in the exhibition playfully blended technologies, geographies, and temporalities, including *The Photo Booth*, which allowed visitors to take a selfie in front of backdrops of various Central American locations. In this way, she invited the viewer to become part of her work and to imagine being in two places at once. For *The Beast*, Cortez rebuilt a pinball machine from the 1980s called Black Pyramid with newer Arduino technologies (circuit boards and software for coding

and programming). She also repainted its surfaces with lacquer markers, inserted freehand drawings of immigrants on a train, and turned its numbers into numbers of deported at given places and times. Combining multiple technologies and narratives, Cortez's reimagined machine is new and old at the same time.

Cortez's *Nomad World* is a space where anyone can access the experience of simultaneity, allowing travel back and forth through space and time, and offering glimpses into the fractured reality of migration and dislocation. She takes advantage of the remarkable power of imaginative play and provides ways to envision alternate presents and invent possible futures.

Cortez now invites you to make your own version of a jukebox. The recordings you make will become portals to other dimensions, capable of evoking the past and triggering powerful experiences of simultaneity.

Beatriz Cortez, The Photo Booth *(2016), in the foreground, and* The Jukebox *(2016), in the background, in* Nomad World *at the Vincent Price Art Museum*

YOUR TURN

We are surrounded by sounds, many of which we hardly notice but nonetheless define the place where we live. When it's safe to do so, close your eyes and pay careful attention to each of the sounds that surround you. Try to imagine what that sound, once removed from this landscape, might evoke for listeners in other contexts. Some sounds might be too common to evoke experiences of simultaneity, while others might have unique potential to transport your listeners to other worlds and other moments in time.

1 As you move around your day, pay attention to the sounds that surround you or visit specific places in order to hear the sounds that you want to collect.

2 Record the sounds that you think could function as portals to other dimensions.

3 Edit each of your recordings to be no longer than one minute.

4 Label each recording with a single word, in order to allow others to imagine these sounds as part of other worlds, beyond the specific places they were recorded.

TIPS/CHEATS/VARIATIONS

▶ If you can't physically go to the place where you want to capture a sound, try to re-create it. What elements or objects might you be able to use to remake the sound that you miss, or a sound that no longer surrounds you?

▶ What are some of the sounds from your childhood that you might want to hear again? How might you be able to capture those sounds? If it's an option, enlist a family member or friend who lives in that place to record and send you a sound that you miss.

▶ Seek out places you don't normally visit. It might open up the possibilities to record interesting soundscapes for your project.

▶ Watch a movie with your eyes closed and try to imagine the landscape that the sounds that are part of the film's soundtrack evoke. Let the experience give you ideas for your own collection of soundscapes.

▶ Think about how you'd like to store your recordings and share them with others, whether it's through an online platform or as a physical object. You could offer your sounds as a podcast, or as a playlist on a music-streaming platform. Perhaps you'd like to consciously use older technologies and create a vinyl record, burn your sounds to a compact disc, or load them onto a USB drive. Maybe you'd like to design and build your own machine that plays them on demand.

INTIMATE, INDISPENSABLE GIF

Toyin Ojih Odutola (b. 1985)

Toyin Ojih Odutola's hands are intimate and indispensable to her. With them she has made countless drawings, from when she was a child sketching her favorite character, Timon from *The Lion King*, to today, when she fills galleries with her striking and intricately detailed portrait drawings.

Ojih Odutola immigrated to the United States from Nigeria at the age of five and moved around during her childhood, from Berkeley, California, to Huntsville, Alabama. Drawing became a constant in her life and a way to create a concrete reality that she could claim as her own, despite the seeming precariousness of life around her. As Ojih Odutola grew older, she evolved her own distinctive drawing style, inspired by influences ranging from manga comics to the works of John Singer Sargent, Elizabeth Catlett, Charles White, and Kerry James Marshall.

For her earlier drawings, Ojih Odutola put to use ballpoint pen to build up a dense network of marks that describe the bodies and skin of her subjects—often herself, her family, and her friends. More recently, she has expanded to a wider variety of materials, including chalk pastel and charcoal, creating vibrantly hued, larger-scale drawings that tell the story of two fictional Nigerian families. Consistent in her work is the rich, textured elaboration of black skin, achieved with numerous materials and marks and tones.

The process that brings these drawings to life is often laborious, and Ojih Odutola often finds herself clenching and unclenching her cramping hand. While she has depicted herself numerous times in past work, in 2014 she set about focusing on her hand alone. First, she photographed her hand in various stages as she clenched and opened it, and then used the photos as references to create a series of five drawings. Ojih Odutola then scanned the drawings and pieced them together into an animated GIF, which displays the individual images in quick succession. When looped, the drawings resolve into a continuous clenching and opening of her fist—an image both powerful and meditative.

Ojih Odutola considers her hands to be the primary instruments that move her forward in life. Her prompt asks you to find and describe the equivalent in yours. You'll not only identify something meaningful in your life but also better understand how we tell its story, breaking a narrative down into still images and knitting them back together again.

Toyin Ojih Odutola, Undoing *(still from animated GIF), 2014, pen on paper*

YOUR TURN

Lean into your existing skills and interests to adapt this assignment to your strengths. Ojih Odutola is a masterful draftsperson, but perhaps you love digital animation, painting, photography, origami, or Claymation. And making a GIF is easy, I promise. There are millions of them on the internet for a reason.

1 Think of something intimate that is indispensable to you.

2 Depict it in the form of an animated GIF or looping-image format of your choice.

A DEFINITION GIF

/gif/ or /jif/, noun

Acronym for Graphic Interchange Format, a lossless format for image files that supports both animated and static images. An animated GIF combines multiple images into a single file, displaying them in succession to create an animation or short video. A GIF can be formatted to loop.

in use: "Did you see the GIF of the cat playing the keyboard?"

TIPS/CHEATS/VARIATIONS

▶ Your intimate, indispensable thing can be anything: an object, place, person, problem, memory, or idea. It can be visible or invisible. Peruse your room, house, or office, paying attention to the things you do, say, or rely on, in the course of a day. Sift through photos, notes, or journal entries. Ask someone who knows you well to brainstorm with you.

▶ Once you decide on your subject, think about how it moves or can be brought to life. If you've chosen a drumstick, show it beating on a table

(or, er, drum). If you love the way your friend rolls their eyes, give us a forever-looping eye roll. If your subject is your steadfastness, think of a metaphor like scissors standing up to a rock that wants to smash it.

▶ Remember that your images are to loop, so consider how that might affect what you choose or how you articulate the idea. Think about how long of a sequence will best capture your idea.

▶ Don't know how to make an animated GIF? Look up a tutorial online or download an app that will guide you through it. It's not hard. You can do it.

▶ It's the future and people don't make GIFs anymore? Make a short video, film, or whatever kind of ingenious moving pictures people are making these days.

▶ Don't want to bother with technical stuff? Make a series of still images and bind them together into a flip book. Or display your still images in succession.

WHAT IS BLACKNESS? IT'S WHATEVER I MAKE IT. WHAT IS BEING A WOMAN? IT'S WHATEVER I MAKE IT. AND THAT'S THE BEAUTY OF BEING AN IMAGE MAKER. YOU CAN DO WHATEVER YOU WANT. YOU CAN CREATE WHATEVER YOU WANT. AND IT'S ALL IN THE REALM OF HOW VIVID AND BROAD YOUR IMAGINATION IS.
—TOYIN OJIH ODUTOLA

EXPANDED MOMENT

Jan Tichy (b. 1974)

When Jan Tichy began combing through the nearly eleven thousand images that form the collection of the Museum of Contemporary Photography in Chicago, he started to recognize a large number of photos from a project called *Changing Chicago*. Launched in 1987, the large-scale initiative commissioned thirty-three photographers to document the life of the city from numerous perspectives. More than two decades after those images had been captured, Tichy felt compelled to respond to them. The museum had invited him to explore their collection and create an exhibition around it, and among other interventions, Tichy set about making himself a part of *Changing Chicago* in his own way.

Tichy was born in Prague, Czech Republic, and lived in Israel before moving to Chicago in 2007, to study and eventually teach at the School of the Art Institute of Chicago. In the five years he had lived in the city, Tichy had created a number of works exploring aspects of the city's built environment, including the John Hancock Center, Mies van der Rohe's Crown Hall on the Illinois Institute of Technology Campus, and the Cabrini-Green public housing complex. In 2011, he illuminated rooms of the last remaining Cabrini-Green high-rise during its final days before demolition, with lights blinking in patterns that corresponded to the pace of poems written by former residents.

When thinking about his response to *Changing Chicago*, Tichy opted to work with video instead of conventional still photography. He trained his lens on a variety of scenes around the city: an empty street just after a neighborhood parade, a section of wall bordering the Cook County Jail, and a section of the stands at a White Sox baseball game. His camera remained stationary, while the scene changed in ways large and small. In one video, we see a view of the Lake Michigan shoreline from high up in an adjacent tower, observing the skyline's shadows as the day progresses and they shift gradually across the frame. In another, Tichy documents the Englewood intersection that had been identified as the most violent spot in the city. It was calm at

the time, with a few people walking by now and then, going about the business of daily life.

In contrast to the original photographs of *Changing Chicago*, which capture what happens in a split second, Tichy's images tell the story of what happens over time. His Chicago was changing as the decades passed but also moment by moment, full of millions of narratives unfolding simultaneously and continuously. With this assignment, Tichy encourages you to add your perspective to the places you bear witness to every day. You're asked to capture not a single moment but an expanded one.

Jan Tichy, Changing Chicago (Sox) *(still), 2012, video installation*

YOUR TURN

You'll need to suppress your photojournalistic tendencies here and willfully ignore most of the weighty history of photography. This is about capturing the nonmoment. Not the iconic, quintessential image that perfectly encapsulates a place or subject or era, but all of the imperfect, banal moments that happened before or after that one.

1 Find a place with the potential for visual movement.

2 Place your video camera on a stable object, or attach it to something, and build the frame.

3 Record at least two minutes of footage without moving the camera, without sound.

TIPS/CHEATS/VARIATIONS

▶ The movement you record need not be extreme. The rustling of leaves or the changing play of light may be all that you're looking for. Alternately, consider a place that people or things move through: a hallway, sidewalk, museum, or cemetery.

▶ A tripod is really helpful with this, but you can be clever in stabilizing your camera. Make a stack of books it can sit atop, use rubber bands or string to tie it to something stable, or place it on the floor. Holding the camera in your hands probably will not work. A shaky camera, however slight, can really ruin this. If your first shot is unstable, try again.

▶ Take care in composing your frame. Think of it like a painting: Where is the horizon line? Where do you want the fixed objects to be? What do you want to see, not see, or only show a hint of? Consider camera angle and whether you're facing the scene from above, below, dead-on, or at a subtle or extreme angle.

▶ Find the movement to record, or stage it yourself. Set up the camera, and then make the action happen.

▶ It's likely that you'll need to record with sound, but you'll need to remove the audio in creating or sharing your final file.

▶ Return to the same spot at a different time and repeat the exercise, whether it's later in the same day, a few weeks later, or five years later. What is the same? What has changed?

HISTORY AS YOUR GUIDE

Photographer Henri Cartier-Bresson (1908–2004) published his first book of photographs in 1952 with the French title *Images à la sauvette*, which translates roughly to "Images on the Run." The title chosen for the English edition, however, was *The Decisive Moment*, drawn from a quote by Cardinal de Retz in the book's preface: "There is nothing in this world that does not have a decisive moment." The book contains a selection of Cartier-Bresson's iconic early works, made before World War II around Europe and in Morocco and Mexico. He describes his early days as a photographer, prowling "the streets all day . . . determined to 'trap' life . . . [he] craved to seize, in the confines of one single photograph, the whole essence of some situation that was in the process of unrolling itself before [his] eyes." The images demonstrate his signature style as well as his philosophy: "photography is the simultaneous recognition, in a fraction of a second, of the significance of an event as well as of a precise organization of forms which give that event its proper expression." Cartier-Bresson's approach was hugely influential, one to emulate as well as one to react against.

WRITING AS DRAWING AS WRITING

Kenturah Davis (b. 1984)

Kenturah Davis has always kept a notebook. Even during a stretch when she was not making art, she continued to fill pages with notes. When she began sketching again, Davis noticed that her drawings had started to overlap with her writing. A lightbulb went on. The quality of a written line, she realized, is really no different than that of a drawn line, except that in the case of a written line, we have learned to assign meaning to that particular sequence of marks. It was a stirring revelation, and one that opened up an avenue of inquiry she has pursued since.

Davis began making drawings by layering handwritten text, building up repeated words and phrases to construct a portrait of a person. The text is at times legible and at other times not, each mark corresponding in some way to the person depicted, through either visual description or words that relate to their life. Davis has experimented widely with this process of conveying writing into drawing, using rubber-stamp letters instead of handwriting, incorporating binary and QR codes, and expanding into three dimensions to create objects and installations. Neither the words nor the image fully captures the person, but that's the point. Davis's process is a metaphor for the ways image and language valiantly try but fail to encompass a human being. The words hint at the unseeable depth of a person, and the image reminds us of their physical reality and presence in the world. Together, they form a blur that admits the nuance of human existence, more closely describing the person than either text or image alone.

In 2012, Davis came across the word "sonder," which seemed to characterize this very idea. It's an original word, made up by John Koenig as part of his project *The Dictionary of Obscure Sorrows*, describing "the realization that each random passerby is living a life as vivid and complex as your own." She began a new series that explores this experience of seeing and noticing strangers, layering stamped letter portraits of people she does and does not know with the word "sonder" and its definition (*Sonder*, 2015–2018). As with previous works, Davis

began with writing, which became a drawing, and ultimately looped back around to become a new form of writing, able to be read in an altogether different way.

In devising this assignment, Davis recalled a class she took in graduate school about the invention of writing, during which time she filled page after page of her notebook with marks. Not letters or drawings, just forms. She was fascinated to find that there was a particular style of mark that her hand wanted to make, and that she could assign any meaning to it that she wanted.

Where and when does language fail you? What kind of a mark might your hand make that could begin to describe it?

Kenturah Davis, Erin *(detail), from* Infinity Series, *handwritten text, graphite on paper*

YOUR TURN

We know that dictionaries don't contain all the words, even the ever-evolving online ones. Language is wonderfully elastic, able to be manipulated not just by authorities but by you, too. In an increasingly digital world, you may have forgotten the mysterious power of your own handwriting, and that the glowing text on your screens started out somewhere as scratches on stone, attempts by one human to communicate with another. We're making this all up, friends. All of it.

1 Think of a feeling or experience that your vocabulary finds hard to describe. Keep that in mind.

2 Use a pen to make a mark on paper with two gestures, without picking up the point of the pen. Repeat ten times, trying to make each one different.

3 Now try three gestures.

4 Now try four gestures.

5 Now try five gestures.

6 Review the characters you have created. You will likely find that your hand naturally tends to make certain kinds of marks, and identify the ones with similar gestures. From those, choose one to represent the feeling or experience that came to mind in the first step.

TIPS/CHEATS/VARIATIONS

▶ Consult your notebook, journal, or however you capture your ideas digitally. Look for ideas or feelings that took more than a few words to describe or that you weren't able to capture well. Alternately, go about your day and pay more attention to any sensations or thoughts that you'd like to convey to someone else.

▶ This specifies pen and paper, but you can interpret it however you like. Want to use brush and ink, markers, or graphite? Go for it. Same goes for your drawing surface. Pick what works for you.

▶ No practice is necessary. Just dive in and see what happens. You might notice you get looser as you go along and find a sweet spot for the number of gestures that feels right.

▶ Made the perfect mark to describe your feeling or experience? Hooray! Not so much? Try it again, repeating the number of gestures however many times it takes to find the right one. Or step away from your marks and return to them a day or two later. Perhaps you overlooked the perfect character and needed some distance to recognize it.

BOUNDARIES

Zarouhie Abdalian (b. 1982)

Zarouhie Abdalian purposely chooses the unremarkable features of a site as the jumping-off point for her work. Her interventions have involved lining the window of a downtown Oakland office building with Mylar that quivers at varying frequencies (*Flutter*, 2010) and placing lacquered wooden wedges in between select floorboards of a gallery in Melbourne (*Simple Machines*, 2014). With these relatively simple, unspectacular operations, Abdalian activated each space in subtle but powerful ways.

When invited to participate in the 2014 Berlin Biennale, Abdalian selected the stairwell of the KW Institute for Contemporary Art as her site of focus. She opened the window at the top of the stairs, placed a plastic owl decoy on the sill, and set up a sound system nearby that played a recording of Franz Schubert's "Nacht und Träume" (Night and Dreams). From the moment you entered the building, you could hear the faint sound of the music, which steadily increased in volume until you reached the top of the stairs and discovered the owl facing outward toward a panoramic view of Berlin rooftops. It was there that you had the loudest, clearest experience of the recording, a moving German *lied* featuring a soprano voice expressing her longing for the night and the dreams that will come. The humble plastic owl looked out along with you, directing your view, and protecting you from unknown intruders from the outside world. Perhaps you contemplated the difference between inside and outside, between spaces designated for "art" and "nonart" experiences. Being in Berlin, perhaps you were reminded of German philosopher G. W. F. Hegel's passage about the owl of Minerva, which "begins its flight only with the coming of the dusk," interpreted roughly to mean that the philosopher only understands an era after it is already over. Or perhaps you just grinned at the funny owl and paused for a minute or two to enjoy the view and music.

The sites Abdalian is drawn to are thresholds—areas that mark a transition from one type of space to another. Using common materials and with a light touch, she makes alterations that slightly shift the

perception of those who interact with her work. Her installations are constructed in such a way that you feel almost as if a place is speaking for itself, quietly but insistently calling attention to aspects that are already there but difficult to apprehend.

Abdalian is asking you to identify the thresholds, be they visible or invisible, that surround you. How might you reveal them and allow them to speak for themselves?

Zarouhie Abdalian, a caveat, a decoy, *2014, installation view, eighth Berlin Biennale*

YOUR TURN

Boundaries are everywhere, but they're not always obvious. There are the human-made ones, like windows, doors, and fences, but there are also those nature offers, like horizon lines, rivers, and cliffs. A boundary might mark the transition between nations, public and private space, or where activities are and are not allowed. You'll need to sharpen your powers of observation, look at the spaces around you as if you're seeing them for the first time, and help other people see that way, too.

1 Find two spaces that share a boundary.

2 Do something to highlight or alter the relationship between these two spaces by reconfiguring or activating the place where they meet.

TIPS/CHEATS/VARIATIONS

▶ Go about your day, or on a walk, and take photos of all the boundaries you see or sense. Look at the pics, think about them, and determine which one is most compelling to you. Return to that site and brainstorm ways you might draw attention to the division already there.

▶ Seek out places where there may be tension, be it a disputed border between countries or the line where your neighbor stops mowing their lawn. Perhaps the contested space is emotional or psychological. Notice where you feel welcome and unwelcome, comfortable and uncomfortable.

▶ Research the location, observe it. How do people move through the space? What are the expectations there? What kind of materials seem at home there, and which ones would feel out of place? Use those questions to generate ways you might highlight the boundary.

▶ If it's visible, photographing the boundary is a straightforward option, as is a rubbing (see "Surface Test," p. 1). Regardless, consider adding or subtracting from the site. You might make something happen there, be it an event or performance. Hold a concert where a shadow hits the ground at a particular place and time. Create a video or sound recording that documents crossing the boundary.

▶ A few boundaries that have been identified and highlighted: between pages of a book; artwork and work surface; home and the world; the curb and the street; where one language is spoken and where another is; wilderness and civilization; order and chaos; right and wrong; cancerous and noncancerous cells; childhood and adulthood; fish and terrestrial beings; my headspace and the physical world; unfinished and finished.

Caroline-Isabelle Caron, Stolen Boundaries, *2015, photomontage*

I've always been fascinated by how neighbors take care (or not) of what is essentially the same yard, how they divvy out each of their spaces. They create imaginary property lines where nature sees none. Neighbors try their best to carve in turf the limits of what they own, a line that moves a little bit every time they mow their lawns. This is especially ironic knowing that my entire city sits on unceded Anishinaabeg territory. We settlers have imposed our ownership on stolen land and usurped sovereignty. It's all in our heads and it's all stolen.

OFF

Lauren Zoll (b. 1981)

We tend to associate the color black with nothingness. But to encounter Lauren Zoll's pure black paintings is to experience dynamic worlds of color, texture, light, and information.

Her motivation for the works came after a period when she needed a lot of sleep. Zoll set about trying to represent the experience of having her eyes closed and began pouring large volumes of black latex paint over panels. She noticed, however, that the moment she tried to represent this void, it materialized into something. As the paint dried, the glossy surfaces of the paintings became puckered, creased, and mottled, reflecting the environment around them in unpredictable and wondrous ways.

After the panels dried completely, Zoll experimented with ways to present them and bring them to life. She positioned the paintings across from still lifes she assembled from props and colorful fabric and paper, so that rough forms of color would appear on their surfaces. Zoll hung and propped them in varying arrangements, capturing their changing reflections through photograph and video. She strapped one of the paintings to the roof of her car, trained a video camera on its surface, and drove through the night recording its wavering play of light and color.

These are not static paintings that hang on a wall and broadcast a fixed image to passive audiences. Zoll's lustrous panels invite movement, offering different views depending on the angle from which they're viewed, the time of day, and the unstable conditions of the room and its inhabitants. For Zoll, the paintings came to life in such a way that they seemed to be talking back to her, saying, "I can see, too."

Zoll was relaxing on the couch one day when she came up with the idea for this assignment. Like having her eyes closed, being "off" in this way still felt productive, offering up unexpected thoughts and alternative ways of seeing. What else, besides our bodies, might be important when "off"? As she gazed out from the couch, a very commonly owned field of "black" came into focus, presenting an astonishing array of visual information.

Lauren Zoll, Fabric + Film, *(video still), 2012, single channel video*

YOUR TURN

This process might not seem like it will yield great insights or interesting images, but it will. Take advantage of the plethora of screens that populate our twenty-first-century lives, and use them not to immerse yourself in images of other places and times, but to expose the dynamic visual world that is at any point above, below, and all around us. Turn off your screen, turn on your eyes, and see what bit of optical magic your "off" screens might reveal.

1 Turn off a screen.

2 Take a photo of only the screen, making sure to think of color, pattern, and form. Don't include any humans in the frame.

TIPS/CHEATS/VARIATIONS

▶ Your phone, computer, tablet, and TV are obvious choices, but consider your oven or microwave door to be a screen, or a particularly glossy tabletop, or the surface of a pond in certain light.

▶ Once you've ID'd your "off" screen and have a photo-taking device in hand, just start taking a lot of pictures. Keep changing your position and take a lot more. Try to capture the reflection in as many ways as possible, and then review your shots to see which ones stand out. Show less of what *you* see and more of what *the screen* sees.

▶ A boring space can make for fascinating reflections. You don't have to take your screen to somewhere remarkable. Hints of light and dark, or blurry shapes reflected in a cracked, fingerprinted screen, can be beautiful.

▶ Do the assignment on purpose, and then look out for "offs" as they occur naturally out in the world. You might be zoning out at a meeting and suddenly see a glorious image appear in the sideways reflection of a laptop.

RESPONSE

Jean Lieppert Polfus, Wedding Phone, *June 28, 2014, Escanaba, Michigan*

HISTORY AS YOUR GUIDE

Claude glass, maker unknown, 1775–1780, blackened mirror glass

Among the wealthy and fashionable of the eighteenth century who made "grand tours" around Europe, the Claude glass was the "it" travel accessory. This small, slightly convex mirror with a tinted black surface was carried in a case and unfolded whenever a particularly lovely landscape appeared. The user would turn their back to the scene and hold the mirror at such an angle that it would reflect the landscape. The glass had the effect of simplifying the tonal range and shaping the image into a neater, more defined view. It gained its name after seventeenth-century French artist Claude Lorrain, whose popular painted landscapes had a glow similar to those viewed through the Claude glass. Artists used them to help frame and flatten their image, while tourists appreciated the way they made a vista look "picturesque," a newly coined term described by William Gilpin as "that peculiar kind of beauty, which is agreeable in a picture."

THOUGHTS, OPINIONS, HOPES, FEARS, ETC.

Gillian Wearing (b. 1963)

Gillian Wearing is not an extrovert but has nonetheless routinely and voluntarily flung herself into interaction and collaboration with strangers. In the early 1990s, she stationed herself around all parts of London with a clipboard and a camera. Stopping members of the public as they passed by, Wearing asked them to write down what was on their minds. Some ignored her, but many more stopped, listened, and took her project seriously. She then photographed each participant holding their statement and secured permission to use the images as part of her series *Signs That Say What You Want Them to Say and Not Signs That Say What Someone Else Wants You to Say* (1992–1993).

Comprising over one hundred photographs, the series portrays a wide cross-section of individuals and ideas. Some of the statements offer a window into the time and place they were gathered ("Will Britain get through this recession?"), others are philosophical ("Everything is connected in life. The point is to know it and to understand it"), and still more are intensely personal ("I'm desperate"). Wearing was surprised by the openness and vulnerability of her collaborators. There was no need to coax out any of the comments. Simply being presented with an opportunity to voice their thoughts was enough. Wearing invited her subjects to play a role in their own depiction, and they accepted.

Subsequent works continued to probe the distance between one's outward appearance and inner reality, and also invited the participation of others. In 1994, she placed an advertisement in *Time Out* magazine reading, "Confess All on Video. Don't worry you will be in disguise. Intrigued? Call Gillian." Those who responded were invited to construct a disguise from a variety of costume elements and confess their secrets on film in the manner they chose. The disguises emboldened participants to make admissions they never would have otherwise, and again Wearing was startled by the frankness of the material and those who readily shared it.

She had grown up watching early British TV documentaries like *The Family* and *Seven Up!*, now oft cited as precursors to reality television, and was intrigued by the authenticity these shows claimed to present. Through her work, Wearing has explored the murky territory between public and private that is now even more challenging to parse in the age of the social internet, with the many opportunities for anonymity, voyeurism, and confession it provides. Wearing is unafraid of implicating herself in this investigation, examining her own construction and presentation of identity as readily as that of others. Recent works have seen the artist photographing herself in a variety of intricately constructed guises and masks, taking on the appearances of famous artists and her own family members, with her own eyes intently staring out.

In describing her approach, Wearing explains, "I create a structure, an idea, and it gives me the doorway to many different worlds." She now invites you to create your own structure, idea, and doorway, and challenges you to be brave enough to walk through it.

*Gillian Wearing, '*I'm desperate,*' 1992–1993, from* Signs That Say What You Want Them to Say and Not Signs That Say What Someone Else Wants You to Say, *chromogenic print mounted on aluminum*

YOUR TURN

We tend to surround ourselves with people with whom we get along, who have similar wants, needs, and social and political ideas. Wearing is asking you to step outside your comfort zone of friends and like-minded acquaintances to engage with someone you have never met, in a circumstance outside your social sphere. Be prepared to not share their views on politics or life, and remember that they don't have to be a reflection of you.

1 Find someone you wish to portray, whom you've never met and about whom you know nothing, in a public setting, with an advertisement, or through a friend or colleague.

2 Ask them a question, specific or general.

3 Record the answer via photography or film, in a way that's as unique as possible and effectively voices their thoughts, opinions, hopes, fears, etc.

TIPS/CHEATS/VARIATIONS

▶ Having the courage to talk to someone you don't know can be an enormous challenge, but if your question means something both to you and to the participant, this can open up the engagement.

▶ If you are approaching people in public with the offer to be asked a question, be prepared to be ignored and rejected. That's okay. Don't take it personally.

▶ Is your question working? You will likely need to ask several people before you know. If it's not resonating, modify it and try asking another way. Consider how the location you've chosen might affect the response.

▶ Try not to put words in participants' mouths. Allow them to speak without guiding their story according to the way you see it.

▶ Feeling overwhelmed? Pretend to be someone else, and then deal with the situation as you imagine they would. Channel your inner census taker or investigative journalist, or find inspiration through artists like Lisette Model, Roy DeCarava, Diane Arbus, or Bill Cunningham.

▶ Resist the urge to copy Wearing's *Signs* project directly. What are alternative approaches that speak to who you are, where you are, and your moment in time?

▶ As is the case whenever strangers are involved, be careful and use good judgment. Tell someone what you're doing and where you'll be, or bring someone with you, like a friend, family member, or collaborator. If you solicit participants through an ad or social media, be sure to meet them in a public setting.

MY WORK FORCES ME TO DEAL WITH THE THINGS I PROBABLY LACK, LIKE NOT BEING AN EXTROVERT OR BEING RESERVED. THAT DOESN'T MEAN I DON'T WANT TO TAKE RISKS OR EXPERIMENT WITH IDEAS, QUITE THE OPPOSITE. SO MANY ARTISTS I KNOW ARE SHY BUT YOU CAN'T TELL BY THEIR WORK. —GILLIAN WEARING

EMBARRASSING OBJECT

Geof Oppenheimer (b. 1973)

Geof Oppenheimer has always been interested in materials and what they have to say. While in school, Oppenheimer learned of a quote by the philosopher Alan Watts: "A thing is a think." It blew his mind, revealing how all the stuff we are surrounded by has meaning that is legible to ourselves and others. This idea made him think anew about his sculpture, which he began to see as a way of taking objects that already carry meaning and arranging them in space to construct new meaning. Unlike painting, which to him seemed to exist in a separate world inside a frame, sculpture occupies our space, composed of materials and objects we all share.

For a work he created in 2014, Oppenheimer brought together traditional materials of sculpture, like marble and steel, with such unexpected objects as a pair of pants and a leaf blower. Looking vaguely like a figure, the sculpture is composed of an electroplated steel ladderlike armature that rises out of a marble base. The leaf blower hangs from the structure at approximately shoulder height, a knob of plaster supports a joint where a knee might be, and the wool Brooks Brothers slacks sit pooled around its "feet." The entire object is elevated off of the ground with a two-foot plinth made of remanufactured wood, and the leaf blower's unsupported spout points limply floorward.

It's a curious sculpture, and funny, too. There is a patheticness about it. It is the opposite of a heroic sculpture of a political figure, philosopher, or heralded war general. The sculpture was born of Oppenheimer's curiosity about what it means to make something in today's world, where hard labor can often be invisible or replaced by automation. "Labor" is no longer slowly, methodically raking leaves by hand but passively blowing them around a yard. Oppenheimer's figure stands as a kind of memorial to "work," a reminder of how it has been dehumanized, devalued, and abstracted.

The sculpture makes Oppenheimer feel embarrassed, and he likes that about it. He titled the piece *The Embarrassing Statue*, intentionally leaving it unclear whether it is the viewer who is embarrassed, the

artist, or the sculpture itself. Oppenheimer's sculpture and his assignment are reminders that art is capable of inducing a wide variety of reactions and states of mind, including unpleasant ones.

What are the materials and objects around you that signal unease? How might you arrange them to create an embarrassing statue of your own?

Geof Oppenheimer, The Embarrassing Statue, *2014, electroplated steel, Husqvarna 150BT, Brooks Brothers pants, marble, plaster bandages, and MDF*

YOUR TURN

Art doesn't always have to make you feel good. It can reflect the painful and uncomfortable moments in life as well as or better than the beautiful or sublime ones. This is a way to think about your own experiences and look at the objects around you with the "a thing is a think" approach. How might you take materials that you already know and make them strange? What novel combination of existing items would make you feel like your pants are down around your ankles? Like your leaf blower is hanging limply for the world to see?

1 Create something that makes you feel uncomfortable, out of a material or group of materials.

2 Give it a title.

TIPS/CHEATS/VARIATIONS

▶ "Embarrassing" has a different meaning to you than it does for other people. Is it utterly wretched or kind of thrilling? Think about what embarrassment means to you and the moments in life when you experienced it most acutely. Take notes, make sketches, or gather images that embody those moments. What are the materials that make you feel embarrassed? Is it something squishy, bulbous, hard, or sharp? (Geof Oppenheimer thinks terry cloth is embarrassing.)

▶ Your object doesn't need to be figurative. Try to do this through material language, thinking about the forms and textures that are embarrassing but don't necessarily look like a body or a symbol of embarrassment directly. Gelatin is an excellent embarrassing substance: jiggly, wrinkled, and suggestive of the body without being directly human.

▶ If you want to make a figure, go for it. The great thing about the body is that we all have one, and it is something we all understand.

▶ You can make a sculpture, but you can also create an installation, or represent your novel arrangement of materials through photography, video, or animation.

▶ Substitute another adjective for "embarrassing" and try again. It can be an eager object, or handsome, jealous, obedient, famous, shy, empty, cold, dull, affectionate, ambivalent, petulant, logical, et al.

RESPONSE

Tilda Dalunde, Embarrassing Object (hair is only allowed in certain places), *2016, hair, door handle*

STAKEOUT!

Deb Sokolow (b. 1974)

Deb Sokolow and her partner faced a conundrum. If they didn't make it to their doorstep before seven thirty on Sunday mornings, their *New York Times* would go missing. Week after week, they tried to beat the thief to their paper. After too many disappointments, they became determined to catch the culprit. One Sunday, Sokolow woke early, retrieved the newspaper, and left an old Sunday edition in a bag on the doorstep with a note reading: "WE ARE WATCHING YOU." And while they had intended to watch, they were too tired and went back to sleep instead. The following week, they planted another dummy paper with a note reading: "WE NOW KNOW WHO YOU ARE." This time, Sokolow did indeed install herself in the café across the street to keep an eye on her doorstep. After she watched and waited all morning, no one took the paper—and no one has since.

Sokolow has a penchant for elaborate plotlines and drama. Since 2003, she has created wall-sized drawings and installations that tell intricate stories through handwritten block text, diagrams, and sketches. Blending fact and fiction, Sokolow has focused on everything from the plot of the movie *Rocky* and the lives of her neighbors, to complex conspiracy theories and tales of political intrigue. Past drawings include works charting the foibles of former United States presidents and investigating the suspicious disappearance of a Greek restaurant called the Pentagon, and *Frank Lloyd Wright's Sadistic Side* (2015–2016), which includes the story of a three-legged chair the famous architect designed for the secretaries of the Johnson Wax company that would tip over unless they sat with correct posture. An unreliable narrator tells each story, weaving together truth and speculation, seriousness and the absurd.

For this assignment, you become the narrator of a story that you set into motion by placing one item—be it ordinary or extraordinary—out in public and watching what transpires. Sokolow followed up her newspaper stakeout with an experiment, placing a curious object on the sidewalk across from her house: a book about conspiracies with

specific chapters marked with dollar bills. Watching from her window, she took detailed notes about who stopped and looked, who picked it up, and what happened next.

It's time to test your observational skills, attention span, and capacity for improvisation. It's time for a . . . stakeout.

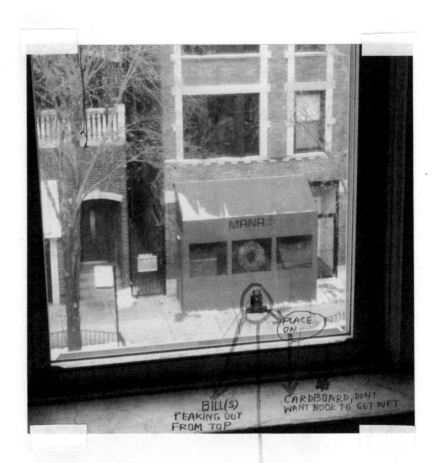

Deb Sokolow,
Stakeout Journal,
Page 3, *2013,*
photo and pencil
on paper

FINALLY

MAN, BETWEEN AGES 24-37

PICKS UP BOOK AFTER CIRCLING BACK AROUND

PULLS OUT BILLS, PLACES BILLS IN POCKET

DOESN'T DISCARD IT! ☆ TAKES BOOK.
THIS IS SIGNIFICANT.

~~GETS IN THE~~
~~JAMONCEDTEREN~~

WILL HE READ
THE BOOK?
IT'S AN EASY
READ

HE'S WEARING KHAKI PANTS ← NOT TIGHT
HAT STUDENT?
BACKPACK NOT FASHIONABLE
 MORE UTILITARIAN

Deb Sokolow, Stakeout
Journal, Page 1, *2013,
photo and pencil on paper*

EXITS THIS
WAY DOWN
DIVISION
STREET.

~~TAKES~~ 33
MINUTES
WAITING?

YOUR TURN

Love people-watching? Redirect your gaze from your screen to real life, and put your voyeuristic impulse to productive use. But also be sure to listen to your instincts and figure out a way to do this that feels right to you. You may need to push yourself a bit outside your comfort zone, but ultimately this assignment is about empathy. You're asked to imagine others complexly, and devise a way to give gifts to strangers without freaking them out.

1 Find an interesting object and place it in a public spot where people can interact with it.

2 Pick a location to observe these interactions.

3 Document your experience.

TIPS/CHEATS/VARIATIONS

▶ Think through your location and consider the kinds of people who pass by and at what times. Not comfortable doing this in the wide open? Set yourself up in a nearby café, your office, your dorm, your school hallway, or even within your own home with unsuspecting family members.

▶ Select an object that will engage passersby in your particular location. Perhaps it's something loud and obvious, or maybe a more subtle curiosity. What might spark someone's imagination? A frog sculpture offering peppermints? A yellow tutu with a tag reading "Dance with me"? A bubble gun? A disposable camera with attached instructions to take a selfie? (These have all been done!)

▶ Is your object not attracting much attention? Move it, modify it, or try something else. Choose a different time of day when the spot might be busier, or less busy. Put yourself in passersby's shoes. What would make you stop?

▶ Develop your observational skills as you go by taking notes, sketching, making audio clips of your observations, or whatever feels natural. Be as detailed as possible, noting even seemingly irrelevant information like what they are wearing, how long they look at the object, whether they appear to be talking with their companion, etc. Highlight any notes you find most interesting.

▶ Do not stalk anyone, and don't break the law. You're within your rights to use your eyes and powers of observation while in public (in most cases), but never follow anyone or put yourself or others at risk.

▶ Never let the truth get in the way of a good story. If what actually happened wasn't notable, why not imagine what might have transpired?

HISTORY AS YOUR GUIDE

Vito Acconci, Following Piece, *1969, gelatin silver prints, felt-tip pen, and map on board*

From October 3 to October 25 in 1969, Vito Acconci (1940–2017) ventured out into the streets of New York City and randomly selected an individual passerby. He committed himself to following the individual, wherever they might lead him, until the person entered a building or private space. Acconci typed out the terms of his plan and documented each journey, mapping out where people took him, how long it took, and any notable events that happened along the way. Part performance and part Conceptual Art, *Following Piece* necessitated that Acconci give up artistic control and put his fate in the hands of strangers. About it he said, "I am almost not an 'I' anymore; I put myself in the service of this scheme." The process laid bare the often confusing lines between public and private space, and posed questions about what kinds of actions we'll deem socially acceptable.

IMAGINARY FRIEND

JooYoung Choi (b. 1982/1983)

JooYoung Choi's expansive fictional land is called the Cosmic Womb, and its motto is "Have Faith, for You Have Always Been Loved." Choi began dreaming up this place when she was a child living in Concord, New Hampshire, with her adoptive parents, and learning about her birthplace of South Korea through books and movies. The "Asia" she read about seemed magical—replete with dragons, mythology, and martial arts—and Choi filled in the gaps of her personal history with an imagined homeland of her own creation.

Over time, Choi became aware of the nuanced reality of life in her home country and as an adult reunited with her birth family. But she didn't want to dismiss or forget the world she had concocted, and set about telling tales of that world through her art. Stories of the Cosmic Womb and its inhabitants unfold through paintings, sets, puppets, costumes, music, videos, and installations. The paracosm is governed by Queen Kiok, with the support of Captain Spacia Tanno, and is populated by a fantastical array of beings and an Earthling from Concord, New Hampshire. Each character has their own creation story and narratives that interconnect to form the Cosmic Womb mythology.

One character, Bernadette Aala Bronaugh, took shape after Choi noticed some of her friends experiencing feelings of hopelessness and despair. She had already created Larry, who likes to pull things in his wagon and eat bad feelings, and so she made Larry a sister who always wants to be with you, has the courage of a bear, and eats up despair. Bernadette's full name combines the American, German, and Irish elements of Choi's adoptive family heritage. And her form is an amalgam of the long-snouted echidna, the hippogriff (the legendary creature with the front half of an eagle and back half of a horse), and the mythical Korean Bulgasari, a being that eats noodles, metal, and fire, and is known for stopping evil. In the process of sketching and making a puppet of the character, Choi discovered that Bernadette is a terrific dancer.

We tend to think of imagination as something we put away when we become adults. But Choi proposes that we get back in touch with our radically imaginative capacities and fill in the gaps of our own lives through creativity. If you had to will into the world one being, what would they look like? Where would they come from? What would be their purpose in life?

JooYoung Choi, Sketches of Bernadette, 2016, hand drawn scanned digital sketch

JooYoung Choi with Bernadette, 2016, fleece, felt, polyfoam

YOUR TURN

Choi has created numerous characters, but you're going to make just one. This doesn't excuse you from building a world around your new friend, however, and imagining them not as a thing, but as a complete being with thoughts, talents, motivations, and feelings. And some of these attributes you might not discover until you bring your friend to life.

1 Make an imaginary friend using any medium you like.

2 Bring that friend out into the world and introduce them to others.

TIPS/CHEATS/VARIATIONS

▶ What is a problem you're facing or issue you're dealing with? Consider what kind of friend might provide comfort, offer protection, or address a need. Or perhaps there's someone in your life who needs an imaginary friend. Make one for them.

▶ Love whittling or working with bent wire? Start with a material you like and see where it takes you. Animation, drawing, photography, collage—anything can work.

▶ What were three animals you really loved when you were younger? Blend them together into one creature, thinking about the aspects of each that you particularly like. (Giraffes, with their long necks, have great perspective.)

▶ To get into the right mind-set, watch some kids' shows! *Pee-wee's Playhouse*, *The Muppet Show*, *H.R. Pufnstuf*—whatever captured your imagination as a child.

▶ Be as thoughtful as you need to be. Your friend might come to you in a flash or take shape over time. Write down your ideas or start sketching to see where it might take you.

▶ You might need to make your friend before you understand their backstory.

▶ Playing with your friend might give you insight into who they really are, where they came from, and what they've been brought to life to do.

▶ Don't skip the last step! This creature is all your own, but take a chance and see what happens when you introduce your friend to others. Place them on your desk, bring them to dinner with your family, take them for a drive, or debut them on social media.

HISTORY AS YOUR GUIDE

Alexander Calder, Pegasus *from* Cirque Calder, *1926–1931, painted wood, wire, sheet metal, and string*

Many associate Alexander Calder (1898–1976) with his abstract hanging sculptures called "mobiles," or his large-scale "stabile" structures that rest firmly on the ground. But before he made either, Calder crafted a circus out of bits of this and that and performed it for his friends and fellow artists. He built a menagerie of miniature figures from wire, bottle caps, clothespins, corks, and fabric, and designed them to move and perform acts. There are acrobats, clowns, a sword swallower, and numerous animals, which Calder presented in succession, entertaining his guests with elaborate, narrated routines performed by the figures and accompanied by music and noisemakers. Calder's mastery of energy was on clear display, as were his ingenuity, empathy for his audience, and wild imagination.

FAKE FLYER

Nathaniel Russell (b. 1976)

When Nathaniel Russell was in high school, he and his friends wanted to start a band. They came up with a name (Dolemite Junior), and Russell even designed a T-shirt for them. The band never actually came to fruition, but shortly thereafter, a real band came to Russell and asked him to make their album art. He gladly obliged.

Since that time, Russell has made numerous works on commission, designing album covers, posters, skateboards, and murals, in a signature style that combines an economical use of line and form, text, and no small amount of humor. He deploys the same style in the work he makes at his own direction or for imagined clients, creating silkscreen and woodcut prints, paintings, illustrations, books, and sculptures. Drawing is central to all of his work. While studying printmaking and its masters, Russell developed a deep appreciation for the power of the line, and the understanding that making one really good decision is better than twenty that are just okay.

An easy back-and-forth between the real and the imagined runs throughout his work. For his *Fake Books* series, Russell conjures covers for imaginary volumes by pairing painted or found imagery with handwritten titles (*Introduction to New Amateur Graffiti for Beginners*; *The Caverns of Tomorrow*; *Wood Soup: Cookbook for Dropouts 1973*) or assembles shelves of wooden slabs painted with cover designs and titles (*Becauses*; *Health Poem: Volume One*).

Another series began when a joke popped into Russell's head and he quickly committed it to paper. Working off of the typical "Lost Dog" flyer format, he envisioned a proud, fluffy French poodle that had left of its own volition. This dog was the leader of a great resistance against human ownership, advertising a call to arms for other dogs to join in. Russell began making other flyers, and it became a kind of daily exercise. Sometimes they were funny and sometimes more abstract, allowing him to explore ideas that may be silly but that he also takes seriously. (DIAL-A-QUIET / 1-800-SILENCE / I PROMISE NOT TO SAY ANYTHING)

Russell didn't invent the idea of a fictional poster, book, or advertisement, but he may have perfected it. Using humor and a nonprecious approach to materials, Russell's series and this assignment challenge us to consider how we communicate with other people, conjure other worlds, and reimagine our own.

Nathaniel Russell, Fake Flyer (Opposite of Lost), *2011, photocopy*

YOUR TURN

The flyers you see tacked to bulletin boards and telephone poles are almost always practical, advertising events, causes, and available services. Here's your chance to create a flyer that is impractical. Loosen up, unleash your imagination, and begin to conjure all the strange and wonderful reasons why someone (or something) might want to communicate with others.

1 Make a flyer that gives advice, shares something about your life, or promotes an imagined event.

2 Put it out into the world.

TIPS/CHEATS/VARIATIONS

▶ Standard-size printer paper and a Sharpie are all you need. Use any and all materials you like, but just the simple stuff works, too.

▶ Existing images can be a good place to start. Cut out photos from a magazine or newspaper, or print out images you find on the internet. You can also draw something on the page and then see what kind of message seems to go with it.

▶ Make a bunch of these and try to have fun with it. Invite over a friend and make a stack of them together. Laugh at the silliness, and marvel at the wisdom that seeps out of them.

▶ Really do put it out into the world. This can mean making copies of your fake flyer and plastering it around town. Or taking a photo or scan and emailing it to a friend, or sharing via social media.

BECOME A SCI-FI CHARACTER

Desirée Holman (b. 1974)

The San Francisco Bay Area is a hotbed of both cutting-edge technology and New Age spirituality. The two worlds are largely separate, and yet it is their overlapping intentions and ideals that Desirée Holman finds compelling. Based in Oakland, California, Holman began a project in 2011 that explores how each of these cultures proposes solutions for complex problems and theorizes about how we relate to our own bodies and to each other.

Holman began the project by researching extraterrestrial sightings, techno-spirituality, theosophy, New Age mysticism, the Back to the Land movement, and the hippie counterculture of the 1960s and '70s. She gathered images representing these histories and the most advanced technological ideas, devices, and apparatuses coming out of Silicon Valley. Holman bought novelty E.T. masks and photographed them with aura cameras, fascinated by the cultural concept of aliens as well as this pseudoscientific way of capturing that which can be felt but not seen. The series would grow to include video installations, performances, costumes, and a soundtrack, as well as paintings, works on paper, and sculptures. She titled it *Sophont* after a term coined by science fiction author Poul Anderson to describe advanced beings, intelligent but not necessarily human.

For the project, Holman devised three fictitious character types—Time Travelers, Ecstatic Dancers, and Indigo Children—that were brought to life through video as well as live performances. She developed costumes and props for the characters and cast performers to play the roles. The elder Time Travelers wear hats she refers to as psionics helmets, designed to enhance each character's extrasensory abilities. Holman visited flea markets to construct each of these, gathering kitchen implements and other odds and ends to tinker with and see what alternate uses she could imagine. A pan, a tea ball, and a strap are joined together to form one of these helmets, which Holman worked with a programmer to retrofit with a microprocessor that causes a light to flash with varying pace and vibrancy.

Holman considers her psionics helmets to fall into a category somewhere between functioning smart glasses, like Google Glass, and self-constructed tinfoil hats imagined by their wearers to transmit or block signals. While one is deemed innovative and the other a mark of insanity, both are technical devices designed to extend from the body and enhance the perception of those who wear them. Holman appreciates how all of these devices make manifest the fantasies that we have about ourselves, and express both our fears and aspirations for the future. In the helmets she creates, and in her assignment for you, Holman poses a critical question: How can we transcend our most pressing problems through technology?

Desirée Holman, Future Time Traveler, *2013, pencil and gouache on paper*

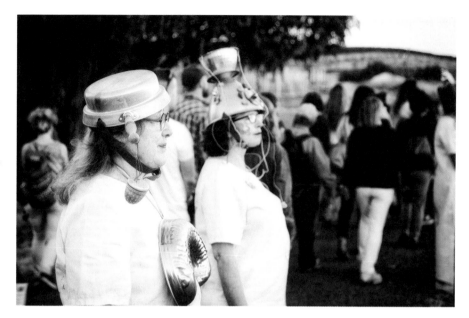

*Desirée Holman,
Sophont in Action
Napa, June 28, 2014,
di Rosa Center for
Contemporary Art,
Napa, California*

YOUR TURN

These days, we are all cyborgs. We walk around with technological devices tethered and affixed to our bodies in numerous ways. But the devices we use tend to be ones that we purchase, designed by others who can only guess at our needs. If you had the power to do so (and you do), what kind of device would you design for yourself? What would it enable you to do? Let the line between fantasy and reality get blurry, and remember that the science fiction of the past is the nonfiction of today.

1 Design a science fiction character for yourself.

2 Create some sort of hardware that attaches to your head and enhances your extrasensory abilities (telepathic communication, time travel, etc.).

3 Wear the hardware and transform into your character.

TIPS/CHEATS/VARIATIONS

▶ Ponder what your existing technologies are not doing for you. You can order groceries and call a plumber, but can you hybridize a lemon and cabbage, mute the world, or call your great-great-great-grandmother? Think about what you'd like to do that your body won't allow. Would you like to hear at high frequencies or breathe underwater?

▶ Take time to conceptualize your character. What are your extrasensory abilities, and how would you put them to use? Write down your ideas, read science fiction, conduct research, go down image-search rabbit holes, watch videos, and make sketches.

▶ Comb through objects in your garage, basement, or closet, or see what you can find in a secondhand store. What function could they serve that they weren't designed to? Which items could somehow attach to your head? How might they be repurposed or reengineered to support a new cause? Try retired kitchen implements, some leftover screws and bolts, and an old belt for a strap. Break out the soldering iron or glue gun and get to tinkering.

▶ Organize a workshop where you and others can make your psionics helmets together. Assemble objects and materials to tinker with in advance, and encourage the others to bring some, too. Invite anyone you know who can program, sew, or weld, or is generally handy. Or not!

▶ Wear the headgear you've designed. Do it alone if you need to, but make sure it fits and adjust it as needed. Think about what you might wear with it, or if you'll need makeup or special shoes. Really occupy your character and try to stay in it for a while. Take pictures of yourself in character, or make a video.

▶ Name your character. If you were to star in a comic, novel, or movie, what would the title be? Consider the character's home base, friends, family, and enemies, and the wider world around them.

▶ If making and wearing the actual headgear isn't possible for you, create a drawing or animation of your imagined character. Make an audio file or video describing what you would do. Then later, when you have the material or means, make it happen in real life.

SCIENCE FICTION IS ANY IDEA THAT OCCURS IN THE HEAD AND DOESN'T EXIST YET, BUT SOON WILL, AND WILL CHANGE EVERYTHING FOR EVERYBODY, AND NOTHING WILL EVER BE THE SAME AGAIN. AS SOON AS YOU HAVE AN IDEA THAT CHANGES SOME SMALL PART OF THE WORLD YOU ARE WRITING SCIENCE FICTION. IT IS ALWAYS THE ART OF THE POSSIBLE, NEVER THE IMPOSSIBLE.

—RAY BRADBURY, *THE PARIS REVIEW*, SPRING 2010

HISTORY AS YOUR GUIDE

Rebecca Horn, Handschuhfinger (Finger Gloves), *1972, performance, fabric, balsa wood*

In the mid-1960s, Rebecca Horn (b. 1944) was a young artist studying in Hamburg, Germany, making sculptures out of polyester and fiberglass without using a mask. She had no idea of the dangers of the material, got very sick with lung poisoning, and was forced to surrender her materials and recover in a sanatorium for a year. Isolated and confined to her bed, Horn began to make sketches and drawings that inspired a new body of sewn sculptures that she would come to call "body extensions." For one of these, *Finger Gloves*, Horn created two prostheses designed to be worn on the hands of a performer, each with five long, thin fingers made from wood and fabric. When worn, the finger gloves made faraway objects accessible and made possible otherwise unachievable actions like scratching both walls at once (which she performed with the gloves for a film in 1974). Horn explained, "The lever-action of the lengthened fingers intensifies the various sense-data of the hand . . . I feel me touching, I see me grasping, I control the distance between me and the objects." *Finger Gloves*, like Holman's assignment, asks us to consider the way we relate to our environments, to acknowledge our bodies' strengths and shortcomings, and to imagine how materials and technologies can enhance our abilities.

GRAPHIC SCORE

Stuart Hyatt (b. 1974)

Stuart Hyatt is a composer with a problem: he can't read or write music. When he was three years old, his parents signed him up for violin lessons in an effort to focus his attention and quiet his hyperactive mind. He studied the Suzuki method, an approach to learning to play instruments that relies on rhythm, repetition, and ear training. Just as musical notation was being introduced, Hyatt promptly quit and moved on to the tuba and stand-up bass, which he played in his elementary school orchestra. By high school, he had taken up guitar, keyboards, and drums, and edited and layered segments of music on a borrowed four-track cassette recorder, which Hyatt treated like an instrument in itself.

He went on to study painting, sculpture, and architecture, and continued to write, record, and perform music along the way. For the albums Hyatt now creates under the moniker Field Works, he collects audio recordings in particular locations and at certain times, and weaves them together with musical phrases culled from musicians from around the world. His two-album set *Initial Sounds* joins field recordings from the edge of a volcano with the chirping of gravitational waves from outer space, along with his own music and that of other musicians. To convey his ideas to collaborators, Hyatt shares recordings of rudimentary parts he has worked out by ear on guitar and keyboard. He also draws on his visual art training to describe musical phrases in terms of shape, color, line, and mass.

Graphic scores have served as a useful tool for Hyatt to represent his musical ideas. First developed by experimental musicians in the years following World War II, these visual representations of music originated as means for composers to liberate themselves from the constraints of traditional notation. In 2014, Hyatt created a graphic score for his composition and performance *E Is for Equinox*, which took place on the grounds of the Indianapolis Museum of Art, underneath an existing artwork by Type A titled *Team Building (Align)*. Hyatt called on seventy electric guitarists to gather beneath the artwork's

two thirty-foot-wide metal rings, which are suspended from telephone poles and trees and oriented so that their shadows align during the summer solstice. Hyatt's graphic score served as both music notation and a stage plot for his crew and performers, who formed a large circle under the rings. The guitarists (blue dots) stood in front of amplifiers (squiggly lines and rectangles) and followed Hyatt (yellow dot), who began the performance by playing four introductory whole notes (yellow squares). They then began to strum the E major chord in unison, playing whole notes (orange squares) and following with quarter notes (smaller light red squares) and eighth notes (smallest dark red squares), increasing in volume and distortion as they progressed (the darker the color, the louder the note). To conclude, they all played a final four whole notes together.

In truth, Hyatt *can* read and write music, just not in the traditional sense. What other ways might there be to represent music?

Stuart Hyatt, E Is for Equinox *(graphic score), 2014, pencil on paper*

Guitarists perform for Stuart Hyatt's sound installation E Is for Equinox *in the Virginia B. Fairbanks Art & Nature Park: 100 Acres at Newfields, 2014*

YOUR TURN

Learning to read and write music is like taking on an entirely new language, wherein you must decode shapes and patterns in order to effectively communicate with others. Let's pretend, for a moment, that traditional staff notation does not exist. How would you go about representing a sonic idea? If you had to make up your own musical language, what would it look like?

1 Grab a few sheets of plain white paper and a pencil or black pen.

2 Choose a short section of music or song, anything from Beethoven to Beyoncé.

3 While the music plays, allow your hand to interpret the sounds in real time as it moves across the paper, using lines, shapes, symbols, or whatever you see fit.

TIPS/CHEATS/VARIATIONS

▶ The music you select can be an old favorite or something you've never heard before. See what happens to be on the radio, or click on a random song wherever you stream music. Something instrumental might be easier to notate than music with lyrics. If a whole song is too much, choose a short phrase from it instead.

▶ Give this an initial try without much forethought or fretting. When the music ends, assess your drawing and consider what you might do differently. Try it again, testing out approaches until you're happy with it.

▶ You might want to develop a set of symbols or shapes to govern your score. Does a square sound different from a circle? Is a bigger triangle louder than a smaller one? How can your notation express pitch, rhythm, volume, and timbre?

▶ Your score doesn't have to be linear. Maybe it should flow along the page from left to right and top to bottom, or perhaps spiral out from the center. The score can also be more of a visual snapshot of the entire piece, rather than a progression.

▶ When you're happy with your results, think about adding some color to your score with colored pencils, markers, or paint. How might color better reflect the music?

▶ This can be a solo enterprise or conducted with friends. Listen to the same piece of music but work separately, and see how different your results turn out to be. Have everyone pick a song to play, and you all give each of them a try.

▶ If you're feeling really ambitious, create a brand-new graphic score for a never-before-heard piece of music. Give it to a musician and see if they can play it. Or perform it yourself and distribute the score as a program.

▶ Share your score with friends without telling them the music that it represents. See if they can guess what it is.

Cathy Berberian, Stripsody, *1966. Graphics by Roberto Zamarin.*

Cathy Berberian (1925–1983) was an American vocalist known for her extraordinary vocal embrace of avant-garde music, and her ability to transition abruptly between sounds and styles. In 1958, she performed John Cage's landmark *Fontana Mix* (1958), for which she sang single consonants and shouted in several languages. Cage's score included ten pages of paper bearing curved lines and ten pages of transparent film displaying points, which could be layered and interpreted in various ways. The score for Berberian's first musical composition, a 1966 piece for solo voice titled *Stripsody*, was similarly untraditional. Exploring the onomatopoeic sounds of comic strips, her composition is mapped out on horizontal lines and features lettering and vignettes illustrated by Italian comic artist Roberto Zamarin (1940–1972). Among its many memorable moments are such exclamations as "BLEAGH!," "BLOMP BLOMP," and "Boinnnggg."

SCRAMBLE SCRABBLE DINNER

J. Morgan Puett (b. 1957)

Deep in the woods of northeastern Pennsylvania, Mildred's Lane is both an art installation and J. Morgan Puett's home. After stumbling across the ninety-six-acre plot of land while traveling with friends in 1997, Puett developed it into a singular site where she and a rotating cast of participants and guests practice "creative domestication." At Mildred's Lane, every aspect of living is reconsidered, from the preparation and procurement of food to cleaning, styling, gaming, sleeping, reading, and even thinking. Puett is the site's founder and "Ambassador of Entanglement," but the daily processes of life are questioned in a collective atmosphere, and new approaches are conceived and produced collaboratively.

During a stay at Mildred's Lane, you might be challenged to wash the dishes in an intentional and artful way, perhaps out in the landscape. Instead of visiting a grocery store, you might forage for mushrooms and herbs on the property. You might attend a workshop on the proper way to clean a toilet, or carefully curate the refrigerator (a kind of styling Puett calls "hooshing"). Guest practitioners share research and knowledge on numerous areas of expertise, such as botany, archaeology, beekeeping, hydrology, engineering, and taxidermy. The goal throughout is to develop new ways of living and working, by mindfully and creatively putting to use local resources.

Eating well and inventively is central to the Mildred's Lane experience, whether it's a humble but thoughtfully arranged spread of foods devised by a "Digestion Choreographer" or an elaborate dinner party determined by an algorithmic game. Scramble Scrabble Dinner evolved as an alternative way to create a meal, abandoning the customary ways food is combined and presented. No single chef can take credit for the result, and recipes may be consulted but never closely followed. As part of a group, you'll follow a shared strategy to concoct each dish, pool resources, and divide cooking duties.

Sounds confusing? Not to worry. Even—or perhaps especially—if you do it wrong, you will still end up with a fantastical and highly memorable

meal. By staging your own Scramble Scrabble Dinner, you'll tap into the experimental spirit of Mildred's Lane while also questioning the labor and rituals we often perform without a second thought. You'll demonstrate how, through a single meal, everyday life can be a kind of art.

Participants playing a Scramble Scrabble game at MoMA studio, 2012

Scramble Scrabble fund-raiser game cloth, 2010

YOUR TURN

This game requires enthusiastic collaborators and a willingness to fail. This is a rough framework for how you might play the game, but feel free to adapt the rules as you see fit. You will feel the urge to create a dish you know, but the key is to defy convention and make it weird! The fun of the game is to concoct a meal that has never before been made in all of human history.

1 Gather a nice cloth or piece of good paper, indelible markers, and two to six people.

2 Each person writes their name on the cloth and then scrambles the letters of their name to make a list of food items (beet, ham, basil), cooking processes (boil, sauté, fry), measurements, and modes of presentation (bowl, cone, stick).

sarah urist green

sugar
grits
tea
greens
sage
sawte
rare

nest grains
stir rashers
tuna
ghee
sushi
garnish
tin

3 One person starts the game by writing out a word from their list. The next participant uses a letter from the first word as an intersection point (like in Scrabble or a crossword puzzle) and either adds a new word from their list or forms an entirely new word to add to their list. You can use letters more than once.

4 Each participant takes turns playing a word off of an existing word, rotating the cloth or paper as you go. Try not to let anyone predetermine the outcome. Continue adding words until you agree that a dish has been formed, remembering to avoid the expected and embrace oddity in your combinations. Sketch out the dish you envision.

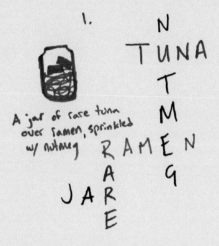

I.

N
TUNA
T
M
RAMEN
A G
A
JARE
E

A jar of rare tuna over ramen, sprinkled w/ nutmeg

5 Repeat steps 3 and 4 to create additional dishes, until all your words are used or you have a variety of dishes to assemble and feel your meal is complete.

6 Make a meal plan, divide duties, and schedule your dinner.

7 Gather your ingredients and make the meal. Prepare and present your dinner artfully.

TIPS/CHEATS/VARIATIONS

▶ Have a bigger group? Divide into teams and have one person per team participate in the game. Or combine your names to create one large nonsensical name and play that.

▶ Think the game can be improved upon? Go for it. Include middle names to increase your pool of letters to pull from. Allow a player to use the word "pizza" even though their name includes only one "z." Or use the names of famous artists or celebrities instead. Decide as a group what rules you want to keep or discard.

▶ To give everyone time to brainstorm and prepare, think of this assignment in two stages:

- Playing the game and planning
- Making your dishes and enjoying the meal

▶ Before you play, sit down and make a list of the food-related words you can spell from the letters of your name. Use an online anagram generator if you like, and grow your list to give you ample options when it comes time to play. Help other players find words from their names, too, before and during game play.

▶ A cloth is suggested for game play so that you have a nice tablecloth for your meal, but feel free to use whatever you have. If you approach either material thoughtfully, you'll end up with an art piece worthy of future presentation (food stains only make it more beautiful).

▶ Your dish not working out as you planned? Adapt it as you go. If you've been dealt a difficult ingredient, make it more of a garnish. Your sketched menu item is only a loose idea from which you can create a dish that best embodies the spirit of the exercise.

▶ Make your table setting as outrageous as the meal. Consider where you eat, the way the table is decorated and set (if you even use a table), the music that's playing, and the order of your dishes.

▶ This is a brilliant activity to do when family is gathered for a holiday or on vacation with friends. Play the game as a first step, and give yourselves time to shop and prepare the meal. Scramble Scrabble Thanksgiving, anyone?

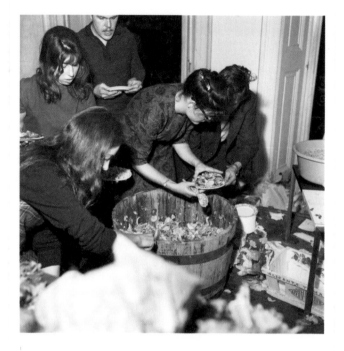

Alison Knowles, Proposition #2: Make a Salad, *1962, gelatin silver print, Festival of Misfits, Institute of Contemporary Arts, London, October 24, 1962*

In 1962, Alison Knowles (b. 1933) appeared onstage at London's Institute of Contemporary Arts, prepared a salad, and shared it with the audience. She was following her own written instructions, an "event score" that prompted her to simply "make a salad." Knowles was a founding member of the Fluxus group, a network of like-minded artists who embraced everyday actions as art. They invited chance into their work through the openness of their prompts, which could be interpreted broadly and acted out by any number of performers. With *Make a Salad*, Knowles not only makes art of the mundane but also professionalizes labor that is often invisible, elevating an activity that in the early sixties was considered to be firmly in the realm of women's work.

PAPER PLATE

Julie Green (b. 1961)

There are few objects less precious than a paper plate, designed to be used once and promptly discarded. In the hands of Julie Green, however, paper plates are transformed into objects of beauty that reward sustained attention. In a series titled *Fashion Plate*, Green took inspiration from the patterns of historical English ceramic plateware and painted paper plates with a range of imagery, exploring the themes of domesticity, decoration, fashion, identity, security, and bias. Beginning with thick layers of gesso, Green rendered onto the paper plates in bright acrylic paint select images from European "flow blue" plates and Victorian transferware, incorporating contemporary details in the patterns and margins. One plate features a pastoral scene in its center, surrounded by women's legs in fishnet hose and a building wrapped in chain-link fence on the campus of Oregon State University, where Green is a professor. The image is rendered in a monochromatic green, with flourishes made in glow-in-the-dark paint that appear when the lights are off.

Fashion Plate is a vibrant, playful counterpoint to the project that has occupied much of Green's time since the year 2000. *The Last Supper* is Green's ongoing series depicting the final meals of death row inmates in the United States, each painted onto secondhand porcelain dishes in a cobalt blue reminiscent of traditional English and Japanese china. With the intention of humanizing the executed prisoners, Green has created over eight hundred plates thus far, and is committed to documenting fifty meals a year until capital punishment is abolished. Some of the meals are elaborate ("Three fried chicken thighs, 10 or 15 shrimp, tater tots with ketchup, two slices of pecan pie, strawberry ice cream, honey and biscuits, and a Coke"), others deeply personal and nostalgic ("German ravioli and chicken dumplings prepared by his mother and prison dietary staff"), and many devastatingly spare ("one apple" or "none"). More recently, Green has begun to document the first meals of exonerated prisoners after they have been released,

rendering their meals in bright colors and interspersing them with text and details derived from interviews with exonerees.

Green's interest in memory and how we process it is evident in each of these bodies of work, probing the details of our histories that we choose to remember and record, and also those we discard and forget. Also clear is the artist's enduring preoccupation with eating and meal-sharing as a central and unifying human experience. It's the thing we all do, and must do, in order to continue on. And a plate is the foundational surface for the entire endeavor. What better material for art?

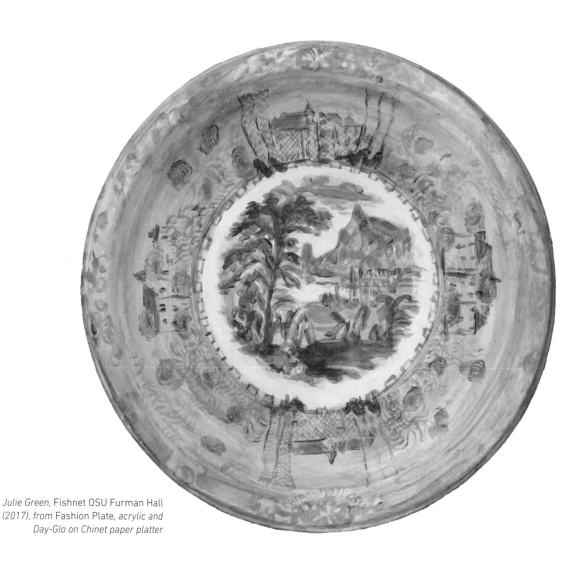

Julie Green, Fishnet OSU Furman Hall *(2017), from* Fashion Plate, *acrylic and Day-Glo on Chinet paper platter*

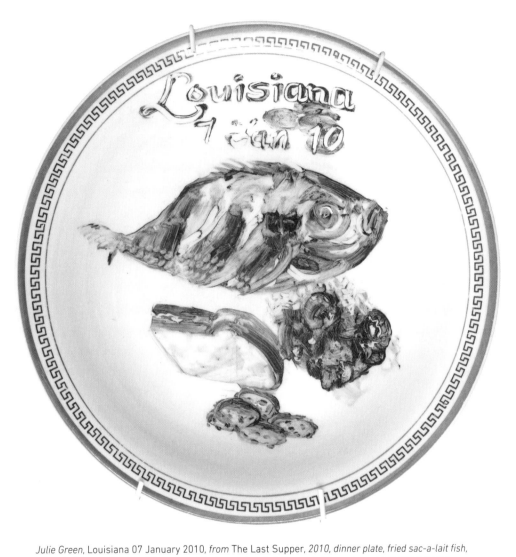

Julie Green, Louisiana 07 January 2010, *from* The Last Supper, *2010, dinner plate, fried sac-a-lait fish, topped with crawfish étouffée, a peanut butter and apple jelly sandwich, and chocolate chip cookies.*

TIPS/CHEATS/VARIATIONS

▶ Chinet paper plates are the brand of choice for Green, as they are durable, rigid, and a good surface to work from. Green pressure-laminates two plates together with glue or gel medium between them, coats them with three layers of white acrylic gesso on both sides, and then applies acrylic paint on top of that. This not only stabilizes the plate and makes it archival, but your acrylic paints will be more vivid and you'll need to use less of them. If you are using watercolor paint, unprimed plates (no base layer of gesso) will work better.

▶ Make a plate hanger before you begin. In the technique described above, Green adds holes to the base plate and loops thread through them before attaching it to the top plate.

▶ Try painting in a single color. "Grisaille" is the art term for the technique of painting in shades of gray, and that can work well here. Or select a single color you love and paint your memory in monochrome.

▶ Have a hazy memory? No problem. Create a dreamlike scene using the paintings of Leonora Carrington or Marc Chagall as inspiration, bringing people into your painting and the bits of information you do recall. For a ceramic plate pattern you can't quite remember, make it up or look online for something that feels similar in your memory.

CONJURE A STUDIO

Hope Ginsburg (b. 1974)

Hope Ginsburg's first studio was a table and chair under the basement steps of the house she grew up in. When she lived in New York, her studio was also her apartment, where she hosted studio visits by neatly making her bed and projecting images onto a screen in front of the couch. Over the course of her career, Ginsburg has made a studio out of many unorthodox spaces: a backyard, where beekeepers helped her fashion a beard out of bees; a Qatari desert, where she meditated in full scuba gear; and a kitchen, where she cooked up vats of wool felt to shape into large-scale sea sponges.

Ginsburg is a self-proclaimed sea sponge obsessive, and her projects have explored the sponge's biology as well as its metaphoric potential as an animal that is highly adaptable and social. Her felt sponges were developed through partnerships with marine biologists, wool vendors, felters, and natural-dye experts. She made the felt sponges collaboratively with local artists and students through workshops in Richmond, Virginia, and Porto Alegre, Brazil, where they were eventually displayed in a former thermoelectric plant.

She dreamed of "planting" her sponge operation somewhere more permanent and established the "Sponge HQ," a base of operations inside Virginia Commonwealth University School of the Arts. For five years, the space served as an interdisciplinary lab, workshop, and classroom, with a felting studio, aquarium, active beehive, and library. The HQ played host to a wide array of lectures and projects by students and visiting artists, and also became Ginsburg's de facto studio.

When that project was winding down, Ginsburg began to think about where she'd like to work next and whether she needed a "proper" studio at all. She'd daydream about what her fantasy studio would look like and then consider the more practical approach of taking over the guest room in her house. Perhaps her studio could be a dive shop, an outgrowth of her series *Breathing on Land*, offering scuba-diving gear for guided meditation sessions on land? Or should it be a more general space that various projects could flow through?

We tend to think of artists' studios as solitary spaces from which artwork emerges fully formed. But Ginsburg's practice is driven by investigation out in the world, learning by doing, and synthesizing the talents of many. What is the right kind of space for her work to happen? And what kind of studio is right for the work that you do?

TURN THE GUEST ROOM INTO A STUDIO, CONJURE A NEW GUEST ROOM.

Hope Ginsburg, Conjure a Studio concept sketches, 2016

CONJURE A STUDIO: FIRST MEDITATION RETREAT ON MARS

YOUR TURN

Think back to the places where you've been the most productive and inspired. What was it about them that helped your synapses fire? Whether your ideal studio is intentionally preposterous or achievable in an afternoon, consider what it is that makes a space suitable for learning, thinking, and making. And not for some imaginary smocked artiste of yore, but for you, and whatever it is that you take seriously.

1. CONJURE A STUDIO: REAL OR IMAGINARY
 * WHERE DO YOU LIKE TO WORK?
 * WHAT WOULD YOU LIKE TO DO?
 * IF YOU COULD DO IT ANYWHERE (OR WITH ANYONE), WHERE WOULD THAT BE?

2. MAKE IT HAPPEN: REAL OR IMAGINARY
 * TAKE OVER, TRANSFORM, BUILD A SPACE . . .
 * MAKE A DRAWING, COLLAGE OR MODEL . . .
 * MAKE IT LIFE SIZE OR MINIATURE (OR GIANT) . . .
 * HIDDEN OR IN PLAIN SIGHT (GO SOMEWHERE OR STAY PUT) . . .

TIPS/CHEATS/VARIATIONS

▶ What sites are available to you? An unused corner of your basement, a closet, a drawer, your computer desktop, or your actual desktop?

▶ Perhaps your ideal studio is a headspace rather than a physical space. Conjuring your studio could entail regular meditation, therapy, yoga, long runs, music lessons, or teaching others.

▶ Is your dream studio a fully staffed luxury yacht in the middle of the ocean? Draw it, animate it, or make a collage. (If you're willing to

compromise, find a junker boat and transform it into an installation/ studio in your garage!)

▶ Already have a work space you like well enough? Create some sketches for how you might make it over. Or empty it out and put everything back in differently. Give away everything nonessential. Change is good.

▶ If you'd like to throw some resources toward the effort, don't be afraid to go big! Use this as an excuse to rent a new space, borrow your aunt's RV, or start that letterpress studio you've been daydreaming about.

SHADOW PORTRAIT

Lonnie Holley (b. 1950)

Lonnie Holley has been an improviser since he was little, by nature and by necessity. His grandmother called him her "king bee," because he was busy working all the time. She taught him how to salvage and repurpose what other people throw away, taking him with her to rake bundles of scrap metal from city lots to sell to the junkyard. One day, Holley took a bundle of wire, straightened it out, and made it into a butterfly that he hung up in their house. When his grandmother came home and discovered it, she cried.

The steel foundries in Holley's hometown of Birmingham, Alabama, also provided material for his creations. In 1979, after his sister's two young children died in a house fire, Holley carved grave markers from discarded stone linings used in industrial molds. The carvings were both a response to a need and a way for Holley to process the devastating loss. In his words, "Art was my savior." And so it was that at the age of twenty-nine he began making sandstone carvings, and soon after sculptures and assemblages made from a huge range of found objects and detritus. Holley populated more than an acre of his family's property with his work, bringing together scrap metal, roots, branches, barbed wire, shards of glass, fabric, bits of plastic and rubber, and much else, to create a sprawling walk-through art environment. As he explains it: "I take things and I put them together, and they end up being what humans call art."

Holley's artworks are intensely personal, bearing traces of his traumatic childhood and telling stories of his life, but they also open out, exploring shared histories and current events. He is deeply troubled by what he calls "America's habits," or the rampant consumerism and waste that is wreaking havoc on our planet. His work is made of what most consider to be trash, which he unearths from ditches, creek beds, and alleys. Holley likens the activity to an investigator's collecting stories, finding the beauty in, say, a warped piece of an old vinyl record, listening to what it has to say, and giving it new life. The material either goes in his backpack to be brought home and incorporated into future

works, or gets reworked on the spot and placed out in the world, resting beside an overpass or woven into a fence. "It's not going anywhere. It's not deteriorating," he says. This is Holley's way of honoring Mother Earth, taking responsibility for the massive volume of waste we produce, and reinvesting it with purpose and meaning.

Lonnie Holley, Memorial at Friendship Church, 2006, metal, found debris, plastic flowers, and ribbon

Never one to stop evolving, Holley released his first musical recordings in 2012 at the age of sixty-two. His music, like his visual art, is improvisational and never performed the same way twice. During a 2013 performance, Holley freestyled parts of the Pledge of Allegiance and "America the Beautiful," in and among whistling, scatting, and criticism of the government. He also worked in a verse that beautifully encapsulates his message and mission: "So much to be harvested, and the harvesters are so few."

With this assignment, Holley beckons us to be harvesters. Let's heed the call.

YOUR TURN

Profiles appear often in Holley's work, crafted from bent wire or peering out from his sandstone carvings. They honor individuals he has known as well as many he has not, representing ancestors and the multitude of people who came before us. It's time to reconsider and refashion the materials already around you and add your own profile to Holley's diaspora of voices.

1 Take a wire coat hanger from your closet (or find one).

2 Twist the hanger from the hook until you separate the two ends, and straighten the wire.

3 Bend the wire into a profile of your face.

4 If you like, add beads, cloth, feathers, or any other item that helps make this feel like you.

5 Hold the piece a few inches from a white wall and take a picture of the shadow.

6 Hang your profile on the inside of your front door and every time you leave your house, be the person you envisioned when you made it.

TIPS/CHEATS/VARIATIONS

▶ Do not buy anything for this assignment. It's against the Holley ethos. You can find everything you need if you look for it.

▶ Use pliers if you like, or wear work gloves to protect your hands as you bend the wire. (Holley doesn't use them, but he's had a lifetime of experience.)

▶ Look at your profile in a mirror. You may give yourself a glance every day, but it is probably less often that you closely observe your distinctive curves. Don't worry about a precise likeness, but do your best to recognize a part of yourself in it.

▶ Let the work evolve. Make the profile, and if you aren't moved to add anything else to it at first, hang it as is. When you find bits that call to you, work them into your profile, allowing it to change over time.

▶ Holley invites you to post the picture of your shadow on Instagram and tag him (@lonnieholleysuniverse). Check your account periodically, and he may just tag you in his own shadow photo.

IF YOU HAVE ANY NEGATIVITY GOING ON, IF YOU HAVE ANY DOUBT, IF YOU THINK THAT YOU HAVE BEEN MISTREATED, NEGLECTED, AND REJECTED, ALL YOU GOTTA DO IS GO TO WORK. IT'LL CHANGE YOUR BRAIN, IT'LL CHANGE YOUR WAY OF THINKING.

—LONNIE HOLLEY

PARTING NOTE

You must be exhausted after doing all of these assignments (or even just one or two).

Give yourself a break and go *not* make art for a while. Take a walk, read a book, watch a movie, stare into the middle distance, and most important, do *not* think about how you might capture your experience or share it with others.

When you are ready to get back to it, remember that no one can tell you how to make your art. Many will offer opinions, but you have to figure out your own way. The approaches represented in this book are but a sliver of the limitless number of ways to create objects and experiences that make up the ever-shifting field of activity we call art.

It is my hope that these assignments have gotten you a little bit closer to finding a way of working that feels right for you. Perhaps you've discovered a new material in one assignment, borrowed a conceptual approach from another, and identified in yet another an idea or question that has the potential to preoccupy and sustain you for months, years, or a lifetime. In the wise words of artist and educator Corita Kent, offered in 1968 in her ten rules for artists and teachers: "Find a place you trust, and then try trusting it for a while."

And then, when things get stale again, I hope you'll come back to this book to figure it out all over again.

ACKNOWLEDGMENTS

I owe an enormous debt of gratitude to the artists represented in these pages for inspiring me and many others with their art and ideas, and for giving generously of their time and energy: Zarouhie Abdalian, Güler Ates, Bang on a Can, Gina Beavers, Kim Beck, Genesis Belanger, David Brooks, JooYoung Choi, Sonya Clark, Jace Clayton, Lenka Clayton, Beatriz Cortez, Hugo Crosthwaite, Kenturah Davis, T. J. Dedeaux-Norris, Kim Dingle, Assaf Evron, Maria Gaspar, Kate Gilmore, Hope Ginsburg, Michelle Grabner, Julie Green, the Guerrilla Girls, Fritz Haeg, Pablo Helguera, Lonnie Holley, Desirée Holman, Stuart Hyatt, Nina Katchadourian, Peter Liversidge, Paula McCartney, Brian McCutcheon, Christoph Niemann, Odili Donald Odita, Toyin Ojih Odutola, Robyn O'Neil, Geof Oppenheimer, Douglas Paulson, Sopheap Pich, J. Morgan Puett, David Rathman, Wendy Red Star, Christopher Robbins, Nathaniel Russell, Dread Scott, Tschabalala Self, Allison Smith, Deb Sokolow, Alec Soth, Molly Springfield, Jesse Sugarmann, Jan Tichy, Gillian Wearing, and Lauren Zoll.

Before this project was a book, it was an educational video series produced in partnership with PBS Digital Studios. Many collaborators on the series helped bring the ideas in this book to life, the foremost of whom is Mark Olsen, who plays the roles of director, head of photography, camera operator, editor, navigator, and friend all at the same time. Mark traveled with me far and wide to interview many of the artists in this book and produced the superb videos that share a selection of these assignments. I am very grateful for the direct and indirect assistance provided by Brandon Brungard, Rosianna Halse Rojas, and Zulaiha Razak, as well as my wonderful colleagues at Complexly. Many thanks go to the good people of PBS Digital Studios, past and present, for supporting the project, especially Matthew Vree, Lauren Saks, Ahsante Bean, and Leslie Datsis.

I am enormously grateful to the *Art Assignment* community, who have followed our exploits since our first upload to YouTube in 2014. I have been blown away by your enthusiasm for each new assignment,

the thoughtfulness of your comments, and the outstanding artworks you've made in response. Each of you was pivotal in the development of these assignments and always in my mind as I wrote this book.

Ginny Lefler, thank you for the crucial and dedicated assistance you provided in creating this book. My gratitude also goes to the unstoppable Jodi Reamer, who found a home for this book, and to Meg Leder, for her belief in this project and invaluable voice in shaping it.

Thanks also go to the many good people of Penguin Books, including Shannon Kelly, Kathryn Court, Patrick Nolan, Lydia Hirt, Brooke Halstead, Rebecca Marsh, Ciara Johnson, Paul Buckley, Sabrina Bowers, Nicole Celli, and Sabila Khan.

My mom may have gotten the dedication, but both of my parents, Connie and Marshall Urist, are responsible for making art a critical part of my life. Thanks also go to my enormously creative and supportive in-laws, Sydney and Mike Green; my amazing friends Marina and Chris Waters; and my brave and loving children, Henry and Alice, who rightfully resist my art direction and make much cooler things on their own.

I could not have written this book without my partner in all things, John, my first and most important reader, and perpetually my contender in the room.

Many of these assignments were gathered in the course of making the web series *The Art Assignment*, produced in partnership with PBS Digital Studios. On our YouTube channel, you can hear directly from a number of these artists, as well as many others. On the Art Assignment website, you'll find additional assignments and resources, as well as a selection of artworks made in response.

Share your responses to these assignments on your social media platform of choice and tag your post with #youareanartist. By following the hashtag, you can find and enjoy art that others make and develop your own community of like-minded artists.

CATEGORIES

OUT IN THE WORLD

The Art of Complaining
Become Someone Else
Body in Place
Copy a Copy a Copy
Expanded Moment
Fake Flyer
Find Your Band
Meet in the Middle
Native Land
News Photographer
Proposals
Question the Museum
Quietest Place
Stakeout!
Surface Test
Thoughts, Opinions, Hopes, Fears, Etc.

IN THE STUDIO

Caption Contest
Customize It
Find Your Band
Graphic Score
Imaginary Friend
Imprint
Measuring Histories
Never Seen, Never Will
Paper Plate
Paper Weavings
Proposals
Shadow Portrait
Sympathetic Object in Context
Walk on It

WITH A FRIEND

Exquisite Corpse
Lost Childhood Object
Make a Rug
Meet in the Middle
Question the Museum
Scramble Scrabble Dinner
Sorted Books

SCULPTURE

Boundaries
Constructed Landscape
Customize It
Embarrassing Object
Lost Childhood Object
Measuring Histories
Never Seen, Never Will
Shadow Portrait
Sympathetic Object in Context

PHOTOGRAPHY

Blow Up
Body in Place
Constructed Landscape
Expanded Moment
Intimate, Indispensable GIF
News Photographer
Off
Sorted Books
Sympathetic Object in Context
Thoughts, Opinions, Hopes, Fears, Etc.
Virtual Seescape
Whitescapes

DRAWING

Drawing What You Know . . .
Exquisite Corpse
Graphic Score
Intimate, Indispensable GIF
Never Seen, Never Will
Psychological Landscape
Self Shape
Surface Test
Writing as Drawing as Writing

PAINTING (IF YOU WANT TO)

Caption Contest
Drawing What You Know . . .
Exquisite Corpse
Imprint
Paper Plate
Self Shape
Virtual Seescape

DESIGN

The Art of Complaining
Conjure a Studio
Emotional Furniture
Fake Flyer
Paper Weaving
Question the Museum
Statement
Vehicular Palette
Whitescapes

CRAFT AND TEXTILE

Imaginary Friend
Lost Childhood Object
Make a Rug
Measuring Histories
Paper Weaving
Self Shape

SOUND

Find Your Band
Graphic Score
Quietest Place
Simultaneity

PORTRAIT

Become Someone Else
The Muster
Self Shape
Shadow Portrait
Sorted Books
Thoughts, Opinions, Hopes, Fears, Etc.

USING TECHNOLOGY

Become a Sci-Fi Character
Copy a Copy a Copy
Intimate, Indispensable GIF
Off
Simultaneity
Virtual Seescape

PERFORMANCE

Become a Sci-Fi Character
Become Someone Else
Body in Place
Combinatory Play
The Muster
Proposals
Walk on It

WRITING

Caption Contest
Combinatory Play
Conjure a Studio
Fake Flyer
Imaginary Friend
The Muster
News Photographer
Question the Museum
Quietest Place
Stakeout!
Statement
Writing as Drawing as Writing

WITH KIDS

Caption Contest
Drawing What You Know . . .
Exquisite Corpse
Find Your Band
Imaginary Friend
Imprint
Meet in the Middle
Native Land
Paper Weaving
Proposals
Quietest Place
Shadow Portrait
Surface Test
Walk on It

IMAGE CREDITS